# THE
# GLOUCESTER
# & SHARPNESS
# CANAL
## An Illustrated History

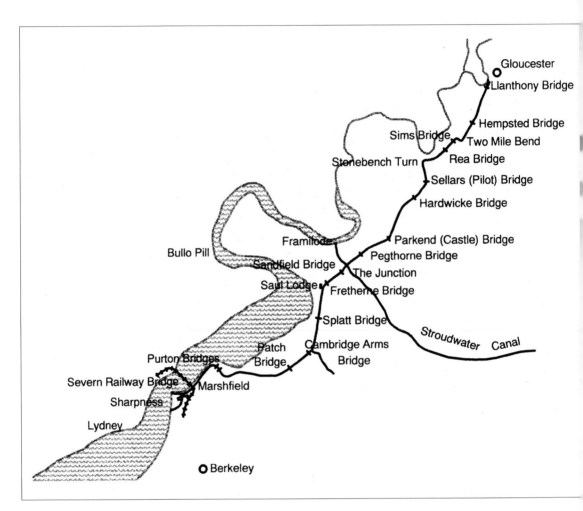

*The Gloucester & Sharpness Canal, built to bypass a winding and treacherous stretch of the River Severn. For detailed maps of Gloucester and Sharpness Docks, see pages 52, 83, 109, 127.*

# THE
# GLOUCESTER
# & SHARPNESS
# CANAL
## An Illustrated History

Hugh Conway-Jones

AMBERLEY

# About the Author

Hugh Conway-Jones is a retired engineer who has been studying the history of the local waterways for over 30 years. His previous books include *Gloucester Docks - an Illustrated History*, concentrating on the docks and warehouses at Gloucester, followed by *Working Life on Severn and Canal*, which describes the life of the boatmen carrying goods through to the Midlands. He has also written *Gloucester Docks – an Historical Guide*, which gives basic information for the interested visitor.

First published 2009

Amberley Publishing Plc
Cirencester Road, Chalford,
Stroud, Gloucestershire, GL6 8PE

www.amberley-books.com

British Library Cataloguing in Publication Data.
A catalogue record for this book is available from the British Library.

ISBN 978 1 84868 601 4

Typesetting and Origination by Amberley Publishing.
Printed in Great Britain.

# Contents

# Key Dates

| | |
|---|---|
| 1793 | Gloucester & Berkeley Canal Company authorised by Act of Parliament. |
| 1794-99 | First phase of canal construction from Gloucester to Hardwicke. |
| 1812 | Basin at Gloucester opened to traffic from the River Severn. |
| 1817-20 | Second phase of construction from Hardwicke to the Cambridge Arm. |
| 1820 | Temporary junction with the Stroudwater Canal opened. |
| 1822 | Exchequer Bill Loan Commissioners took financial control. |
| 1823-27 | Final phase of construction from the Cambridge Arm to Sharpness. |
| 1824-25 | Barge Basin constructed at Gloucester. |
| 1826 | New line of the Stroudwater Canal at the Junction commissioned. |
| 1827 | Ship canal opened on 26 April. |
| 1834 | Mills on the River Frome purchased and steam pumping engine set up at Gloucester to ensure a reliable supply of water. |
| 1836-40 | Bakers Quay constructed. |
| 1847 | Berry Close Dock constructed. |
| 1847-49 | Victoria Dock constructed. |
| 1848 | Midland Railway line to the docks opened. |
| 1850 | Government loan replaced by one from the Pelican Life Insurance Co. |
| 1852 | Llanthony Quay constructed. |
| 1860 | Steam tugs introduced for towing vessels along the canal. |
| 1861-62 | Dock extended and new Llanthony Bridge constructed. |
| 1871 | Last repayment made to the Pelican Insurance Office. |
| 1871-74 | New dock and entrance constructed at Sharpness. |
| 1874 | Name changed to the Sharpness New Docks & Gloucester & Birmingham Navigation Company. |
| 1879 | Severn Railway Bridge opened. |
| 1881 | Timber pond formed at Two Mile Bend. |
| 1891-92 | Monk Meadow Dock constructed. |
| 1893 | Hydraulic equipment provided for lock and entrance gates at Sharpness. |
| 1895-96 | Entrance piers at Sharpness extended. |
| 1896 | Monk Meadow timber pond constructed. |
| 1899-1900 | Midland Railway bridge across the canal at Hempsted constructed. |
| 1905 | Timber pond at Marshfield constructed. |
| 1940-42 | New quay constructed on the west side at Sharpness. |
| 1942 | Sandfield Wharf constructed. |
| 1948 | Canal and docks came under the authority of the British Transport Commission. |
| 1960 | New wharf and oil depot at Quedgeley opened. |
| 1965 | Monk Meadow Quay completed. |
| 1986 | North Warehouse converted to offices for Gloucester City Council. |
| 2007 | Netheridge Bridge completed at Two Mile Bend. |
| 2008 | High Orchard Bridge completed near Gloucester. |

# Sources and Acknowledgements

The first half of this book is mainly based on archives held at the National Archives, Gloucestershire Archives (including the Gloucestershire Collection), the Ironbridge Institute and the British Waterways Archives now held by The Waterways Trust. I am really grateful to the staff of these establishments for the help they have given me in finding documents and suggesting avenues for research. The principal references are noted at the end of the book.

The second half of the book is partly based on archives but also includes much additional information from the memories of those who worked on the canal and the docks at each end. Many people have helped me to build up a picture of what life was like when there was commercial traffic on the canal, and I am particularly grateful to those whose memories are acknowledged in the references.

I am also grateful for help received from fellow researchers David Clement, Brian Edwards, Nigel Harris, Mike Nash, Rose Spence and the late Neville Crawford, from David McDougall, then at the National Waterways Museum, Irene White, then at British Waterways, Dr. Ray Wilson of the Gloucestershire Society for Industrial Archaeology and from my wife Rosemary.

Finally, I am pleased to acknowledge the following organisations and individuals who made illustrations available:

The Citizen 166, 170, 173; Gloucester Art Gallery and Museum Col.1, 2, 4; Gloucestershire Collection (at Gloucestershire Archives) 19, 64, 78, 82, 93, 103, 112, 121, 123, 141, 154, 164, 175; Gloucestershire Archives 33, 41, 46 (Household), 59, 69, 83, 92, 114, 128 (Cyril Hart); National Monuments Record 99, 120; National Waterways Museum 60 (Hirst), 72, 73, 75, 76, 107, 111, 117, 118, 125a, 129, 140, 146, 153, 155, 157, 168, 169, 174b, 175; Railway & Canal Historical Society 135, 151; The Waterways Trust (Waterways Archive) 31, 160, 161, 172, 180, 181; Norman Andrews 162, Col.13, 14, 15, 16; Marian Barton 133; Howard Beard 144; Margaret Boakes 38, 94, 134, Col.7, 10, 11; Doris Butt 44, 67; Cadburys Trebor Bassett 106, 145, Col.12; Fred Carpenter Col.22; Gill Pearce 79; Edward Cook 55; Sheila Cooke 102; Les Dalton 148; Peter Davis 101; Dennis Fredericks 152; Ken Gibbs 96, 176, 177, 183; Carol Hearn 178; Lionel Hill 174a; Bob Ingram 139; Tom James 165, 179; Mike Marsden Col.8, 9; Campbell McCutcheon 137, 138; Wilfred Merrett 50, 70; Bev Minett-Smith 131; Robert Moreland, 105; Jim Nurse Collection 56-7, 63, 80-1, 86-7; Neil Parkhouse 116, 125b, 147; David Clement 104; Ken Price Col.19, 24; Sheila Proctor 136; Rod Shaw 65, 89; Betty Shill 150; James Timms 182; Pam Walsh 91; Richard Watkins 143; Phyl Wilkins 39, 62; Dick Woodward 159.

Hugh Conway-Jones, Gloucester.

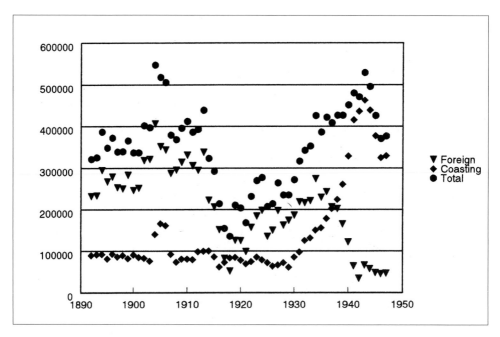

*Annual totals of registered tonnage of vessels arriving at Sharpness. This shows the peak tonnage handled in 1905, the dramatic reduction during the First World War and the slow recovery afterwards. In the 1930s, the coasting (barge) traffic increased due to the growing demand for petroleum products, but foreign imports fell again during the Second World War. The registered tonnage of a ship was a measure of volume, and the actual weight of cargo carried was much higher than the figures shown. For example, the total weight of cargo in the peak year of 1943 was over one million tons, almost half being petroleum products.*

# I

# Great Excavations

In the eighteenth century, the River Severn was a major highway for trade between the Midlands and the great port of Bristol, with a wide range of cargoes being carried in shallow draught sailing vessels known as trows (pronounced to rhyme with crows). The development of industries in the upper Severn valley and the opening of the Staffordshire & Worcestershire Canal in 1772 encouraged the growth of traffic on the river, and this highlighted the restriction caused by the narrow winding stretch below Gloucester. With its strong tides and hazardous sandbanks, navigation was only possible for shallow draught vessels and then only for a few days each month around the times of the spring tides. The idea of building a ship canal to bypass this bottleneck was first suggested by Samuel Skey, who owned a very successful chemical works near Bewdley. As well as providing a safe route for local traffic at all states of the tide, the canal would also allow sea-going ships to reach Gloucester, where cargoes could be transferred directly to inland canal boats (known locally as longboats), thus enabling the city to challenge Bristol as a primary port. Planned as the deepest and widest canal in the country, it was clear that, if successful, it would provide far-reaching benefits to both Gloucester and the Midlands.

To promote the canal, Skey was joined by business and professional men in Gloucester and in those parts of the West Midlands which relied on the Severn navigation. The largest individual subscribers included Samuel Skey himself, Samuel Skey jnr, ironmaster William Reynolds of Ketley, merchant George Humphreys of Birmingham, carrier Aaron York of Stourport and banker Joseph Berwick of Worcester. The local activists included pin-maker Thomas Weaver, who as Mayor of Gloucester chaired the initial meeting of subscribers on 6 November 1792, wool-stapler Richard Chandler, barrister and banker William Fendall and surgeons Richard Brown Cheston and Charles Brandon Trye.

The promoters had arranged for an initial survey of the route to be carried out by Josiah Clowes, the Principal Engineer of the Herefordshire & Gloucestershire Canal which had been authorised by Parliament in the previous year. He proposed a canal 16 miles long, 72 feet wide and 15 feet deep from the River Severn at Gloucester, crossing the Stroudwater Canal near Whitminster and having an entrance from the Severn estuary about a mile above an inlet known as Berkeley Pill. The route was

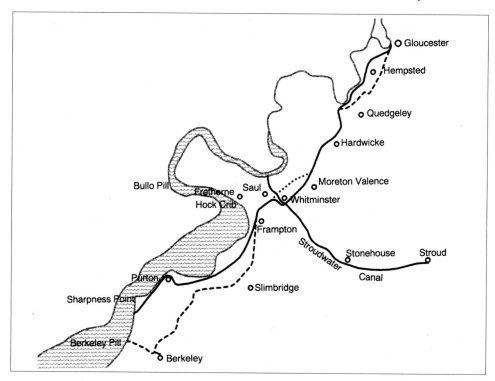

*Initial routes for the canal proposed by Josiah Clowes (solid line) and Richard Hall (dashed line) with the later amendment proposed by Mr Crossley (dotted line).*

generally through low ground, quite near to the river in places, and the estimated cost was £102,108. Such was the enthusiasm for canals in the early 1790s that there was no shortage of potential subscribers, and it was agreed to press ahead quickly to obtain early parliamentary approval. This was the time of the "canal mania" when speculators rushed to invest in the expectation of making big profits.

Unfortunately, the route proposed by Clowes did not suit the interests of two influential landowners. Dr Daniel Lysons, owner of Hempsted Court, strongly objected to the canal cutting through his tenants' farms to the west of Hempsted Hill, and Lord Berkeley of Berkeley Castle insisted on having a branch into Berkeley town. Furthermore, a respected estuary pilot advised that Berkeley Pill was the only fit place for an entrance. A second survey was therefore carried out by Richard Hall, a local land surveyor. To meet the objections, he proposed one deviation from Clowes's route that would pass to the east of Hempsted Hill and another deviation passing near to Berkeley on the way to an entrance at Berkeley Pill with a short branch into the town. Before applying to Parliament, the promoters arranged for this route and the original one to be reviewed by Robert Mylne, an eminent architect and water supply engineer who also became involved in canal schemes during the mania period. In late January 1793, having spent just five days looking over the ground, Mylne reported that he thought both routes were practicable, although Hall's route would be the

more expensive as it required deeper cutting. Mylne later wrote that an entrance at Berkeley Pill was never a favourite with him, but it is not clear if he ever proposed an alternative.

Desperate to secure the support of the landowners in Parliament, the promoters agreed to adopt Hall's route and to accept other conditions that were to cause difficulties later. They also held meetings with the proprietors of the Stroudwater Canal and agreed to include clauses in the bill that would protect their rights. Mylne estimated the cost for Hall's route as £137,238 and, based on this, the promoters asked Parliament for authority to raise £140,000 by shares and a further £60,000 if needed by further shares or by mortgage. Mylne gave evidence to a House of Lords Committee that the project was practicable, and the bill was given the Royal Assent on 28 March 1793, having been rushed through all its stages in a little over one month. The speed with which all the arrangements were made was a tribute to the spirit and enterprise of those involved, but the agreements reached in the enthusiasm of the "canal mania" were soon being regretted by the shareholders of the newly authorised Gloucester & Berkeley Canal Company.

The first general meeting of the shareholders of the new company took place at the Booth-hall Inn, Gloucester on 4 June 1793, and subsequent gatherings were held each spring and autumn. At each meeting, a Committee of nine shareholders was elected to run the day-to-day business for the following six months. In the early years, the Committee was mainly drawn from the leading business and professional men of Gloucester who had been active in promoting the canal, the usual chairman being the pin maker Thomas Weaver. John Wheeler was appointed Clerk, and a house off Southgate St. (in what became Albion St.) was purchased to serve both as a residence and office for him and a place for the Committee to meet. To finance expenditure, calls were made when required on all shareholders to pay up a proportion of their promised commitment, usually five per cent at a time.

Few members of the Committee could have had any experience of civil engineering, and now they were embarking on one of the biggest such projects ever undertaken. To give them guidance, the Committee asked each of the two leading engineers, William Jessop and Robert Whitworth, to re-survey the route of the canal, but when it was clear that both were too busy on other projects, the Committee had to fall back on recalling Robert Mylne, who had helped in obtaining the Act. He spent two weeks in September setting out the line of the canal, taking levels, measuring the flow in the River Cam, sounding the river and talking with the Committee, and in October he was appointed Chief and Principal Engineer. This was not a full time appointment, and Mylne needed to fit the work in with his many existing commitments. Meanwhile, however, the financial situation had deteriorated following the outbreak of war with France, so that some shareholders did not respond to the early calls for cash and many of the landowners did not take up any of the shares that had been reserved for them. To meet this difficulty, it was agreed to follow the common practice of paying 5% interest to shareholders who paid up on time, even though this meant a drain on the capital.

Before digging could start, it was necessary to give careful consideration to how work on the huge project would actually be carried out, given that the width of the canal was due to be 70 feet at the top and 20 feet at the bottom and it was agreed to increase the depth from 15 to 18 feet to accommodate larger ships. Expecting that drainage of the huge excavation would be a difficulty, the Committee asked Boulton & Watt to provide a steam pumping engine. Mylne initially specified that this should be capable of either working in a boat or fixed ashore so that it could be used wherever it was needed, but when he appreciated the size of boat that would be required, he arranged for the engine just to be land-based. Mylne also prepared drawings of the canal. Recognising that the excavation of a huge trench by manual labour would be a daunting undertaking, the Committee made enquiries into possible mechanical aids, and one trial machine was ordered.

As the initial surveys had been done in rather a hurry, a new study of the whole line was carried out by a Mr Crossley in the spring of 1794, and he found more favourable levels than the previous surveys. He also suggested a diversion to the north and west of Whitminster to avoid a major cutting through Pegthorne (or Packthorne) Hill between Whitminster and Moreton Valence, but Mylne dismissed this as impractical, saying that the landowners would not accept any deviation from the Parliamentary line. However, Mylne himself did propose a change at Berkeley where the branch would also have involved deep cutting, and he suggested instead having a basin where the main line of the canal crossed an existing road about one mile from the town.

Taking account of Crossley's levels and allowing for basins at each end, Mylne presented a new estimate to the Committee in June 1794. This assumed lower costs for land and for labour than had been used in the original estimate, and so in spite of the increased depth of the canal, the total estimate was reduced to £121,330. This was particularly good news, as the lower estimate virtually eliminated the earlier concern about the shortfall in capital pledged by shareholders. In a contemporary report, Mylne recommended initially digging a 20 feet wide canal from Gloucester to the Stroudwater Canal. This would facilitate the movement of excess soil from the cuttings to parts where the banks would need building up, and it would allow some trade to London, via the Stroudwater and Thames & Severn Canals, long before the ship canal could be completed. Apparently seeing this as a distraction from their prime objective, and encouraged by Mylne's reduced estimate, the Committee preferred to press ahead with what became known as the Grand Scheme.

The first contract for work on the ground was soon arranged with William Thornbury, who agreed to start preparing a wharf on the river bank near the proposed lock at Gloucester for the delivery of materials. In July 1794, however, the Herefordshire & Gloucestershire Canal Company complained that Thornbury had recruited three men who had been working on their canal. As this contravened an agreement between the two Canal Companies not to allow men to switch jobs until they had finished what they had agreed to do, Thornbury was asked to discharge the three men.

The Committee also started negotiations with landowners, approved specifications for the main contracts and appointed Dennis Edson as resident engineer to supervise

the construction work. Then in October 1794 they contracted with Sampson Lockstone of Sodbury to dig out the basin at Gloucester. At the same time, they arranged for William Montague of Gloucester to dig the canal to the Sud Brook, 450 yards south of the basin. William Montague was actually a member of the Committee, and the idea of digging this short length was to show other contractors what was required and to try out a machine invented by another member of the Committee, Charles Brandon Trye. Unfortunately, the weather that winter was particularly bad so that little work was possible for four months, and when digging started again, it soon became clear that Trye's machine was of no use. Work on the basin was delayed further when Lockstone went down with consumption, and such was the difficulty of the work that three other contractors struggled for short periods before Charles Holland took on the job and started making real progress. Some of the clay dug from the basin was used to make bricks, but most was spread over the adjoining land to bring it above river flood level.

During 1795, the Committee awarded further contracts for digging the canal. William Montague agreed to dig the half a mile south from the end of his existing contract at the Sud Brook, James Pinkerton took on the next half mile (excluding a short length through the side of Hempsted Hill) and George Mills started on the next half mile crossing the stream later known as the Black Brook. For these contracts, the Company agreed to pay from 4 pence per cubic yard for shallow digging to 6½ pence for deeper work, the contractor providing planks, wheelbarrows and tools and the Company keeping the works free of water. The cut through the side of Hempsted Hill was excluded because it required particularly deep excavation and the landowner, Dr Daniel Lysons, had obtained a clause in the Act requiring the spoil to be removed. This work was later carried out by Thomas Walker at a rate of 9 pence per cubic yard. The

*The seal of the Gloucester & Berkeley Canal Company drawn by Philip Moss from surviving share certificates. This design was by Thomas Bonner of Gloucester after an earlier prototype from Matthew Boulton of Birmingham was rejected because the engraving was too shallow and two flags were blowing in opposite directions!*

Committee also arranged for John Toye of Dawley to supply 16 inch diameter cast-iron pipes to form culverts under the canal and for George Stroud and Daniel Spencer of Gloucester and Thomas Cook of Brimscombe to carry out all the brick-laying and mason's work for the canal structures.

With construction work well under way, Mylne criticised the conduct of resident engineer Dennis Edson, and the Committee found that he had not given clear instructions to the workmen and not taken proper measurements of the work done so that stage payments to contractors had been delayed. On Mylne's recommendation, Edson was replaced by James Dadford of Cardiff in August 1795. However, as the enormous scale of the earthworks gradually became apparent, Mylne also found his own authority being challenged. The first matter of contention was Mylne's plan to build the basin walls to only half the full depth where they would be based on a protruding ledge of clay about nine feet above the bottom of the basin. Then Charles Brandon Trye produced a paper highlighting the high cost of forming the spoil banks on either side of the canal in the example length being done by William Montague. Where the natural ground was the same as the water level, the banks were about 10 feet high and 25 feet wide at the top. Also Edmund Stock, a close friend of Trye, put forward figures claiming that Mylne had underestimated the cost of cutting the canal and forming the basin at Gloucester, and he asked for a new estimate.

Mylne responded to the comments at a special meeting on 8 January 1796 attended by 44 shareholders. With regard to the spoil banks, Mylne said he had originally intended to bury the spoil under the topsoil of the surrounding fields, but subsequent calculations showed it was more economical to buy more land and form high banks with steep sides totally within the Company's property. This would avoid the need to pay damages to neighbouring landowners, and the high banks would enclose the land and so save the need for fences. He considered that Trye's costing had assumed a price for land which was far higher than was reasonable, although he did acknowledge that this was more a matter for a land agent than for an engineer to judge. With regard to Stock's comments about the cost of cutting the canal, Mylne acknowledged some concern about the scarcity of labour since the outbreak of the war with France, but he thought that as contractors gained experience, the efficient ones would reduce their prices. However, he stressed that this would only come about if the men were paid more regularly than had been the practice, and he emphasised the need for the resident engineer to take fair measurements of the work done every Friday afternoon and for the Company to have a means of authorising payment by noon on Saturday. In response to Stock's comment that no cost had been allowed for widening the canal to form the basin at Gloucester, Mylne said this should not amount to much as it was only proposed to excavate the western half of the original hexagonal plan, leaving the eastern half to be financed from the profits of trade in the future.

Although the general tone of Mylne's responses was to rebuff his critics, in presenting a new estimate, he did allow for higher costs for land and for cutting as had been suggested by Trye and Stock. Adding in some other increases as well, his new estimated cost of construction amounted to £145,000. For the first time,

Mylne also allowed for the interest likely to be paid to shareholders over five years (£16,000) and for other administration expenses (£8,000) which he felt had to be considered although they were not really part of an Engineer's responsibility. The total for the new estimate thus came to £169,000, which was considerably more than the £118,000 so far pledged by the shareholders. With the interest payments particularly in mind, Mylne emphasised the need to move forward quickly, and he repeated an earlier recommendation to build initially a canal with a depth of eight or nine feet for local traffic, in order to get some return on the investment, leaving the whole scheme to be completed later. After due deliberation, the shareholders thanked Trye and Stock for their comments and expressed a favourable view of the full size canal, provided the work was carried on with proper expedition.

Responding to Mylne's comment on the need to pay contractors promptly, the Committee immediately empowered their Chairman to authorise payments each Saturday, and noting the plea for faster progress, they pressed ahead with three more contracts for the next 1¾ miles of canal through the parish of Quedgeley. Thomas Walker and Edward Wright were responsible for the length which included the two sharp bends later known as Two Mile Bend and Netheridge Turn. It seems that these

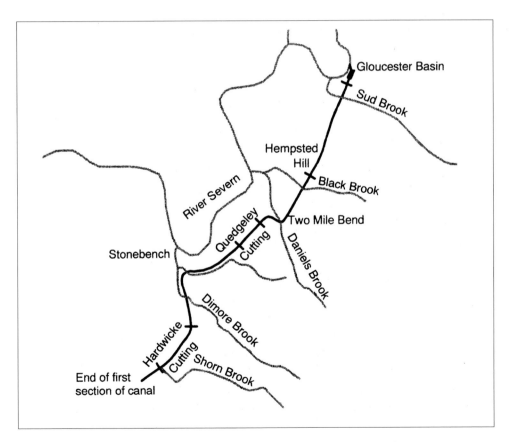

*The first section of the canal from Gloucester to Hardwicke built during the 1790s.*

bends were necessary to minimise the earthworks needed to cross the valley of the Daniels Brook and to find the easiest path through the high ground to the south. The challenge of cutting through the high ground was taken on by John Pixton who charged 6 pence per cubic yard for depths up to 24 feet rising to 8 pence for depths between 30 and 36 feet. The length to the south of Quedgeley Cutting, which included Stonebench Turn, was started by William Attwood, but he gave up after nine months and it was finished by John Pixton. As the Company accepted responsibility for keeping all of the excavations free from water, the Committee asked Boulton & Watt to supply a second steam engine capable of raising 1000 gallons per minute to a height of 20 feet. Mylne initially set out a sump for it near Stonebench, although it was designed to be moved to other places when necessary.

Attwood's failure illustrates the difficulties contractors faced at a time when there was a shortage of labour due to the demands of the army and a proliferation of other canal projects around the country. Desperate to hang on to their workers, both Charles Holland and James Pinkerton resorted to obtaining warrants at Gloucester Petty Sessions against men who had deserted their work. Additional difficulties arose when the Canal Company was late in making stage payments, and then it was the turn of navvies to get Petty Sessions to issue summonses for non-payment of wages to the contractors themselves or to the gang leaders who dealt directly with the men. It is likely that most of the navvies were former farm labourers attracted by higher pay for what must have been very hard work. They lived in makeshift shelters near to their work, and the usual practice was for them to buy their food, known as "tommy", from a shop which paid a commission to the contractor. It seems that one such shop was in Aston Cottage near Quedgeley Cutting, as the deeds of the cottage record that the property was formerly known by the name of Tommy Shop. Inevitably there were complaints from local people about unruly behaviour by navvies, and the Canal Company had to tell the contractors to remove the navvies huts from neighbouring land and make good any damages done by their workmen. As well as employing contractors, the Canal Company also hired some men directly for tasks that were not covered by the contracts - such as draining water from the works, burning lime, making fences and taking levels.

The employment of additional contractors certainly had the desired effect of speeding up progress, but there was growing disquiet that some of the matters raised by Charles Brandon Trye and Edmund Stock had not been properly resolved, and Mylne himself had admitted that the cost of following his plans would exceed the money available. These concerns prompted Dr Daniel Lysons (who's niece was married to Trye) to write to the Committee in March 1796 asking for a new survey by a new engineer. The matter was referred to the imminent General Meeting, when, under the chairmanship of Dr Lysons himself, many of those present expressed dissatisfaction with Mylne's plans, and it was resolved to ask the eminent engineers William Jessop and Robert Whitworth to take a view of the whole project.

While arrangements were made to get Jessop and Whitworth to inspect the canal, the Committee felt that they had to continue pressing ahead with the work in hand, and on 8 April 1796 a small ceremony was held to mark the laying of the first stone in the quay

wall on the west side of the basin at Gloucester. The contract for the stonework had been placed with experienced master mason Thomas Cook and his partners, and it required the supply of weather stone from the quarries on Bisley Common above Brimscombe Port on the Thames & Severn Canal. Cook had to provide transport from the quarry to the canal, and then the stone was carried by trows to a specially-built jetty on the bank of the River Severn near the site of the basin. Payments made to Cook & Co indicate that by 1 April they had laid over 200 tons. So the subsequent ceremony of "laying the first stone" was more symbolic than real and was evidently arranged to suit one of Robert Mylne's visits to Gloucester. The start of wall-building, however, prompted Trye to remind the Committee of earlier concerns about Mylne's plan to have quay walls that only went to half the depth of the basin. As Whitworth happened to be passing through Gloucester, his view on this specific point was sought, and when he recommended a full depth wall, the Committee agreed that the work on Mylne's wall should stop until both engineers had reported. Keen to support ways of reducing the cost of digging the canal, the Committee also arranged for Edward Haskew to try out a machine that he had patented on a new section of the canal to the south of Hardwicke Hill. The machine, worked by two men, raised loaded wheel-barrows out of an excavation and returned empty ones, and the local newspaper reported that it carried 1400 loaded barrows from the bottom of the canal to the distance of forty feet in twelve hours.

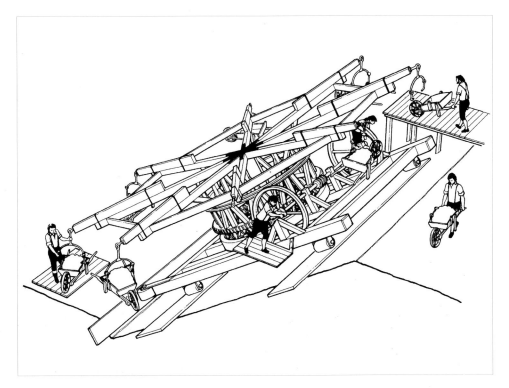

*Edward Haskew's machine for raising wheelbarrows from the canal excavation, drawn by Philip Moss from the 1796 patent specification.*

Meanwhile concerns about Mylne's plans were expressed by more shareholders, including the influential ironmaster William Reynolds of Ketley and Samuel Jones of Bridgenorth. Over twenty specific questions were passed to William Jessop and Robert Whitworth for consideration, and a special meeting of shareholders was held on 15 August 1796 to hear their responses. Jessop started by recommending that the line of the canal be moved to the west of Whitminster church in order to avoid the deep cutting through Pegthorne (or Packthorne) Hill, and Whitworth agreed. This deviation was just what had been suggested by Mr Crossley two years earlier but had not been taken up by Mylne. Jessop also suggested a more westerly line past Frampton and Slimbridge that would save cutting, avoid many small enclosures of valuable land and require fewer bridges. Although these deviations would require a new Act of Parliament, Jessop believed that they would be so much to the advantage of landowners in general that there would be no difficulty in obtaining their consent. With regard to Mylne's plans for high spoil banks on Company-owned land, both engineers preferred limiting the height of the banks, spreading the excess on neighbouring land and covering it with topsoil. Whitworth added that, even with Mylne's steep sided banks, a boundary fence would still be needed.

Commenting on Mylne's specification of sixteen inch diameter cast-iron pipes for culverts under the canal, both Jessop and Whitworth thought that a diameter of two feet would be preferable, giving double the capacity for little extra cost. Both agreed the canal needed to be wider in places to allow vessels to pass, and Whitworth highlighted the need for a dry dock where vessels could be repaired. Whitworth also recommended the basin at Gloucester should be extended to the south before the canal opened, as it would be difficult to enlarge it later to the east in the way that Mylne had suggested as so much spoil had been dumped in that area. Both engineers agreed that full depth quay walls in the Gloucester basin were preferable, but Jessop acknowledged that Mylne's plan for a half-depth wall could be cheaper, although wooden jetties would then be needed for big ships to come alongside. At the end of the meeting, C.B. Trye claimed that these critical comments from Jessop and Whitworth fully justified the concerns that he and others had raised about Mylne's plans for the canal, but to Trye's surprise, a motion of no confidence in Mylne was defeated by a small majority. So Mylne survived, but his authority was badly damaged, and more challenges were to follow.

Following the vote by the shareholders, the Committee felt justified in ordering that the building of the wharf wall of the basin and the upper lock be proceeded with as fast as possible. At the same time, they arranged for plans to be prepared for the changes in route recommended by Jessop. As this involved crossing the Stroudwater Canal where it was at a lower level than in the previous plan, the subsequent Act included a clause authorising the Company to build a new lock to raise that length of the Stroudwater Canal to match the planned level of the Gloucester Canal. Recognising the shortfall in subscriptions due to shareholders defaulting and landowners not taking up all their allocations, the Act also allowed a greater proportion of the authorised capital to be raised by mortgage.

CANAL-OFFICE, GLOCESTER, FEB. 4.

## To Canal Cutters.

THE Committee of the GLOCESTER and BERKELEY CANAL COMPANY are ready to receive propofals for cutting and completing fix miles of their Canal, which is to be feventy feet wide on the water line, and eighteen feet deep ; the fame to be let out in feveral lots or parcels, and the perfons contracting may be furnifhed with Planks and Wheelbarrows; or may find them themfelves, at their option. The Work will be ready to be entered upon early in March. The fituation of the land may be known, and a fection of the depths may be feen, by applying at the Canal-office in Glocefter.

JOHN WHEELER,
Clerk to the Company.

*An advertisement from the* Gloucester Journal *of 13 February 1797.*

The Committee also pressed on with more contracts for digging 1¼ miles through the parish of Hardwicke. Charles Holland (who was also working on the basin at Gloucester) contracted for the first length crossing the Dimore Brook, Thomas Bolton took on the major cutting through Hardwicke Hill and Hawkins & Keeling agreed to continue south to Edward Haskew's work. At the same time, the Committee made special arrangements to remove the Lias clay stone found along the line that they thought could be used in building the bridge abutments. At first they employed quarrymen to establish a fair cost for raising the stone, and then they negotiated additional payments for the contractors to do the work. The Committee also had to replace George Mills and limit the work of James Pinkerton who were both failing to meet their contract deadlines. Their work was taken on by other existing contractors, but the cost to the Company rose to 7 pence and even 10 pence per cubic yard.

As well as these high costs for labour, the Committee found that some landowners demanded prices up to twice the level allowed for in the Company's Act of Parliament. Although there was a procedure laid down in the Act for summoning Commissioners to settle disputes concerning land purchase, most of those named in the Act were county landowners, and it seems the Company never invoked the procedure, presumably because they did not expect a sympathetic hearing. These rising costs, combined with the increasing number of shareholders who did not pay their instalments when asked, led to a minor cash flow crisis in May 1797, when payments authorised by the Committee exceeded the funds in the Company's three bank accounts. To try to avoid

this happening again, at the next General Meeting it was agreed to proceed against shareholders who were in arrears with their payments.

During 1797, Mylne spent even less time than usual on the business of the canal, as he was having to cope with family problems as well as his other professional commitments. This led to further criticism from Charles Brandon Trye, and the Committee forced Mylne to give up his annual salary and accept payment by the day instead. Mylne's position was undermined further when the half-height north quay wall of the basin at Gloucester collapsed during the winter of 1797-98. This followed a period of extremely severe weather which brought almost all work on the canal to a halt for a time. Mylne blamed the collapse on poor workmanship and the effects of water that had entered the basin while the river was in flood. Resident engineer James Dadford disagreed, claiming that the collapse was due to the winter weather acting on the bench of clay on which Mylne's half-height wall was built. Dadford also estimated that just to complete the canal as far as the Stroudwater Canal would cost £34,747, which was well in excess of the available funds. When these matters were discussed at a General Meeting in March 1798, the shareholders accepted that their vast undertaking was in real trouble. To conserve what little money they had left, they agreed to stop paying interest on the money already subscribed, and with Mylne once again absent on other business, they agreed to rely on Dadford for advice in future and resolved that Mylne be no longer employed.

Mylne later bitterly criticised the way the Company had been run and the work of resident engineer Dadford, even though the latter had been appointed on Mylne's recommendation. It is certainly difficult to understand why the Committee persisted with the ship canal for so long when they could have changed to building a barge link to the Stroudwater Canal as Mylne had recommended. On the other hand, the advice of Jessop and Whitworth showed that the shareholders had good reason to question some of Mylne's views, particularly as much of the advice given by the two engineers was taken up in the eventual completion of the canal. Subsequent experience also showed that Mylne's choice of slope for the sides of the canal was too steep so that large masses of the banks slipped in, and these slips were made worse by Mylne's high spoil banks on either side.

After the crucial General Meeting in March 1798, there was no question of starting new digging contracts, and the Committee concentrated on completing what was already in hand. The north wall of the basin was rebuilt, digging continued along the line to Hardwicke, bridges were constructed, culverts were installed and slips in the banks were removed. By the end of 1799, the contractors had finished their work, and in the following year tolls began to be collected for occasional boat movements on the five mile stretch between Gloucester and Hardwicke. According to local tradition, a building erected on the bank near the Hardwicke end of the canal was used for storing equipment in the expectation that it would be needed when work got underway again. The building was constructed from the Lias clay stone found in digging the canal and was later occupied as a house that became known as Dainty's Cottage after the family that lived there.

Meanwhile, the shareholders began discussing whether there was any way of moving the project forward again. Robert Lucas proposed that a five mile ship canal be made from the end of the existing canal to an entrance on the River Severn at Hock Crib, a breakwater intended to reduce erosion of the river bank between Saul and Fretherne. Other shareholders preferred the idea of a three mile barge canal to link with the Stroudwater Canal and so allow through traffic to London. However, with little prospect of raising the money for either scheme while the country was still at war, all thoughts of further construction were abandoned, and Dadford was given notice in October 1800. It seems that all of those involved in this first phase of construction were overwhelmed by the unprecedented scale of the undertaking, particularly as it was taking place during a period of appalling weather conditions and extreme shortage of labour.

# 2

# Completing the Canal

During the early years of the nineteenth century, there was much talk about how new life could be injected into the project, but there was very little real progress. In 1804, wine merchant David Saunders took up the earlier idea of a link to the River Severn at Hock Crib. Having been responsible for bringing vessels right up to Gloucester on the river, he argued that the main difficulties were nearer to Gloucester and there had never been any problem getting to Hock Crib. In spite of mixed feelings among the shareholders, an Act of Parliament was obtained in 1805 authorising the construction of the link and the raising of £80,000 by the issue of shares at the reduced price of £60 each. However, as it was difficult to sell the original £100 shares at any price, it is not surprising that there were few  takers for the new shares, and no action was possible. Five years later, Saunders presented a new case for building the link to Hock Crib, claiming that the existing traffic on the river would pay sufficient toll on the canal to give a good return to shareholders. This time, a considerable sum of money was subscribed on the promise of a 5 per cent interest rate during construction, but engineer John Rennie estimated that the cost of the scheme including a harbour in the river would be as high as £130,000, and again there was no action.

Meanwhile, future prospects appeared a little brighter when plans were publicised for building a tramroad with horse-drawn wagons running on cast-iron rails between Cheltenham and Gloucester, communicating with the river by means of the basin. A similar tramroad was being planned to bring Forest of Dean coal down to the River Severn at Bullo Pill near Newnham, and the intention was for coal to be carried by boat to Gloucester and then by tramroad again to Cheltenham. Prompted by this development, the Committee ordered the lock between the river and the basin to be cleared of mud, and the first vessel passed through on 5 October 1812. To help celebrate the occasion, some young men brought three swivel guns. Unfortunately, one gun had the charge rammed down very forcibly with wet wadding and, when a match was applied, the gun exploded, causing the deaths of two bystanders including the youth who had held the match.

The opening of the lock allowed the basin to be used by local trows to discharge cargoes while remaining afloat - instead of having to go on the bottom at low tide when using the riverside quay. The safe haven provided by the basin also encouraged

narrow canal boats from the Midlands (known in Gloucester as longboats) to bring coal direct to Gloucester instead of it being transhipped into trows for the river journey as had been the previous practice. However, this usage showed up a few problems, particularly the lack of a proper water supply to the basin and short length of canal that had been completed. The task of sorting them out was given to John Upton, who was appointed clerk to the Canal Company in 1813 in the knowledge that he also had practical experience of canal works. Upton cleaned out feeders, stopped leaks from the canal, laid new tramroad lines, improved road access to the basin and got the Company's steam engine working again to help maintain the water level in the canal.

As well as making improvements to what existed, Upton also undertook a thorough review of what needed to be done to get the whole project moving again. In 1815, he presented a paper criticising both the original line to Berkeley Pill and the shorter line to Hock Crib, and he proposed instead a route that joined the Severn immediately north of Sharpness Point. He argued that an entrance there would have four feet more water than in Berkeley Pill and be sheltered from the prevailing winds by the high ground of the Point. Any vessels that missed the entrance could safely go on to the soft mud nearby until the next tide. The route was similar to the southern end of that originally proposed by Clowes, and it required less cuttings, passed through easier soil, crossed lower value land and required fewer bridges.

Upton's proposal for an entrance at Sharpness Point caused quite a stir among the established shareholders but, encouraged by Mark Pearman, an enthusiastic newcomer, they agreed to get a survey of the route carried out by Benjamin Bevan, the Engineer of the Grand Junction Canal. Bevan backed the Sharpness proposal, and in May 1816 the shareholders agreed to raise the £150,000 that was estimated to be needed by the issue of shares bearing an interest of 5 per cent. Even with this promise of interest, however, the initial response was disappointing, and the idea developed of reducing the cost by only making the basin at Sharpness to the full depth of 18 feet and digging the canal to Gloucester at a lesser depth. This plan received provisional support from the Exchequer Bill Loan Commissioners, who's remit was to promote public works that would employ soldiers returning from the war with France, and the Committee was at last in a position to move ahead.

To help generate confidence in the concern, the Committee agreed a contract with Thomas and Benjamin Baylis in October 1817 to link the existing canal to the Stroudwater Canal at a depth of 15 feet, later increased to 16 feet, and work was well under way by the end of the year. They also obtained an Act of Parliament authorising the new route to Sharpness, and they agreed a second contract with the Baylis brothers for the completion of this route. Before approving their contribution, the Loan Commissioners called in the eminent engineer Thomas Telford to report on the whole scheme. Based on the contracts agreed, the cost of land purchase and an allowance for repairs to the existing canal, Telford estimated the total cost of completion would be £130,723, and the Loan Commissioners agreed to advance just under half of this on the security of a mortgage.

As digging work got under way, the Committee also opened negotiations with local landowners about the location of bridges, and some road and track diversions were agreed to reduce the number of bridges that needed to be built. Rather than provide a bridge for the old lane to Laynes Farm, the Committee agreed to provide access by making the towpath from Hardwicke Bridge into a more substantial track. Similarly, tracks were promised along the towpath to the north of Parkend Bridge and to the south of Fretherne Bridge to give access to fields that would be separated by the canal from the rest of each farmer's land. Pegthorne Bridge had to be located where the adjoining land levels were suitable, and this required diverting the approach tracks 130 yards north-east of their original alignments. The need for a second bridge north of Frampton was avoided by diverting the Saul road to join the Fretherne road to the

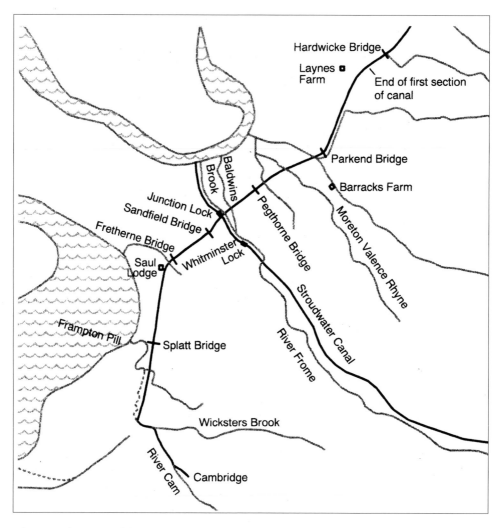

*The second section of the canal from Hardwicke to the River Cam built 1817-20. The broken line marks the former course of the River Cam on its way to Frampton Pill.*

west of the canal. Splatt Bridge could not be avoided because, as well as leading to a few fields, it was also the access to Frampton Pill which was used by small trading vessels bringing coal to Frampton and taking away locally made bricks.

The Baylis brothers concentrated their early efforts on the link to the junction with the Stroudwater Canal, a basin at the Junction and a further link to the River Cam. This river was seen as an important source of water for the canal, and it was also to be made navigable for barges to reach a wharf at Cambridge on the Bristol road. To keep the diggings free of water, a steam pump was set up where the new canal was due to intersect the Stroudwater Canal, and a tunnel was dug under the Stroudwater Canal and the River Frome so that the pump could drain the new workings to the north and to the south. A second steam pump was set up beside Fretherne Bridge to drain the works in that area. To prepare for the Junction itself, work started on a new lock on a modified alignment of the Stroudwater Canal that would raise the water level about four feet to suit the eventual level of the Gloucester Canal.

Some work was also started on the entrance basin at Sharpness, where HRH the Duke of Gloucester laid the first stone on 15 July 1818. The Duke and Col. Berkeley were met by the Mayor of Gloucester and members of the Committee on the summit of Sharpness Point, which the Berkeley family had laid out many years earlier as an attractive plantation with fine views over the river. Preceded by a band and colours, the party descended to the site of the basin, and the Duke laid a stone weighing nearly four tons. This carried a brass plate with a lengthy inscription recording the Canal Company's objective of facilitating trade between the interior of the kingdom and foreign countries. After the ceremony, the party went off to Berkeley Castle for lunch, and three hogsheads of ale were provided for the workmen.

The laying of the first stone at Sharpness must have been a very proud day for John Upton, who deserves the main credit for getting the great project moving again. With evident confidence in the outcome, he started building himself a fine house about 300 yards below Fretherne Bridge, later known as Saul Lodge. Upton took advantage of materials that came from digging the canal - starting with the cellar walls which were built with Lias clay stone. The main walls were formed by a mixture of sand, gravel and lime that was constrained by temporary shuttering until it set and then given a coat of render. Unfortunately, however, within four months he was in deep trouble, as he found it impossible to keep a proper check on all the work that was being done along the canal. When he did report faults, the contractors blamed him for the problems. The resulting confusion led the Committee to arrange for an investigation to be carried out by John Woodhouse, who had worked on the Worcester & Birmingham Canal.

Woodhouse submitted two reports which confirmed the Committee's worst fears. He criticised the structure of the embankments built on low ground and the composition of the puddle that was meant to provide a waterproof wall in the centre of each embankment. He noted that two culverts were leaking and a third had unacceptable brickwork, the masonry of the bridge piers used poor quality stone and did not go deep enough and the masonry at Sharpness did not have proper interlocking of the joints.

*One of the stones marking the boundary of the Canal Company's property where no hedge was planted.*

He also recommended digging the canal 18 feet deep instead of 16 feet, deepening the entrance at Sharpness by two feet to improve access for keeled vessels and building a pier head at the entrance to protect vessels arriving and departing. Faced with this appalling state of affairs, in January 1819, the Committee relieved Upton of his job as engineer, purchased his new house at Saul and appointed Woodhouse in his place. Upton continued as clerk for two months, but finding that this confined role did not suit him, he resigned and was replaced by Shadrach Charleton. Meanwhile, the Committee agreed a new contract with the Baylis brothers that included the additional work recommended by Woodhouse, but two weeks later the brothers gave up the contract because they found that the cost of the stone required would be very much higher than they had allowed.

Before seeking further tenders, the Committee called in Thomas Telford to survey the existing works of the canal and the proposals for completion. Telford approved Woodhouse's recommendations, and in March 1819 the Committee arranged three contracts to carry out the main work required. Thomas and Henry Holland agreed to complete the earthworks between Hardwicke and Sand Field, Saul. These included major embankments across the low ground drained by Moreton Valance Rhyne where, in places, the bottom of the canal hardly cut into the solid ground. William Tredwell and Charles Pearce contracted for the section between Sand Field and the River Cam, and William Tennant took on the last section to Sharpness, including the entrance

basin there. Learning from the earlier difficulties, the specification called for the sides of the canal to have a shallower slope than in Mylne's design with an underwater ledge 4 feet wide, and the height of the banks was limited to three feet above water level. The bottom width of the canal was reduced to 13 feet at a depth of 18 feet, and the width at the water level was increased to about 86 feet. It was expected that the earth dug out would be piled in banks on either side of the excavation and that some excess earth from cuttings through high ground would be moved by boat to build the embankments needed on low ground. Where there would still not be enough spoil to build embankments to the full height, the contractor was encouraged to set out the canal wider and to cut one foot deeper than the normal bottom level. Where the cutting would produce more earth than needed, the spoil was to be laid out on the adjoining land and covered with good soil. Where an embankment was required, a wall of puddle 4 feet wide was to be formed in the centre, and the bank and the puddle were to be built up together in courses.

The new contractors started work in March 1819, and with plenty of labour available after the demands of war had passed, they had over 400 men employed by the end of the month, rising to over 900 in the autumn. Some smaller contracts were also arranged for building bridges and culverts, and a few men were employed directly by the Canal Company to work the pumping engines and to burn lime for making mortar. Small culverts were made of cast-iron pipes, intermediate size culverts were formed from baulks of timber held together as a tube by iron rings and two large culverts for the two branches of the River Frome were built in brick. It is possible that some of the navvies lived in the buildings of what later became known as Barracks Farm (to the north of Moreton Valence church) as the term "barracks" was occasionally used for navvies' accommodation. Progress with the digging was generally good, but difficulties were experienced in building some sections of the embankments across low ground because the underlying soil was found to be porous in places, and it was necessary to carry the puddle walls down 12 to 15 feet below the surface.

While work on the three main contracts continued, arrangements were made in the autumn for additional work needed to complete the whole project. Existing contractors Tredwell & Pearce took on the extra task of raising the banks of the River Cam and making it into a navigable arm for barges to reach a basin and wharf at Cambridge, serving the Cam and Dursley area. The plan was to take the water from the River Cam into the canal, but a sluice was provided in the raised banks of the Wicksters Brook tributary so that some water could be run off, passing through culverts under the Cam and the canal to maintain a supply of drinking water for cattle grazing in the fields to the west. While this work was in hand, Woodhouse prepared a plan for an extension of this Cambridge Arm across the Bristol road and up the steep valley to the cloth-making village of Uley. However, as he proposed to build eleven lifts varying in height between 18 and 36 feet, it is not surprising that no action was taken. Tredwell & Pearce also contracted to clear the mud and slips from the old part of the canal between Gloucester and Hardwicke. This required draining out all

of the water for a time, with consequent interruption to the commercial use of the basin at Gloucester and the adjoining dry dock that had been built there by John Bird. Meanwhile, mason Thomas Sharp agreed to finish the masonry for the lock and stop gates at the Junction, and carpenter Edward Corbett agreed to make four pairs of stop gates each having a paddle worked by a rack. These gates, two pairs on each side of the Stroudwater Canal, were specified in the Company's original Act of Parliament as a means of minimising any water loss from the Stroudwater Canal.

Progress on all these jobs was so good that in December 1819 the Stroudwater Company was given a month's notice of the intention to make a temporary junction at the existing level of the Stroudwater Canal. The plan was to make the permanent junction at the higher level in the spring. The Stroudwater Committee initially objected to this temporary junction as it was not properly protected against water loss, and the Gloucester Committee was forced to install temporary stop gates on the north side of the Junction. To supervise the gates and to check the traffic passing between the two canals, they appointed Robert Miles, a carpenter who had been helping Woodhouse supervise the contractors' work. The work needed to link the two canals was carried out during a period of neap tides, when traffic on the Stroudwater Canal was necessarily stopped because of lack of access between the canal and the River Severn, and the Junction was completed on 28 February 1820.

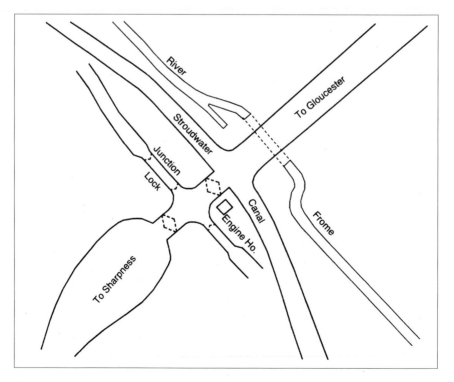

*The initial Junction was made with the existing alignment of the Stroudwater Canal, leaving the commissioning of the lock on the new alignment to be carried out later.*

The formation of the Junction allowed commercial traffic to start using the Gloucester Canal as a through route which bypassed the difficult stretch of the River Severn south of Gloucester. Initially, it was mainly used by barges carrying coal from Staffordshire and Shropshire to wharfs along the Stroudwater and Thames & Severn Canals, with occasional cargoes of iron, bricks and salt. There was also some traffic to and from the new wharf at the end of the Cambridge Arm, where Thomas Woodhouse (the son of the Company's engineer) advertised stocks of coal and road stone and also made bricks from clay that had been excavated from the basin there. Since the water in the Gloucester canal was well below its eventual level, the level of the Cambridge Arm was maintained by a temporary weir, and cargoes had to be transhipped at the weir to and from barges that were kept on the arm. As well as the water in the main canal being low, the banks were not fully built up in places, and further contracts were agreed to finish the banks and to stone and gravel one towpath. Prior to this, it had always been the intention to have a towpath on each side of the canal, but the second path was never completed.

With the canal in operation between Gloucester and the Cambridge Arm, more attention turned to the major works at Sharpness. Tennant's men had built much of the sea wall and entrance piers to a height of ten feet or more, but Telford was not happy about John Woodhouse's role in supervising the work. He particularly criticised the composition of the mortar being used and the size and shape of the Bristol stone supplied by Woodhouse's son, and when nothing seemed to have changed by a second visit in May 1820, Telford declared his confidence in Woodhouse was completely destroyed. He strongly recommended that some of the defective wall be taken down and rebuilt with better stone and proper bonding and that stone for the more exposed piers be obtained from the Forest of Dean. He also emphasised the necessity of employing a resident engineer who was wholly unconnected with suppliers of materials or labour. Woodhouse defended himself by saying that the matters complained of had in fact been rectified quickly, and he suspected that false information was being spread by Samuel Jones who had tendered unsuccessfully in competition with Tennant. When Telford came to Gloucester in July, however, the Committee accepted his views and authorised him to find a new resident engineer.

The man Telford recommended to replace Woodhouse was Thomas Fletcher, but when he arrived in September 1820, he found all was confusion. The plans and specifications for Tennant's contract were so loosely described that he thought there were plenty of openings for dispute, and to make matters worse, Woodhouse had agreed extra work without keeping proper account and without telling the Committee. After the best investigation he could manage, Fletcher advised the Committee that it would cost significantly more to complete the contract than the unspent part of the contract price, and when word of this got around, some of Tennant's creditors had him put in prison for debt, which immediately brought the works to a halt. This prompted 150 of his men to go to the Canal Office seeking payment of their wages, and after some negotiations, they agreed to settle for half of what they were owed. Desperate to come to some arrangement with Tennant, the Committee reluctantly agreed to guarantee his

bail so that he could leave prison and join in negotiations, but then the Committee were faced with their own financial crisis.

It had always been known that the additional cost of making the canal deeper would require raising more money, but an earlier appeal had produced little response. By December 1820, funds were running low and there was a need to repay an instalment due to the Loan Commissioners. A General Meeting agreed to raise £120,000 by issuing preference shares promising to pay the very high interest rate of ten per cent, but as this would take time to organise, it was also agreed to sell some surplus property at auction. Unfortunately the property did not find a buyer, and with their toll income having to be used to pay essential workers, the Committee had to ask the Loan Commissioners for more time to pay.

The financial crisis continued throughout 1821, leaving the works neglected and falling into a dilapidated state while arrears of interest began to accumulate and contractors accounts were "reserved for further consideration". Even Fletcher's salary was not paid, and after running up some local debts, he was obliged to accept a loan from Telford for a time. Shareholders James Lloyd and Mr Unett did their best to encourage subscribers by publicising the income that could be expected from a completed canal, but their favourable forecast was dependent on charging a high rate of toll, and there was little response. Desperate to find some way forward, the shareholders agreed in November to apply to Parliament for authority to cut a branch to an entrance at Frampton Pill at an estimated cost of only £16,000, but the Loan Commissioners did not support this. Instead, the Commissioners decided in December to take formal possession of the works while agreeing to allow the Company to continue temporary management until some means could be found to repay their loan. In practice, this meant that future decisions of the shareholders and the Committee were all subject to the approval of the Loan Commissioners who's officials kept a close watch on their proceedings.

While these negotiations were taking place, the arrival of a twin-hull steam boat in the basin at Gloucester attracted considerable attention. Called the *Sovereign*, she had two paddle wheels in the central gap worked by separate 10 horse-power steam engines in each hull. She was intended to carry passengers between Gloucester and Stourport, and the principal cabin at the bow was fitted up as a coffee room capable of containing over 70 people. On her way down the river, a problem had developed with some of the plates forming the boiler, and she spent several weeks at Gloucester while repairs were carried out. Then, as steam was being raised for a trial trip down the canal, her boiler exploded, throwing one man into the water and badly scalding two others. This setback evidently proved too much for her owners, and she was broken up a few months later.

The partnership arrangement with the Loan Commissioners at last gave the shareholders confidence that there was a viable way forward, and encouraged by an attractive forecast of toll income from the completed canal, they obtained another Act in May 1822 to authorise raising a further £150,000. £60,000 of this was promised by the Loan Commissioners and the remainder was raised by issuing preference shares

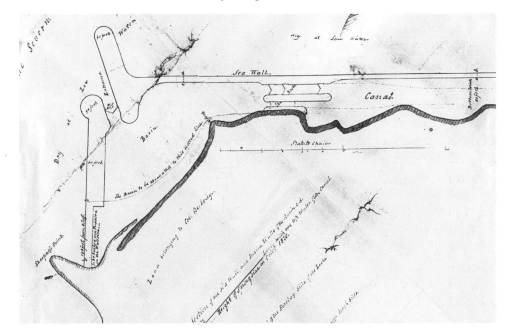

*Plan of the tidal basin and the ship and barge locks at Sharpness 1823 - one of the drawings signed by Thomas Telford for the contract with Hugh McIntosh. The protrusion of the north pier was later reduced to discourage sand accumulating between the piers.*

paying the very high interest rate of 10 per cent. As the money came in, Tennant tried to claim £4,000 for work he had not been paid for at Sharpness, but after some negotiations, he agreed to settle for £500.

The settlement with Tennant opened the way for a new contractor, and the Loan Commissioners arranged for Hugh McIntosh to put in a tender. McIntosh had worked on many other canals and docks and, assisted by his son David, was the first contractor to have a national organisation. As for the previous contracts, the specification called for the canal to be 18 feet deep, 13 feet wide at the bottom and 86 feet wide at the top with the side slopes interrupted by 4 feet wide ledges on each side. Detailed requirements were also laid down for removing mud and obstructions from the old part of the canal and for completing the new part, including the locks and sea walls at Sharpness. To help in the preparation of his tender, McIntosh sent some of his men to carry out trial excavations at Purton, but the land had not been purchased and Col. Berkeley's steward ordered the men to quit and pulled down the huts they had built. Having established the point that no digging was allowed until the land had been paid for, the steward readily co-operated with Fletcher in laying out the line of the canal, which included a deviation to the north of the Berkeley Estate duck decoy pool at the request of Col. Berkeley.

McIntosh was so highly respected that his price of £111,494 was accepted without seeking another bid, and the contract was signed on 2 April 1823. The Committee also asked the Berkeley magistrates to grant McIntosh a licence to sell beer and spirits to the navvies. Due to a slight delay in obtaining possession of land from Col. Berkeley,

McIntosh was authorised to start by building up the existing embankments either side of Pegthorne Bridge. It seems likely that the additional material came from a shallow excavation in the tongue of high ground just to the north of the bridge. When the canal water was later raised to its proper level, this excavation was flooded and formed a large bay in the canal bank which became known as Pegthorne Hole.

The progress of McIntosh's work was supervised by Thomas Fletcher, assisted by Hugh Rose at Slimbridge and George Barratt at Purton. Fletcher sent monthly certificates of work done and other reports to Thomas Telford, who approved the certificates for payment and visited the works periodically on behalf of the Loan Commissioners. To look after the interests of the shareholders, George Nicholls agreed to spend a considerable amount of his time superintending the Company's affairs, and in Oct 1823 he was elected permanent chairman of the Canal Company Committee with full authority to act in its name. McIntosh was soon making good progress with 300 to 400 men at work, although there was a setback in December when the dam between the River Cam and the new works gave way, allowing water to spread over 30 to 40 acres of pasture.

Meanwhile, doubts had arisen as to whether there was enough quay space at Gloucester to handle the traffic expected. Telford recommended building a new quay wall along the east side of the basin, in place of the existing earth bank, and forming a new barge basin that would be served by sidings from the Gloucester & Cheltenham tramroad. Telford also recommended the construction of at least three pairs of stop gates on the canal and a lock at the entrance to the Cambridge Arm so that fully loaded barges could reach the wharf by the Bristol road. Authorisation for all this work was included in a second contract with Hugh McIntosh dated 9 March 1824. Another concern was that sand was accumulating between the entrance piers at Sharpness, and Telford recommended reducing the protrusion of the north-east pier and modifying the shape of the other pier to encourage the currents to clear the sand away.

To carry out the additional works, and at the same time to refurbish the old part of the canal, it was necessary to stop the traffic and drain out all the water. To maintain the level in the Stroudwater Canal while this was being done, two dams were built across the Gloucester Canal at the Junction during the summer of 1824, and then water was drained out through the lock at Gloucester and via let-off pipes installed in the banks at Pegthorne and Frampton Pill. These measures were only partially effective, however, as it was only at Frampton Pill that the let-off was below the bottom of the canal, and it was necessary to wait the convenience of the Stroudwater Company for permission to lay pipes under their canal to allow the residual water from the Gloucester end to pass on down to Frampton Pill. As water was eventually drained from the various sections, so the additional works and refurbishment work got under way.

Meanwhile, work at Sharpness had been proceeding rather slowly. At harvest time, many men left the work and others asked for higher wages. It was not until March 1825 that the sea walls were sufficiently advanced to make it worth constructing a dam across the entrance to keep out the tides, and unfortunately this was almost immediately overwhelmed by a particularly high tide. When the dam collapsed, the water flooded

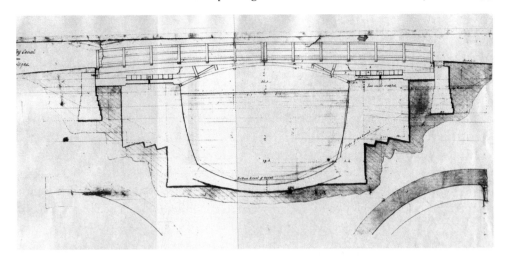

*Plan for the canal bridges 1823 - one of the drawings signed by Thomas Telford for the contract with Hugh McIntosh. The two half-spans are all wood, rotating on cast-iron spindles and rollers, with short hinged arms that could be lowered on to the stone piers to provide additional support.*

up the canal and into the workmen's huts, where a navvy's wife who had recently given birth had to be hastily evacuated. The flood also damaged the west sea wall which had not yet been built to its proper thickness, but within four months the tides were excluded again and work started on building the locks and excavating the basin.

The commitment to the additional work in McIntosh's second contract meant that there was a need to raise additional money, and experience gained in the course of both contracts led Fletcher to identify a range of yet more jobs that needed to be paid for. The Canal Company therefore obtained another Act to authorise raising a further £50,000, of which the Loan Commissioners promised to provide £35,000.

One of the major jobs to be done while the canal was drained was to modify the junction with the Stroudwater Canal to facilitate the change to the eventual level of the Gloucester Canal. To minimise the disruption to traffic on the Stroudwater Canal during the changeover, Fletcher realised that the new alignment of the Junction would need to brought into use initially at the existing water level, leaving the change to the higher level to be accomplished when circumstances allowed. This required lowering the upper cill of the lock and the cill of the stop gate opposite, both of which had been built originally to suit the eventual water level. The specification for the work also required the banks of the Stroudwater Canal and two bridges between Whitminster Lock and the Junction to be raised. The huge stop gates across the Gloucester Canal and their sluice gear were to be refurbished, and they were to have rollers on the bottom of the mitre posts, running on curved rails in the bottom of the canal, to carry the weight when the Gloucester Canal was not at its nominal level. In addition, a cast iron pipe was to be laid under the Gloucester Canal with a sluice just above the Stroudwater stop gate (the handle of which may still be seen). The pipe was to allow

water in the pound to the east of the Junction to be let off into the lock on the west side if the former pound ever needed to be drained for maintenance. These complicated works were completed by September 1825, but other work needed to be done before the Gloucester Canal could be refilled and the new Junction put into operation.

During the autumn of 1825, work was drawing to a close on the wall and barge basin at Gloucester, on the lock at the Cambridge Arm and on various bridges and culverts, but clearing the mud from the old part of the canal took longer than expected and there were difficulties in laying down a culvert for the Daniels Brook at Two Mile Bend. Water was eventually let in to the basin again early in 1826, but a weakness was found in the cills of the stop gates at the Junction, and there was a further delay until these were repaired. Then plans were prepared to commission the new line and lock of the Stroudwater Canal at the Junction while that canal had a planned stoppage for six weeks starting on 29 May. All went well initially, but when the six weeks was almost up, the stop gates across the empty Gloucester Canal failed and Fletcher found that the cills were laid on bare ground and framed in such a loose way that they were not strong enough. He arranged for stone to be brought from the Forest of Dean, and men worked through the night to get the repairs done as quickly as possible. Unfortunately, two weeks later, the stop gates failed again, and again men had to work though the night and also on a Sunday as there was a desperate need to supply coal to the mills in the Stroud valley. This time the repairs were successful, and the Stroudwater Canal was passable again on 5 August, almost four weeks behind schedule. However, the stop gates on the south side of the Junction were still rather leaky, and further modifications were carried out during the next period of neap tides when traffic on the Stroudwater Canal was necessarily stopped because of lack of access between the canal and the River Severn. Although fraught with difficulties, the commissioning of the new line was a major feat of canal engineering, preparing the way for the only crossing of two independently owned canals in the country.

While Fletcher was having to cope with the difficulties of commissioning the new works at the Junction, he was also involved in a major project to improve the drainage of the extensive area of low lying land on either side of the canal between Shepherds Patch and Purton. The streams that drained the area flowed into the Severn at an inlet known as Kingston Pill, where the soft ground was being eroded, and at an outfall known as the Royal Drough (pronounced Druff), which was in danger of being washed away by the Severn. Telford had advised Col. Berkeley, the main landowner, that drainage would be improved and erosion reduced if the streams were diverted to one new outfall on hard ground to the west. This required a new drain along the south side of the canal to carry water from the Shepherds Patch stream and the Gilgal Brook to an extra large culvert under the canal near the Decoy Pool and a further length of drain north to a new Royal Drough outfall into the river. Another new drain on the north side of the canal collected water from the fields on that side and discharged into the first drain. After these works were completed, Col. Berkeley built an embankment across the former outlets and continued it to the north-east to recover a large additional area of the New Grounds.

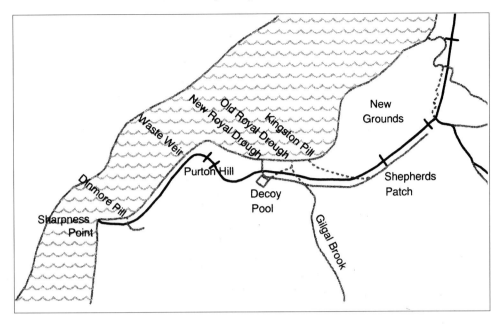

*The third section of the canal from the River Cam to Sharpness started 1817-20 and completed 1823-27. The broken lines mark the former courses of streams, particularly those that were diverted to the New Royal Drough outfall.*

Meanwhile, during 1826, McIntosh's men were making good progress with the lock structures at Sharpness, the design of which was modified to incorporate two additional culverts. One culvert allowed water to pass between the ship and trow locks as a means of saving water, and the other allowed water to bypass the locks so that mud could be scoured from the tidal basin when necessary. In fact such good progress was being made that the Committee began to look forward to the day when the canal would be open for traffic. Realising the need for storage space to be available at Gloucester, they arranged for two semi-detached warehouses to be built at the north end of the basin. They also drew up a table of tolls to be paid by vessels using the canal, agreed bye-laws and identified the employees who would be needed to keep the canal operating. To take overall charge as Engineer and General Superintendent, they appointed William Clegram, who had designed the improvements to the harbour at Shoreham (Sussex) and had supervised their construction. He was authorised to have repairs carried out at Saul Lodge prior to him moving in. Fletcher stayed on to oversee the completion of the canal, which owed much to his persistence and engineering skill, and he also became supervisor of the work on Telford's Over Bridge near Gloucester.

By September 1826, there were only a few more construction tasks to complete, and it was expected that these would be done in a few weeks, but then a number of problems occurred, starting with a major slip in the cutting through Purton Hill. This required the removal by boat of rock that had slipped down the hillside and was threatening to fall into the canal, followed by the clearing of more rock that

had already fallen into the canal. The construction of stop gates at Shepherds Patch was delayed when it was found that the foundations were on quick sand, and this required extra deep piling and additional stone filling. While these matters were in hand, Col. Berkeley objected to a waste weir discharging excess canal water into Frampton Pill as he feared it would erode the soft shore there, having recently spent a lot of money stopping the same effect at Kingston Pill. Telford directed that the offending waste weir be built up to prevent water loss, and a replacement weir was constructed below Purton. To provide water to fill the canal, arrangements were made with the occupiers of Whitminster and Framilode Mills to allow water from the River Frome to flow into the Stroudwater Canal at Whitminster and so into the Gloucester Canal at the Junction. Other jobs included finishing the bridges, gravelling the towing path, putting up fencing, fitting elm baulks to act as fenders at the head of the locks and installing mooring posts. Eventually, all the necessary work was completed, and Telford confirmed that the canal was ready for opening.

The official opening of the canal took place on 26 April 1827. The locally owned schooner *Meredith* had previously passed through the entrance at Sharpness with a cargo of brandy from Charente (France), and a large crowd gathered to watch the arrival of the much larger ship *Anne* of 300 tons register, which came from Bristol to pick up salt for the Newfoundland fisheries. As the tide reached its peak, there were fears that *Anne* would not make the entrance as she was still a considerable distance away and there was very little wind. With great exertion, however, the Canal Company's engineer William Clegram managed to get a rope conveyed out to her, and as the tide was ebbing strongly, she was slowly hauled into the entrance accompanied by the shouts and congratulations of spectators and the firing of guns. Once through the lock, both vessels hoisted their colours and manned their tops, and with the help of towing horses, they set out on their historic journey along the canal. At the junction with the Stroudwater Canal, the Canal Company Committee and their ladies went on board and several other boats joined the procession. As the convoy passed through each bridge, crowds gathered to greet them, and an ever increasing number of spectators walked along the towpath until the crowd lining the banks became almost too dense to move. Eventually the vessels entered the basin at Gloucester amid the firing of guns, the ringing of church bells and the cheering of the large mass of people who crowded every vantage point to get a better view. The local newspaper reported that "it was long ere the novelty of the scene would allow the collected assemblage of spectators to disperse". In the evening, the shareholders of the Canal Company and their friends attended a dinner at the Kings Head, where one of the guests was the Mayor of Gloucester, who that year happened to be the Canal Company's clerk, Shadrach Charleton. To mark the occasion, many toasts were drunk to those who had helped the great enterprise which was at last successfully completed, 34 years after the original Act of Parliament.

# 3

# Early Operation

With the canal in operation, the day-to-day business of the Canal Company was managed by four key employees. All operation and maintenance activities were the responsibility of William Clegram, the Engineer and Superintendent based at Saul Lodge near the mid point of the canal. Under him, vessel movements and moorings were supervised by Richard Wraith, the Harbour Master at Sharpness, and by John Bateman (soon replaced by Thomas Francillon), the Dock Master at Gloucester. The fourth key man was William Clegram's son, William Brown Clegram, who in 1829 succeeded Shadrach Charleton as Clerk in charge of the Company's accounts. This remarkable group carried the Company forward for the next thirty years. They reported to a Committee of shareholders elected at each twice-annual General Meeting, but the authority of the Committee was tightly constrained by the Loan Commissioners who required priority to be given to paying off their loan and were reluctant to allow any new developments.

Initially, the canal was mainly used by trows and barges trading between Bristol and the Midlands, and longer distance trade was slow to develop. Even some local traffic continued to use the river, if the tide was favourable, in order to save paying the canal toll. To encourage more trade, therefore, the shareholders agreed in July 1827 to make an average reduction on the scale of tolls by about one-third. This helped to attract larger vessels that brought slates from North Wales, coal from South Wales, oats from Ireland, wool from Bridgwater, wine from Portugal and timber from North Russia and Canada. As there were no facilities for handling cargoes at Sharpness, all such vessels had to pass up the canal to discharge in the basins at Gloucester. Vessels were towed along the canal by horses who's owners paid an annual licence fee. Most of the imports were then sent on up the River Severn in barges or longboats, the latter being able to pass through the narrow canals to the growing industrial towns of the Midlands.

A vessel approaching Sharpness came up the river on the flood tide, aiming to arrive around the time of high water. When nearing the entrance, the normal practice was to turn round to head into the last of the flood, and as the tide eased, the vessel was steered across the channel towards the entrance. In practice, this was no easy task, and the local pilots had to cope with many difficult situations. When the barque *Isabella* was delayed for half an hour by customs officers at Beachley, she could not reach

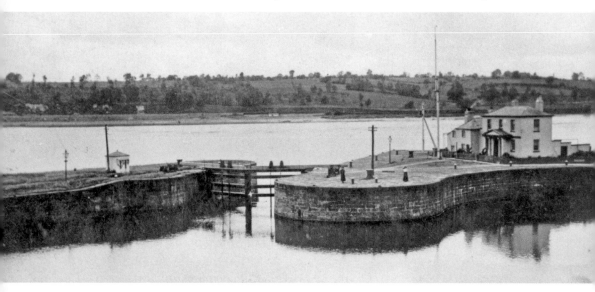

*The entrance to the tidal basin at Sharpness with the Harbour Master's House, c. 1910.*

Sharpness on that tide, and her pilot had to chose a place for her to settle on the mud before taking her safely into the entrance on the next tide. Such was the feeling in the port of Bristol against their new rival further up the river that accounts of this incident became much exaggerated, and one Bristol newspaper delighted in reporting quite wrongly that when the *Isabella* had grounded, her back had broken and most of her cargo had been washed out. Vessels that arrived well before high water occasionally needed to anchor temporarily while waiting for the current to ease, and the timing of the entry into Sharpness basin was so critical that it was sometimes then necessary to slip the anchor rather than delay while it was fully raised again. One attempt to recover a slipped anchor proved embarrassing for the Harbour Master, Richard Wraith, as it resulted in the loss of the Company's large rowing boat, and he had to pay for a replacement.

Harbour Master Wraith was in charge of two or three permanent lockmen, and he employed additional casual labour at tide time as required. It was common for an arriving vessel to send a rope ashore which was made fast to a capstan on the pier-head, and by this means the vessel was pulled into the entrance. The strain in the rope during such an operation could be considerable, and there were instances where the recoil of a failed rope caused a broken leg or worse. A different source of concern arose when an over-zealous ship broker tried to do business with masters of vessels just at the critical time they were entering the tidal basin. When Wraith reported that this was putting the safety of vessels at risk, the Committee immediately banned onlookers from the piers and arranged for gates to be erected to enforce the ban. However, this provoked complaints from other ship brokers, and so the Committee eventually agreed to issue admission tickets on condition of good conduct.

Once arriving vessels were in the safety of the tidal basin, the entrance gates were closed and it was possible to relax a little. Then each vessel took its turn to pass through one of the locks at the start of the canal, large ships using the big lock and trows and barges using the small lock. While this was going on, Wraith took an account of each vessel's cargo on which the toll for using the canal would be charged. The locking operations did not always go smoothly. One day when only one lockman was available, a winch used for opening the lock gates was broken while a vessel was passing through, and Wraith was told in future always to have two men present when the locks were being worked. Wraith was in trouble again when a vessel passing down the canal crashed into the upper gates of the ship lock, causing considerable damage. He was summoned to Gloucester and forcefully reminded of the requirement to place a boom across the mouth of the lock to protect the gates when they were not in use.

As a vessel passes through a lock, some water is lost from the higher level, and with the canal in operation it soon became apparent that there was going to be a difficulty with replenishing the lost water. For the opening day, the canal level had been two feet below its nominal depth of 18 feet, and by July it had dropped a further 15 inches, in spite of the co-operation of the millers on the River Frome who at weekends allowed their spare water to flow in via the Stroudwater Canal. Clegram found that the River Cam provided very little water in the dry weather as farmers had the right to take off as much as they needed, via a culvert under the canal, for the numerous head of cattle they kept on the meadows to the west. A further consequence of the shortage of water was that mud began to collect in the tidal basin at Sharpness because of a reluctance to release water from the sluices to scour it away. After negotiations, therefore, agreements were reached with the millers and the Stroudwater Company to take any spare water from the river during the week, as well as at weekends, on the understanding that the millers could draw from the canal if there was a shortage in the river.

*The locks at Sharpness looking east c. 1900, with a man using a capstan to move a vessel.*

Another early concern was the stability of the major canal embankments. After less than three months of operation, engineer Clegram spotted that the embankment on the green-bank side (opposite the towpath) across the Royal Drough valley was slipping into the deep drain adjoining it, raising the fear that the whole bank would collapse if the canal was at its full level. Following consultation with Thomas Telford, he arranged for a footing of piles and planks to be installed along 160 yards of the base of the embankment. Unfortunately, this did not address the real problem, and when the autumn rains allowed the canal to approach its full level, there was so much leakage through the bank that the canal level dropped one foot in a day. To stop this, Clegram had to dig a trench along the bank and insert much more puddle clay to make the bank watertight again.

Eighteen months later, Clegram's worst fears were realised when a major breach occurred in the towpath embankment below Cambridge Arms Bridge. Water began seeping through a layer of sand that had not been properly sealed by puddle, and eventually a large section of the embankment was carried away. The effect on the rest of the canal was limited by the prompt closure of the stop gates above and below the breach, but water from the affected section flooded the neighbouring fields, and the Canal Company had to pay out £100 for damage done to 1258 sacks of potatoes, 15 acres of new-sown wheat and 21 acres of fallow land prepared for bean setting. Traffic on the canal was inevitably interrupted for a time, but Clegram's men worked hard to repair the bank and the canal was reopened within a week.

In spite of these early engineering difficulties, merchants came to appreciate the great advantage of Gloucester's inland position for supplying the growing industrial towns of the Midlands. In October 1829 the local paper was pleased to report that on one day there were ten large brigs in the basin at Gloucester, four schooners and fourteen sloops. The main imports were corn from Ireland, timber from Canada and wine from Spain and Portugal, while the chief exports were iron manufactured goods and salt for foreign ports and the Newfoundland fisheries. One such export cargo did not go very far, however, as while the brig *Mary Ann* was on her way down the canal loaded with 400 tons of salt and iron, it was found she had sprung a leak. She was too big to go into the dry dock, so Clegram had to lower the water level in a section of the canal by three feet while much of her cargo was discharged and temporary repairs carried out, and she eventually sailed for London where the necessary work could be done properly. Domestic traffic on the canal included longboats bringing coal from the Midlands and regular packet boats carrying passengers and goods between Frampton and Gloucester, particularly on market days. Fly boats began operating between Gloucester and London via the Stroudwater and Thames & Severn Canals. These travelled day and night with relays of horses and a relief crew, carrying small consignments of general merchandise. The canal towpath was often used by pedestrians as well as by horses, but it was not a public right of way, and when John Sims's family wanted to convey his body along the towpath from Sims Bridge to Hempsted for burial, Clegram collected one penny as an acknowledgement.

# PARKER & FOSTER'S FLY BOATS,

### TO AND FROM

## Hambro' Wharf, *(adjoining the Iron Bridge)* London.

### *THAMES WHARF, OXFORD.*

## THEIR WHARF, AND CANAL BASIN, GLOSTER,

#### BY WAY OF ABINGDON, BRIMSCOMBE, AND STROUD.

| Leave Hambro' Wharf. | DELIVER GOODS AT | | | | Arrive at Their Wharf, Gloucester. |
|---|---|---|---|---|---|
| TUESDAYS | Wantage, Faringdon, Highworth Leachlade, Fairford, Quinnington Swindon, Cricklade, & Cirencester | SATURDAYS | Chalford, Brimscombe, Stroud, Caincross, Ebley and Stonehouse, | MONDAYS | MONDAYS |
| THURSDAYS | ......Ditto......Ditto ....... | TUESDAYS | Ditto......Ditto...... | WEDNESDAYS | WEDNESDAYS |
| SATURDAYS | ......Ditto .....Ditto ........ | THURSDAYS | Ditto......Ditto...... | FRIDAYS | FRIDAYS |

| Leave Gloucester. | Leave Brimscombe. | Arrive at Hambro' Wharf, London. |
|---|---|---|
| MONDAYS ..................... | MONDAY Evening .............. | ...........FRIDAYS |
| WEDNESDAYS.................. | WEDNESDAY ditto ............. | ...........MONDAYS |
| FRIDAYS ..... ..............., | FRIDAY ditto.. ..........•........ | ...........WEDNESDAYS |

Goods conveyed by these Fly Boats to all places on the line of the River Thames, WILTS & BERKS, and THAMES & SEVERN Canals; also forwarded to *Cheltenham, Worcestershire, Herefordshire, Monmouthshire, & North & South Wales*

*\*\** Should navigation be impeded by frost or high floods, all goods, that are required, will be speedily conveyed by land at a moderate rate.

### (OVER.)

*Business card advertising Parker & Foster's fly boats c. 1830.*

As trade developed, there was a need for more storage space than was available in the Canal Company's warehouses, and the Committee leased plots of land so that merchants could build their own. A row of three-storey warehouses with cellars was erected *circa* 1830 on the west side of the Main Basin by three firms: Humphrey Brown, a long-established river carrier, J. & C. Sturge, corn merchants from Birmingham, and the Droitwich Salt Company. On the east side of the basin, a single warehouse was built by John Biddle, a miller from Stroud. Much of the remaining space around the Main Basin was occupied by timber merchants, with two yards used by wharfingers who handled general cargoes, and the land around the Barge Basin was divided into small yards for coal and stone merchants. On the opposite side of the canal to the Barge Basin, a ship-building yard was established by William Hunt close to the dry dock, and at the north end of the basin, the Canal Company built an office with living accommodation for their clerk.

By 1830, the traffic on the canal was exceeding expectations, but the financial situation was not good because, to attract business, the tolls being charged were well below the levels envisaged when the shareholders had invested their money. The canal had cost £450,000 to build, of which £160,000 had been advanced by the Loan Commissioners, but the surplus income was not enough to pay the interest on the loan and there seemed no prospect of repaying the principal debt. The matter came to a head in 1830 when

the Loan Commissioners threatened to sell the canal unless a satisfactory arrangement was made to pay off the borrowed money. After a debate lasting twelve hours, spread over two days, Mark Pearman persuaded his fellow preference shareholders to forego their arrears of interest and to consolidate their stock with the ordinary shares as a means of paving the way to raising a further £200,000 by mortgage or by the issue of new preference shares. The Bill to authorise the proposal ran into difficulties in the House of Lords, due to the influence of the Loan Commissioners, and it was only through Pearman's personal influence with a near relative of Earl Grey, the Prime Minister, that the opposition was withdrawn. Lord Seagrave of Berkeley Castle also opposed the Bill until the shareholders accepted a clause requiring them to remove the waste weir at Frampton Pill. This was evidently still in use in spite of Lord Seagrave's earlier objections, and the Canal Company later built a replacement weir near the Junction. Eventually the Act was obtained in 1832, but the new money could not be raised, as potential investors realised that the operating surplus was not enough to pay the interest on any new money as well as on the old loans, and the Commissioners eventually granted more time for the Company to find a way out of its difficulties.

While the Canal Company was struggling with its financial problems, it was also hit by a crisis in water supply. The arrangement with the owners and operators of Whitminster and Framilode Mills on the River Frome was that any surplus water from the river could be passed into the Stroudwater Canal through square pipes in the intervening bank just above Whitminster Lock, about half a mile from the Junction. With the Gloucester Canal at its full height, Whitminster Lock had become virtually redundant, and the gates were normally left open, allowing the water to flow freely on into the Gloucester Canal. The problem was that water from the Frome carried a lot of mud into the Stroudwater Canal, and where this settled out it caused difficulties for the passage of boats. The Stroudwater Company had only allowed their canal to be used as a water conduit on the understanding that the Gloucester Company would clear away any mud, and when failure to do this caused a problem in October 1831, the Stroudwater Committee felt justified in closing the gates of Whitminster Lock to raise the water level in the pound above, with the consequent interruption to the supply to the Gloucester Canal. The Stroudwater Committee made it clear that they were prepared to reopen the gates while a better way of taking the water from the Frome was negotiated, but the owner of Framilode Mill, Mr P.B. Purnell, added to the pressure by withdrawing his permission for any more water to be taken until a new arrangement was agreed. The situation came to a head when it was found one morning that water had been drained from the Gloucester Canal overnight under suspicious circumstances, causing the level to drop nine inches.

Forced to take the matter seriously, the Gloucester Committee proposed seeking Parliamentary authority for a water supply from the Frome that would avoid having to rely on Whitminster Lock being left open, the preferred plan being to construct new conduits entering the Stroudwater Canal below the lock. Arrangements were agreed with the mill owners and the Stroudwater Committee, but Lord Shaftesbury ruled that such private arrangements could not be included in an Act, and they should instead

be the subject of a formal agreement between the parties. The Stroudwater Committee tried to get such an agreement with terms that would fully protect their interests, but the Gloucester Committee (who could not do anything without the approval of the Loan Commissioners) would only offer vague assurances. This prompted P.B. Purnell to take the law into his own hands, and in April 1833 his men closed the sluices of the supply pipes.

Mr C.O. Cambridge, who owned Whitminster Mill, did not approve of this unilateral action, particularly as Purnell's men had trespassed on his property, and he sent his blacksmith to open the sluices. This prompted Purnell's men to close them again, and these opposite actions were repeated several times over the next few days until Cambridge had the sluice boards removed completely. Not to be outdone, however, Purnell's men fixed new boards in place. Cambridge ordered the boards removed, but while his men were doing this, Purnell himself arrived, red in the face, and knocked down Cambridge's carpenter with such violence that his legs were injured. Two days later, Purnell brought a mob of thirty men, and although being served with a legal notice not to trespass, they boarded up the sluices again. When Cambridge and his men returned the next day with saws and axes, they were physically restrained by some of Purnell's men who were keeping watch, and after one man was cut in the face, Cambridge thought it was prudent to retire. This phase of the battle was finally ended by William Clegram who brought sixty men from Gloucester at five o'clock one morning to break up the sluices completely and allow the water to flow freely into the canal.

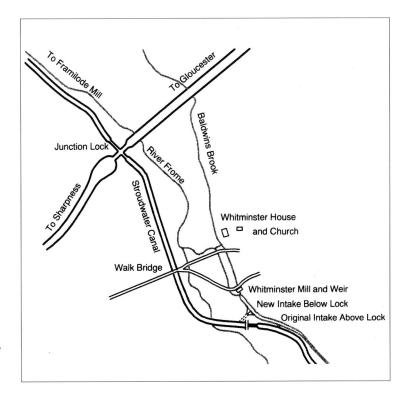

*Map showing how water was obtained from the River Frome via the intakes above and below Whitminster Lock.*

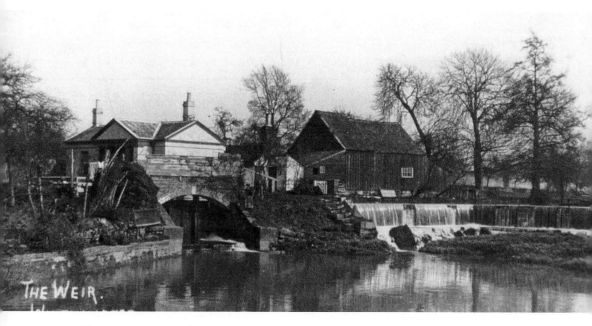

THE WEIR.

*Whitminster Weir on the River Frome. Behind the flood gate is the attractive cottage for the weir keeper which set a pattern for the subsequent bridge houses.*

These events finally convinced the Loan Commissioners that an alternative supply of water was needed, and on the recommendation of Thomas Telford, they allowed the Committee to order the construction of a 45 horse power steam engine and pump at Gloucester. Recognising that a wholly pumped supply would be expensive, negotiations continued with the mill owners and the Stroudwater Committee, and a new Act was passed in 1834 which authorised the Gloucester Company to raise a further £50,000, to purchase the mills and to construct a new conduit from the Frome into the Stroudwater Canal below Whitminster Lock. The Act required the Gloucester Company to control the level in the Frome in order to supply the pound of the Stroudwater Canal above Whitminster Lock, and the Gloucester Company also had to clear mud from that part of the Stroudwater Canal between Whitminster Lock and the junction with the Gloucester Canal. To ensure that someone was on hand to monitor and adjust the levels when necessary, the Gloucester Company built a cottage near the sluices for the keeper of Pegthorne Bridge. This cottage had a classical style porch with columns supporting a pediment, possibly to add interest to the view from nearby Whitminster House, the home of Mr C.O. Cambridge who had been so helpful during the dispute.

Keeled vessels were not allowed to use their sails to move along the canal, and to minimise the risk of mishaps while being towed, large square-rigged vessels had to strike their top-gallant masts, take in projecting spas and lift their anchors on to the foredeck. The Committee agreed a set of regulations with the horse owners who were required to supply between one and six horses, depending on the size of vessel, and to charge twelve shillings per horse for a loaded vessel or ten shillings if light.

In addition, saddle horses were provided for the use of ship's masters to ride ahead to Gloucester on business. In 1836, the Committee did allow the steam boat *Alert* to try towing vessels along the canal, and she moved the vessel *Thalia* when the wind was too strong for horses to do the job, but there was concern about damage to the banks due to the wash from her paddle wheels and the Loan Commissioners blocked further experiments. Following concern about the level of charges, new arrangements were made in 1837 with horse owners based around Purton to tow up the canal and with owners in Gloucester to tow down the canal, both groups charging ten shillings per horse for a loaded vessel or eight shillings if light. At the same time the Canal Company built stables for the horses at Sharpness and near the Junction.

Perhaps not surprisingly the conduct of some of the horse drivers led to complaints from ship's masters. The most frequent problems were not providing sufficient horses and delays of two hours or more due to late starting or long breaks. Another complaint arose after an attempt by a light vessel to overtake a loaded one ended in a collision. One master complained that his vessel was delayed two hours because the horses were not brought at the time ordered and the boys driving them misbehaved because they were refused "grog" by the master. The Committee agreed that the particular horse drivers should be fined, that any horse drivers asking for grog in future be dismissed and that no boys under fourteen years of age be employed to drive horses. Another complaint of a delay *en route* was not substantiated as it was considered that the break was no longer than was needed for the horses to have their food and water. When there were suspicions that some horse drivers were receiving payments direct from masters, rather than via the Canal Company, three of the bridgemen along the canal were directed to demand the production of official tickets and to stop any vessel using horses without one.

Each vessel was accompanied along the canal by a hobbler walking along the towpath. His job was to take a rope from the ship when needed and put it round a checking post on the bank to help control the movement of the vessel, particularly when approaching a narrow bridge-hole. This was required by a bye-law that was brought in after a vessel crashed into the wall at the Junction with such violence that she sank. Another bye-law specified that if two vessels met in a wide part of the canal, both should keep to the right, but if there was not room to pass safely, the lighter loaded one had to go back to a wider place and moor on the green-bank side while the loaded boat came through. For use in these situations, there were a number of recesses in the canal bank (known as lie-byes) where mooring posts were provided.

There were originally fifteen road bridges crossing the canal with one footbridge at the Junction. Several took their names from local villages (such as Hempsted and Fretherne) or from nearby farms (such as Sims, Sellars and Pegthorne). Splatt Bridge took its name from the former open land at the head of Frampton Pill, and Parkend Bridge was near land which had once been a deer park. Parkend Bridge became commonly known as Castle Bridge after the Castle Inn was built nearby, and Sellars Bridge is often called Pilot Bridge because of the nearby pub of that name. Cambridge Arms Bridge is not linked to a pub, and it is possible that the name originally had an apostrophe and meant the bridge associated with the Cambridge Arm.

*Fretherne Bridge c. 1910.*

Most of the bridges were attended by a specific bridgemen, although the two bridges close together at Purton were looked after by one man and the man at Rea Bridge also had responsibility for the nearby Sims Bridge. The early bridgemen lived in existing houses nearby and were just provided with a simple brick hut for shelter while on duty. Each road bridge comprised two wooden half-spans which could be swung open to let vessels pass through. The bridgeman opened one side of the bridge, and the hobbler accompanying the vessel opened the other side. Each half-span was rotated by pushing on a long arm attached to the tail of the span. For the older bridges near to Gloucester which were mounted on small diameter piers, a curved wooden staging was provided for the bridgeman to walk out on while doing this. The later bridges, from Hardwicke southwards, were mounted on larger piers and so there was no need for staging.

Approaching Gloucester, vessels came under the authority of the Dock Master, Thomas Francillon. It was his job to allocate moorings, ensure that each cargo was properly recorded, arrange ballast when needed and only authorise clearance when everything was in order. He also had to supervise the outdoor staff at Gloucester, which included six watchmen, and ensure that timber discharged into the canal due to a shortage of wharfage space did not cause undue problems.

Traffic on the canal increased rapidly during the early 1830s, particularly with respect to corn imports from Ireland and Europe and timber imports from the Baltic countries, north Russia and Canada. Facilities at Gloucester came under great pressure, but the Loan Commissioners would not allow the Canal Company to make any major investments, and so it was left to private capital to meet the new demands. A warehouse was built beside the Barge Basin for timber merchant James Shipton

(1833), another beside the lock for corn merchants J. & C. Sturge (1834). A third was built near the lock for Thomas Phillpotts & Samuel Baker (1835) who were importing 1000 hogsheads of sugar a year. The soil excavated for the foundations of these warehouses was used as ballast for ships departing with no cargo. Two smaller warehouses for the storage of salt for export were also put up near Hempsted Bridge by the Droitwich Salt Company and the British Alkali Company based at Stoke Prior in Worcestershire (1835-36).

There remained the problem of overcrowding in the Main Basin which was so bad at times that some vessels were moored end on and discharged over the bow while others had to wait their turn in the canal. To alleviate this, a group of merchants led by Samuel Baker built a quay to the south of Llanthony Bridge where a warehouse supported on pillars was financed by Samuel Baker and James Shipton (1838), and the rest of the space was laid out as timber yards. The excess soil excavated from these works was again used for the ballasting of ships, and when this source was exhausted, material was taken from the bank at Two Mile Bend.

Traffic on the canal was interrupted in January 1838 when a long frost kept the canal frozen for two weeks. During a temporary thaw, the Canal Company tried to clear a way through using a makeshift ice-boat, but as the thickness was more than six inches in places, they had very little success. To try to avoid having such a long stoppage again, the Committee arranged for a proper ice-boat to be obtained by the following winter. This was probably of the type designed by Stephen Ballard, Engineer of the Herefordshire & Gloucestershire Canal, which had a sloping projection on the front so that when the boat was drawn along, the projection went under the ice and lifted it. To provide a covered mooring for the new acquisition, a boathouse was built over a short arm off the Stroudwater Canal just to the east of the Junction.

The construction of Baker's Quay eased the overcrowding in the Main Basin, but in the belief that traffic could increase even more, the Committee wanted to build a second Barge Basin and widen the entrance at Sharpness to accommodate steamers trading to Ireland. These proposals for yet more expenditure evidently prompted the Loan Commissioners to wonder whether they were ever going to get their loans repaid, and to bring matters to a head they gave notice that if arrangements to liquidate the debt were not in place by 1 July 1840, they would advertise the property for sale. The financial position of the Company had very much improved since the similar threat ten years earlier, and after intense negotiations with the Loan Commissioners, the Canal Company handed over £60,000, raised through the issue of preference shares, and promised to allocate £8,800 annually from surplus revenue to the liquidation of the remaining debt over the next twenty years.

Traffic on the canal was particularly busy in 1840, making the basins crowded with vessels and the quays bustling with activity. Price & Co. had contracts for almost 20,000 tons of timber for building the Cheltenham & Great Western Union Railway, and to help bring the timber across the Atlantic, the partners purchased two barques which on the outward voyages took parties of emigrants going to seek their fortune in the New World. Conditions for the emigrants must have been rather

primitive on what were really cargo ships, but it was said that Gloucester was a better departure point than Liverpool because the firms involved were respectable and so the passengers were less exposed to frauds from self-styled emigration agents. The corn trade was also prospering, and new warehouses were built on the east side of the Main Basin for J. & C. Sturge and for Charles Vining & Sons (both 1840). There was still a good coastal trade as well, although this was about to be threatened by the spread of the railway network.

To give fore-warning of vessels coming up the canal, Gloucester merchants had for some time paid for a daily messenger on horseback to bring news of arrivals and departures from Sharpness, but in 1841 they complained to the Canal Company that difficulties had been put in the way of them receiving the information. It seems that Lloyd's Agent J.G. Francillon was paying the Harbour Master at Sharpness to give him exclusive access to the list. The Harbour Master was told to stop this practice and give priority to the merchants. However, it wasn't long before Francillon complained after his messenger could not get the information because the merchant's messenger had not turned up. The Committee then told the Harbour Master to display the list at the door of his office where it could be seen and copied by all.

Vessels passing up the canal often had to moor up for an overnight stop, and a favourite spot was near the Castle Inn beside Parkend Bridge (also known as Castle Bridge). One evening in May 1842, those at the inn were entertained by a stranger who sang songs and told stories, but this distraction did not prevent other men being spotted loading mysterious packages from a large outbuilding into a wagon. The authorities were alerted, and when the packages were tracked down at Paddington Station, having been put on a train at Cirencester, they were found to contain more than six tons of tobacco. Inquiries established that the packages had been discharged from a vessel on the way up the canal, and three men (including the master of the vessel) were later convicted of smuggling. The outbuilding subsequently became known as the Smuggler's Warehouse.

As well as the vessels arriving from other ports, the canal was also used by local boats delivering coal to the canal-side communities and by regular horse-drawn packet boats carrying passengers and light goods to and from Gloucester, particularly on market days. In the 1840s, one packet boat left Frampton Wharf (to the north of Fretherne Bridge) every morning, and there were two extra boats on Saturdays. These were evidently run by Thomas Pilkington of the Packet Office near Fretherne Bridge (now Alexandria Cottage) and his son James, who lived in the house nearer the bridge (now Westmont). Other boats conveyed passengers the full length of the canal, and there were some pleasure parties, but they were not allowed to pass through the bridges after dusk.

The maintenance of the canal was the responsibility of the Engineer, William Clegram, who lived at Saul Lodge, about 300 yards below Fretherne Bridge. In the grounds were workshops and store sheds for the maintenance men who in 1843 comprised a foreman, two millwrights, one carpenter, two sawyers and nine navvies. Their work included repairing any damage to the bridges and the locks, stopping

leaks, removing slips in the canal banks, cutting hedges and maintaining the towing path. In addition, men were employed as needed to help with dredging operations. Initially the dredging was done using a large spoon formed by leather thongs attached to an iron hoop worked over the side of a boat, but this could not keep up with all the material slipping down the banks and being carried in by the feeder streams. So, based on an idea being used at Newry, Clegram fitted a boat with a dredging machine worked by manual power, and this removed 13,000 tons of mud in six months. Much of the mud was evidently disposed of on land adjoining the canal by means of the stock of wheelbarrows and planks held by William Tudor, the ganger of the navvies, but some may have been dumped into the River Severn at Sharpness as was the practice in later years.

A particular concern for William Clegram was the stability of the various embankments forming much of the southern half of the canal, especially the huge bank across the Royal Drough valley where a major leak had occurred in the first year of operation. Another serious leak was found in 1843 which threatened to carry away the whole bank, but fortunately it was discovered before this happened. The problem again was that the base of the embankment was being weakened by the close proximity of a major drainage stream. Clegram visited Lord Fitzhardinge at Berkeley Castle to ask if the Company could purchase a strip of land about half a mile long beside the bank to allow a new drain to be made further from the canal. Unfortunately, Fitzhardinge still felt aggrieved over previous actions of the Canal Company, which had included taking more of his land than had originally been paid for, and he made it clear he was not inclined to help the Company repair "the blunders committed by their own inefficient agents". When pressed, Fitzhardinge said he would only sell the land for £1000 per acre, which was so exorbitant that Clegram had to settle instead for installing a strong retaining wall along the base of the bank.

In the mid-1840s, traffic on the canal was booming, the Canal Company's finances were healthier than they had ever been and prospects for the future looked bright. In 1843, the ship *Rothschild* (640 tons reg.) from Canada with spruce deals and battens for Price & Co. was welcomed as the largest vessel to pass up the canal. Two years later the ship *Mexican* from New York with grain for J. & C. Sturge was welcomed as the first vessel to arrive from the United States, and then the barque *Jane Boyd* was the first arrival from the west coast of South America, bringing 550 tons of guano for use as fertiliser. In one week, seventeen vessels from foreign ports arrived with grain, timber and wine, and although coastal traffic from Bristol was suffering from railway competition, there was a brisk trade with South Wales, including 100 tons of iron daily for the Midland Railway Company. There was also the prospect of an export trade in coal when in 1843 the Bilson & Crump Meadow Coal Company established a depot at the Junction, supplied by barge from Bullo Pill, and early cargoes were sent to Canada, Spain and some British ports. The toll income from all this traffic at last allowed the Canal Company to pay a small dividend on its ordinary shares in 1845. In that year too, a new Custom House was opened in what was to become Commercial Road, as the existing office in town was no longer adequate for the business being transacted.

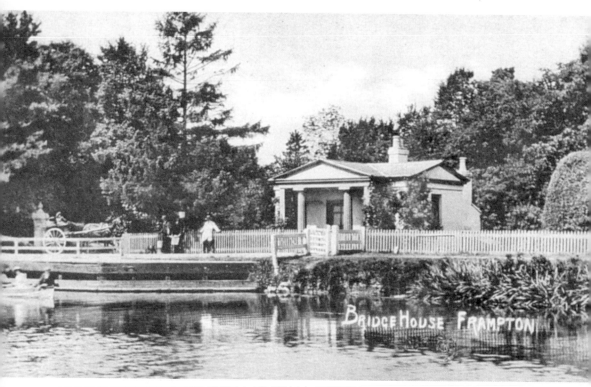

*The bridgeman's house at Fretherne Bridge c. 1908.*

Traffic on the canal was affected in two ways by the construction of the Bristol and Gloucester Railway which opened in 1844. Some materials for the line were evidently carried, as the contractor was given permission to erect a temporary crane near Rea Bridge, but more seriously, the line offered real competition to the regular traders carrying goods between the Midlands and Bristol. To encourage these traders to use the canal rather than the river, the Canal Company had previously agreed that they could pay a moderate composition rate for virtually all cargoes and make some use of the canal at night. Now, in response to the threat from the new railway, the Committee agreed that trows should be permitted to pass on the canal at all hours of the night, provided that the state of the tides required it. This made it important for the bridgemen to have accommodation close to their bridges, and so over the next few years, special cottages were provided where needed. For these, William Clegram used the same classical style design as for the cottage at Whitminster Weir, each cottage originally having two rooms, a scullery and a front porch comprising a pediment supported by two Doric columns. These delightful buildings were only needed at about half of the bridges, as at the other bridges the bridgemen were already living close by.

A new type of vessel appeared on the canal in 1845 with the arrival of the steam boat *Clara*, operated by Southan & Evans. The Canal Company had long resisted

the introduction of paddle steamers for fear that the wash would damage the banks, but after a trial, the propeller driven *Clara* was allowed to start operating provided her speed was limited to 4½ miles an hour. After a few months just towing Southan's unpowered vessels on the canal, she started a regular service carrying passengers and goods to and from Chepstow. These movements led to a complaint from J. Curtis Hayward Esq. of Quedgeley about noise, and it was agreed to ban the use of a whistle. Also Lord Fitzhardinge of Berkeley Castle reminded the Company of the weak embankment through his estate and threatened an injunction to stop the steamer operating for fear that damage to the banks would lead to flooding of his land. In response, William Clegram advised that as the bank had been protected since the earlier concern, he considered that with a speed limit of 4½ miles per hour, any damage to banks would be acceptable, and the Committee allowed the steamer to continue.

Having established the feasibility of a regular steamer service from Gloucester, Southan & Evans ordered a larger vessel from the Neath Abbey Ironworks. The *Henry Southan* was capable of carrying about 100 tons and nearly as many passengers, and in January 1846, she started running twice a week between Gloucester and Swansea. *Clara* ran three times a week to Newport, and such was the success of the venture that the steam packet *Swiftsure* also joined the service to South Wales ports. Unfortunately, while returning to Gloucester one night, *Clara* was hit by another steamer and her hull was holed down to water level. Being constructed of iron, the water only entered one compartment, and by the buoyancy of the other water-tight compartments she was able to get into Bristol for repairs. A few years later, Lord Fitzhardinge complained that the operation of his duck decoy pool near Purton was being affected by smoke and noise from passing steamers which drove the wild fowl away. So Southan was asked to tell his men not to put on fuel when in the vicinity of the pool and not to use the whistle or let off steam.

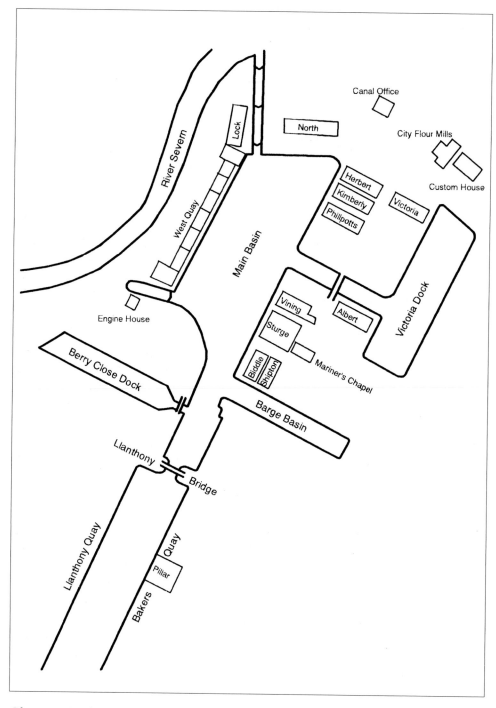

*Gloucester Docks in 1852, showing the new Victoria Dock, Berry Close Dock and Llanthony Quay.*

# 4

# Towards Prosperity

With traffic continuing to grow, and more expected following the virtual abolition of import duties on foreign grain by the repeal of the Corn Laws in 1846, there were moves to develop more facilities at Gloucester. To provide more wharf space for discharging ships, the Canal Company agreed to build a large new dock to the east of the Main Basin, linked to it by a narrow cut. They also agreed to build a small barge dock running into the field called Berry Close opposite to the Barge Basin. Finance for these projects was raised by the issue of more preference shares. While work on the new docks was getting under way, three new corn warehouses were built on the east side of the Main Basin for Samuel Herbert, Humphrey Brown and Abraham Phillpotts (1846). The land for these warehouses had formerly been used as timber yards by Price & Co., and they only agreed to move out on condition that they could expand their premises to the south of Bakers Quay by taking over the land used by John Bird for boat building. Bird was relocated to the south of Hempsted Bridge, where he constructed a small dry dock for the repair of trows and barges.

To save money, Berry Close Dock was built with earth sides and wooden landing stages suitable for barges, and it was completed in 1847. The construction of the new ship dock, later known as the Victoria Dock, was a much bigger project. The initial contractor was removed for not proceeding in a "proper manner", and the work was finished by William Guest in 1849. On the opening day, ten vessels decorated with flags entered the dock and were welcomed by the bells of St Mary de Crypt church and the cheers of thousands of spectators. The new dock was served by a new branch of the Midland Railway, which also included lines serving the Main Basin with some turn-tables needed to get round the corners of the existing warehouses. This rail link was of great benefit to the merchants as it provided another means of sending on imports to the Midlands in competition with the existing river and canal routes. Traffic on the old horse-operated tramroad to Cheltenham was also affected by the arrival of the railway, but the line continued to give good service for another decade. Over the next two years, the land around the new dock was put to good use with the construction of two corn warehouses financed by William Partridge (named Victoria and Albert) and the City Flour Mills built by the brothers Joseph and Jonah Hadley. Other areas were used initially for storing timber, coal and builder's materials.

Following concern about the moral welfare of sailors and boatmen, money was raised to build a chapel for mariners and to pay for a full time chaplain.

Meanwhile, masters of vessels were reporting difficulties in their passage up the canal to Gloucester. Many complained about towing delays, inefficient horses and abuse by horse drivers. As fining those found guilty seemed to have little effect, the Committee eventually terminated the existing agreements, and in 1848 they accepted a tender for the whole operation from William Guest, who had just taken over the contract for constructing the new ship dock. They also agreed that Guest could lease land at Berry Close and at Purton to build stables and that he could alter the existing stables near the Junction for his use. Guest's management evidently made a big improvement, although he was occasionally criticised for not providing enough horses. His successor as towing contractor, James Davis, maintained a team of 24 mares, geldings and colts in order to keep the traffic moving.

Another source of complaint was the increasing accumulation of mud in the bottom of the canal, which meant that part of the cargo of any deep-draughted ship had to be transferred to lighters at Sharpness. The problem was that the various feeder streams brought large quantities of deposit into the canal during periods of heavy rain, and with the limited capability of the existing manually operated dredging equipment, the depth in places had reduced from the original 18 feet to nearer 14 feet. In 1849, therefore, the Canal Company obtained a set of steam-driven dredging machinery from Rothwell & Co. of Bolton and a wooden vessel to fit it in from local shipbuilder William Hunt. This removed around 70,000 tons of mud in one year, most being dumped on neighbouring fields, and in due course the problem was brought under control. Some of the mud was initially dumped in the River Severn at Gloucester, but after a complaint from the Admiralty, this practice was stopped.

Another improvement affecting the passage of vessels along the canal was the licensing of canal pilots. It had become common practice for visiting masters to hire local men to steer their vessels along the narrow channel of the canal and give orders to the hobblers walking the towpath with checking lines, but not all those offering themselves for service were competent. In 1849, therefore, the Committee arranged for potential canal pilots to be examined, and they brought in a bye-law barring anyone who had not received a certificate. Of the first group to be authorised, six lived in Gloucester and six in Purton.

The boom in traffic during the 1840s had allowed the Canal Company to maintain the schedule of repayments to the Loan Commissioners, and there was every expectation of liquefying the debt over the next ten years as promised, but this left little surplus for paying any dividends to shareholders. In 1850, therefore, arrangements were made to pay off the whole debt by taking a loan of £60,000 from the Pelican Life Insurance Company, with lower repayments spread over 21 years, and by issuing £17,000 of preference shares. This allowed modest dividends to be paid - at least while the good times lasted. It also had the effect of putting the shareholders in full control of their own affairs for the first time in almost thirty years. At last there were grounds to hope that the Company was moving towards prosperity.

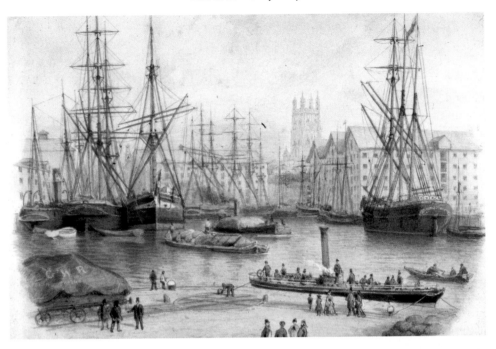

*The basin and warehouses at Gloucester in 1876 with a passenger steamer in the foreground.*

One sign of the times in 1851 was the introduction of a regular passenger steamer service between Gloucester and Sharpness organised by the corn merchant John Kimberly. The aim was to serve the commercial community as well as to provide pleasure trips for the public. In the following year, Kimberly added a second boat and John Francillon and another operator also began running their own steamers. This led to much squabbling, and on one occasion two rival skippers were penalised for racing. The Committee tried to regulate proceedings by arranging for the main competitors to start from opposite ends of the canal for one week and then swap ends for the next week, but there were still difficulties. So for the third year, the Committee invited tenders for just one operator to run two boats, and the successful bidder was John Francillon. He was already running the *Wave* which came from Bristol and was licensed to carry 258 passengers (although it was only required to carry two lifebelts). For his second boat he ordered the *Lapwing* from the Neath Abbey Iron Works. While this was being built, he made use of *Clara*, which was available as Southan & Evans's services to South Wales had ended due to competition from the railways. The two boats ran three times a day in each direction during the summer and twice daily in winter. Passengers included merchants and ship brokers visiting Sharpness to meet arrivals, sailors joining their ships at the last moment before departure and a growing number of labourers who worked at Sharpness during the week and only returned to Gloucester at the weekends. The packets also provided transport into Gloucester for the inhabitants of the villages along the line of the

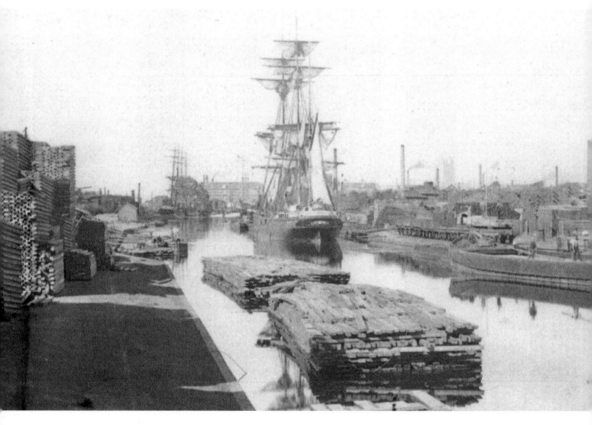

*Timber yards beside the canal to the south of Gloucester in the 1890s.*

canal, and during the summer they were used by thousands of city dwellers to enjoy a day out in the countryside.

Meanwhile, imports of corn and timber continued to flourish in the early 1850s, causing traffic on occasions to touch the limit of the canal's capability. The repeal of the Corn Laws had encouraged a marked growth in foreign imports, which at times were limited by the warehousing available. The foreign corn from Mediterranean and Black Sea ports often arrived in very large ships like the *Devore* of nearly 600 tons register, which brought 3900 quarters of wheat for Lucy & Co. from Odessa and was thought to be the largest corn-laden vessel to have arrived. Timber imports were also flourishing due to a second boom in railway building, with Price & Co. and Heane & Co. bringing in large quantities from Quebec and the Baltic for construction contracts in the Midlands and South Wales. Two railway contractors, William Eassie and Tredwell & Co., set up yards between the Bristol road and the canal for converting the timber, and the Canal Company installed piling along the frontages to form a new quay which was served by a siding from the Midland Railway. Long baulks of timber were initially discharged into the canal and later lifted by cranes on to wagons which took them to be sawn to the required shapes. William Eassie had 80 to 100

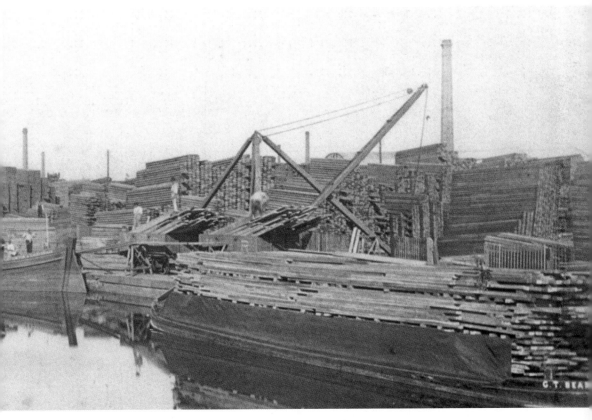

*Note the use of rafts as well as lighters for bringing the timber from Sharpness.*

pairs of sawyers at work and eight circular saws worked by steam power. Batches of sawn timber were put into cylinders to be impregnated with a preservative, and about 1000 tons a week of treated wood were sent away in railway wagons. Gas lights were provided so that the work could continue day and night, providing employment for about 600 men.

One consequence of the boom in imports was that it highlighted the trend towards the use of larger ships, which were far too big for the existing dry dock at Gloucester and so had to go elsewhere if they needed any hull repairs. After much debate, the Canal Company eventually constructed a new dry dock in 1853 that was large enough to take the biggest ship that could come up the canal fully loaded. Another consequence of the boom was the increased consumption of water due to greater use of the locks, so that it was not always possible to maintain the full depth of water in the canal. In the dry summer of 1854, a notice was posted daily at Sharpness specifying the draft to which vessels needed to be lightened to suit the level of water in the canal that day, and in October the level was as much as two feet below normal. This prompted the Canal Company to install a second pumping engine at Gloucester supplied by the Neath Abbey Iron Company. However, some ships were so large that they were too big even

to pass though the lock at Sharpness, requiring complete cargoes to be discharged into lighters in the tidal basin. As well as causing congestion, this prevented the basin being drained to scour out the mud that washed in when the entrance gates were open, and instead the mud had to be removed at greater cost using the steam dredger.

Although imports were booming in the early 1850s, the level of exports was still disappointing. Price & Co. continued to use their timber ships to carry emigrants across the Atlantic, and Humphrey Brown sent a few ships to Australia following the discovery of gold there, but salt shipments were in decline partly due to production difficulties in the Midlands. It was hoped that the construction of a new quay to the south of Llanthony Bridge by the Gloucester & Dean Forest Railway Company would lead to the regular export of coal from the nearby Forest of Dean, but it turned out that little was available for export because the home demand was so high. Nevertheless, the quay and its railway, soon taken over by the Great Western Railway, were useful additions to the dock facilities.

The good times of the early 1850s were interrupted by the outbreak of the Crimean War in 1854. This particularly affected Gloucester as most of the foreign corn imports came from the Black Sea area and much of the timber came from north Russia, and both these sources were stopped by the war. In view of the diminished traffic, the Canal Company were forced to economise, and the Committee agreed to dispense with a toll collector, three watchmen at Gloucester and ten maintenance men. However, one remarkable venture did prosper due to the war, and that was the provision of prefabricated wooden huts to provide shelter for the allied troops in the bitter Crimean winter. Similar huts had originally been made by William Eassie and sent to Australia during the gold rush, but now production was stepped up to help the war effort, and over 2000 were produced from timber imported by Price & Co., with some huts being shipped out direct from Gloucester. After the war, trade gradually recovered, and there were hopeful signs of new opportunities in 1856 when a ship arrived with a mixed cargo from India, another in the same week brought bones from South America and there were several substantial shipments of salt to Russia.

During the 1850s, two innovations affected the movement of vessels along the canal. After Patch Bridge was damaged by a French lugger because the bridgeman was absent, signal poles were erected at each bridge that could warn of such an absence and enable any approaching vessel to stop in good time. Also a bye-law was introduced that generally required vessels to keep to the left side of the canal, when meeting a vessel of similar type coming in the opposite direction, instead of the more usual waterway practice of keeping right which had pertained previously. Presumably the reason for this was to allow incoming vessels, which were usually loaded, to keep close to the towpath and maintain towage, while  outgoing vessels, which were often empty, kept out of their way. A further innovation was the establishment of a telegraph link between Gloucester and Sharpness in 1858, which ended the need for the daily messengers on horseback. This was financed by an independent company set up by local merchants, and the Canal Company contributed to the cost in exchange for the right to add a connection to Saul Lodge and to send messages free of charge.

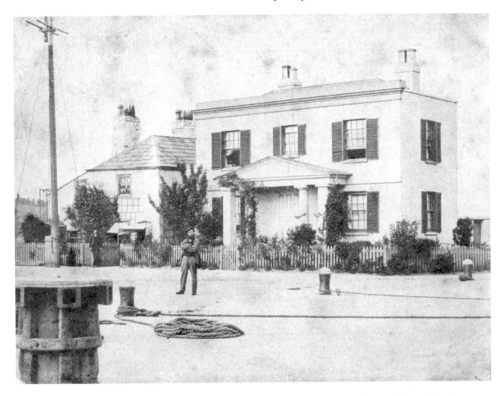

*The Harbour Master's house at Sharpness. The original building is on the left and the larger block with the classical-style porch was an extension added in 1853.*

The canal drew much of its water supply from feeder streams, but during the 1850s, the Sud Brook, which had an outlet under Bakers Quay, was becoming more trouble than it was worth. With the rapid growth in the suburbs of Gloucester without proper sewers, the stream had become a mass of liquid filth, and the smell from its outfall spoiled the enjoyment of summer evening canal-side walks and boating activities. In 1858, therefore, the Canal Company agreed to pay towards the cost of diverting the normal flow of the stream into the city sewer, leaving only excess water at times of flood to pass into the canal.

Following the successful operation of propeller driven steamers on the canal, the Canal Company began to think about the use of steam tugs in place of horses for towing unpowered vessels. Starting in 1858, Messrs Danks Venn & Saunders, the principal carriers between Bristol and the Midlands, were allowed to use the tug *Pioneer* to tow their own vessels. As this seemed to work well, the Canal Company hired the *Reindeer* from J.M. Hyde & Co. of Bristol for a one month trial of towing larger vessels. This showed a 25 per cent saving compared with using horses, and so the Company arranged terms with the existing towing contractor, Timothy Hadley, to replace most of his horses with tugs. Hadley's first tug, *Moss Rose*, started operating in July 1860, *Mayflower* arrived in the following year and *Violet* came the year after, all three being

built by Stothert & Marten at Bristol. Hadley lived at Pockington Farm, Purton, near the Sharpness end of the canal, and he rented part of the wharf just below Purton Lower Bridge on which to store coal for his tugs. As the stables at Purton were no longer required, the Canal Company agreed he could convert them to three cottages.

Hadley's contract was initially limited to towing sea-going vessels over 30 tons, but it was later extended to include river and canal boats and rafts of timber baulks discharged at Sharpness from ships that needed lightening to pass up the canal. Sometimes as many as ten loaded vessels of 50 to 100 tons register were towed by one tug at about three miles per hour. With fewer vessels, the tug could go faster, but it was restricted to four miles per hour to limit damage to the banks. If two or three large vessels were towed together, it was found difficult to keep the last one in line, but this was remedied by attaching three or four timber rafts behind to keep it steady. Towing by steam tug was found to have several advantages over the use of horses. The cost was reduced, the speed was increased and the wear on ropes was less. As the pull was straight ahead, rather than to one side, the vessels rubbed much less against the banks and the damage to the bridges was halved. When there was a strong wind across the canal which would have prevented horses doing the work, vessels could be kept moving by taking one or two at a time. An unexpected benefit was that the faster movement of vessels washed away mud from the sides of the canal and left it on the bottom where it could be more easily removed by the dredger.

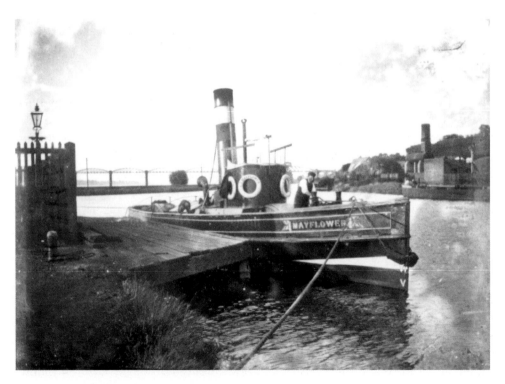

*The tug* Mayflower *at the coaling stage at Sharpness c. 1900.*

The main disadvantage of using tugs was the additional injury to the canal banks caused by the wash and the back run of water round the sides of large vessels. This was initially met by protecting the vulnerable lengths of the banks with a facing of good weathered sandstone, the cost being offset by the reduced maintenance needed on the towpath. Also, as a consequence of the greater speed of towing with tugs and the practice of towing several vessels together, it was found necessary to put in more checking posts along the canal bank for attaching ropes to when needed. A different problem was caused by the increasing number of very large ships that arrived at Sharpness needing some cargo to be lightened there before they could continue up the canal. These large ships were particularly involved with the timber trade, so that in the summer and autumn importing season (when the loading ports were free of ice) there were more lighters and rafts to be moved than the tugs could cope with, and Hadley had to be told to bring in horses when necessary. Later, as traffic increased generally, the tugs *Myrtle* and *Hazel* were added to the fleet, both being built by G.K. Stothert & Co. at Bristol.

At the same time as the steam tugs were coming into service, two small cargo steamers started using the canal regularly. *Edmund Ironsides* and *Cuirassier* were built for the Staffordshire & Worcestershire Canal Company with the idea of carrying cargoes from coastal ports through Gloucester and up the River Severn to the beginning of their canal at Stourport, but it was soon found that the condition of the river would not allow a regular trade. In 1862, therefore, the two steamers were switched to trading between Gloucester and Cork. Unfortunately, it seems that there was not sufficient business to support both of them on that route, as after trying a few voyages to Nantes, Charlestown and Swansea, *Cuirassier* was sold. *Edmund Ironsides* continued trading to Cork for many years, carrying a wide range of general cargoes including imports of farm animals and butter. Visiting steamers were also beginning to use the canal, bringing cargoes such as barley from Nantes and minerals from Bilbao.

Meanwhile, a significant change had been made in the arrangements for piloting vessels in the estuary approaching and leaving Sharpness. Vessels on their way to or from foreign ports had long been required by Act of Parliament to employ Bristol pilots in the Bristol Channel west of Kingroad, the anchorage at the mouth of the Bristol Avon, and then they had to pay again for Gloucester pilots between Kingroad and Sharpness. This had long been of concern to the Canal Company, and after much lobbying against opposition from Bristol, a new Act was passed in 1861 authorising an independent pilotage board for Gloucester with powers to license pilots to guide vessels all the way between Lundy Island and Sharpness. Of the eighteen men given the first licenses, half lived at Purton and most of the rest at Wanswell, near Sharpness. To avoid having to pay for a tug, smaller vessels often waited at the Kingroad anchorage until conditions were suitable to make the difficult passage to Sharpness, and this meant that on favourable tides a group of vessels all arrived at the same time. On one such occasion, two vessels got foul of each other when approaching the entrance, and while one of the newly licensed pilots was trying to help get them disentangled, a spar fell on his head and killed him. The merchants collected a subscription for his widow and five children.

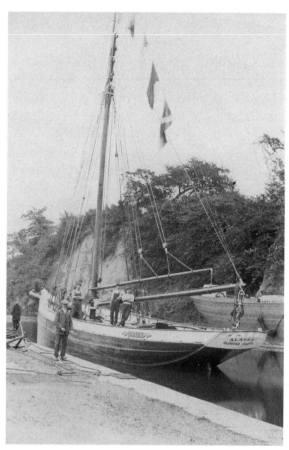

*Pilot boat* Alaska, *built by Frederick Evans at the Junction in 1886.*

With the pilotage reorganised and foreign imports increasing, confidence was high in the early 1860s, and this led to another phase of developments at Gloucester. The Canal Company set an example by building a quay wall in the south west corner of the Main Basin to bring more land into commercial use. They also replaced the old wooden Llanthony Bridge with an iron swing bridge which carried a link between the Midland Railway lines on the east side of the docks and the Great Western Railway on the west. At the same time, William Partridge financed the Britannia Warehouse beside the Victoria Dock and the Great Western Warehouse beside the new quay, both leased by corn merchants. Meanwhile, the brothers T.N. & R.G. Foster from Evesham built an oil and cake mill at the southern end of Bakers Quay, and William Hall & Sons established a flour mill in an existing warehouse at the southern end of the West Quay. This flurry of activity must have been of great satisfaction to William Clegram, the Canal Company's engineer and general manager, who had devoted over thirty years of his life to overseeing the operation of the canal. Now aged well over seventy, he was forced to resign due to ill health, and in 1862 he was succeeded by his son, W.B. Clegram, who had worked with his father on engineering matters while serving as clerk to the Company.

In a quite separate development near the other end of the canal, in 1863, another flour mill was built beside Purton Lower Bridge by Timothy Hadley, who ran the tugs on the canal and was the brother of Joseph and Jonah Hadley of the City Flour Mills in Gloucester. Two years later he added a saw mill, and the adjoining wharf was used for storing timber as well as the coal for the mill and the tugs. The mill was run by Timothy's sons Sidney and Francis for about twenty years until the building was destroyed by fire.

During the 1860s, there was a remarkable resurgence in shipbuilding in Gloucester after a period of inactivity. Messrs Pickersgill & Miller of Sunderland leased the shipbuilding yard beside the large graving dock and also took over John Bird's yard and dry dock at Hempsted. Using both locations, the partners launched ten ships in three years, and then Miller and his son built sixteen more in the next five years. These were mainly barques, schooners and brigantines of between 200 and 350 tons register which were sold to British and foreign owners for trade all over the world. During the same period, William Barnes built seven similar ships at Hempsted and one small steamer that was destined for Rio de Janeiro. Also William Hunt built five more sailing ships on the west bank of the canal to the south of Llanthony Quay, the largest being the clipper barque *Lizette*, 371 tons register, intended for the palm-oil trade. While all this was going on at Gloucester, half a dozen smaller vessels built for local owners were launched into the canal at Saul, between the Junction and Sandfield Bridge. The shipbuilding boom at Gloucester virtually died out by the end of the 1860s, as the principal owners went in for bigger ships built of iron, but wooden trows and ketches continued to be built at Saul for the rest of the century, the main builder being Frederick Evans.

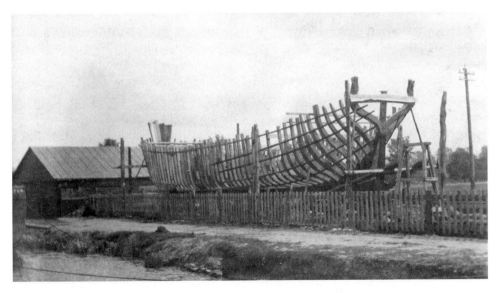

*A sailing vessel under construction at Saul Junction – probably the schooner* Julia *completed in 1891.*

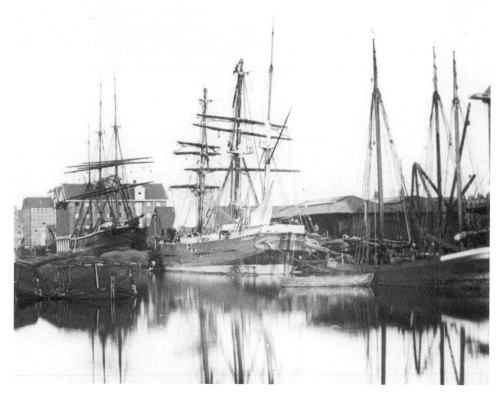

*Sailing vessels moored by Bakers Quay in the 1880s.*

During the 1860s, the tonnage carried on the canal was much the same as it had been in the 1840s, although the total now included a far larger contribution from foreign imports. The foreign corn trade was particularly healthy, having expanded three-fold since the import duty had been virtually abolished by the repeal of the Corn Laws. Many small vessels brought corn from Europe, including one from Rouen that discharged at the Junction, and an increasing number of larger vessels came from the ports on the Black Sea around the mouth of the Danube. Occasionally ships brought corn from North America, but when the *May Dundas* arrived from Montreal with over 1000 tons of wheat, peas and flour for Messrs J. & C. Sturge and W.C. Lucy & Co., she was too big to enter the canal and all her cargo had to be transferred into lighters at Sharpness. The foreign timber trade was also growing, again helped by the abolition of import duties in accordance with the Government's policy of Free Trade. Most imports came from the Baltic and Canada with some also coming from the United States, Norway and the Arctic coast of Russia. A rather unusual import cargo was 400 tons of ice from Norway that was destined for Hillier's bacon-curing factory near Nailsworth. Salt was still the only significant export, and most vessels went elsewhere for a return cargo, often calling at one of the South Wales ports to pick up coal.

As well as carrying this growing foreign traffic, the canal was still also used by very many smaller vessels with cargoes such as oats from Ireland, coal from South Wales and Lydney, stone from Chepstow, general cargoes from Bristol and salt going outwards. Most of these passed along the full length of the canal, but coal and roadstone were discharged at makeshift wharfs near bridges and some went up the Stroudwater Canal or the Cambridge Arm. In the 1860s, the wharf at the head of the Cambridge Arm was leased by John Hodgson, a coal merchant who lived in the house there and owned two small barges, *Hero* and *Eagle*. These brought coal from Lydney and Bullo Pill for the Cam and Dursley area and stone from Chepstow for making up the roads. Hodgson was also allowed to make bricks from the pile of clay that had been left when the basin was dug out. However, traffic along the Arm was declining, particularly due to competition from the Midland Railway's branch serving Dursley, and Hodgson gave up his business early in the next decade.

Keeled vessels were not allowed to set any sails while passing along the canal, but barges did use their sails occasionally when the wind was favourable, to avoid having to pay any towing charges. When approaching a bridge, the practice was to use the vessel's boat on a long line to put a man ashore and to use it again to pick him up after the bridge. Unfortunately, this proved too much for a crewman on the *Betsy*, who had been drinking, as during one such operation, he fell into the water and was drowned. The ban on the use of sails was later extended to all vessels.

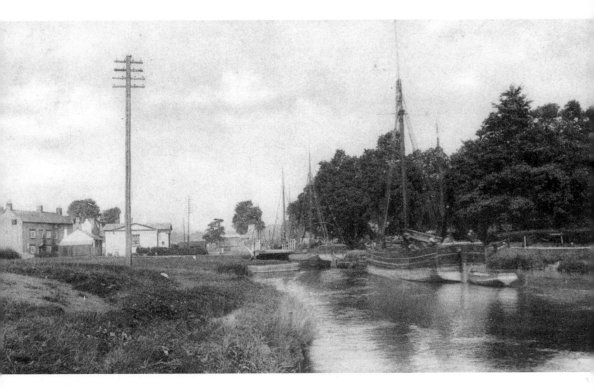

*A tow of trows passing through Purton Upper Bridge on the way down the canal.*

The passenger steamers *Wave* and *Lapwing* maintained their regular service on the canal, bringing village people to visit Gloucester and taking Gloucester people to the Pleasure Grounds overlooking Sharpness Point. When the *Lapwing* was approaching Parkend Bridge one day, an over-helpful passenger prematurely lifted the moveable section of rail where passengers would disembark and promptly fell into the water, taking his young son with him. A ship broker and a ship's captain dived in after them, but fortunately the father and child reached the bank without needing their assistance. On another voyage, the engineer of the *Wave* was not so lucky when he lifted a gun out of the parcel box and it went off, firing its contents into his body. A message was sent from Splatt Bridge to summon a doctor to Fretherne Bridge, but the young man died before the steamer reached there. On a happier occasion, both steamers were crowded for an excursion to Sharpness organised by members of the City Rifle Band. The band was in uniform, playing at intervals during the voyage, and on arrival, the party went to the Pleasure Grounds to enjoy dancing and other pastimes. Another unusual excursion took passengers to watch two swimming races organised by the Gloucester Gymnastic Society in the cutting between Sims and Rea Bridges. The high banks offered good views for hundreds of spectators, some of whom walked beside the competitors, cheering them on.

The maintenance of the canal structures was carried out by a team of men based at Saul Lodge, the official residence of the Canal Company's engineer W.B. Clegram. In the grounds of the house were a number of sheds, spread around a yard, including a carpenter's shop with saw benches, a smith's shop with a portable forge, an iron house with weighing equipment, a lathe room with a treadle-operated lathe and a storeroom with a wide variety of tools and containers. Laying around the central yard were more tools, grind stones, pumps, ladders, winches, barrows, pile driving equipment and a crane. A second smith's shop was sited on the green-bank side of the canal just south of the Junction, where replacement lock and dock gates could be constructed and launched into the canal. In the late 1860s, the men who used these facilities included a foreman carpenter (Joseph Harris who lived in the cottage on the canal bank opposite Saul Lodge), four other carpenters, two sawyers, a blacksmith and a labourer, and two of the men's sons were training as carpenters.

The men based at Saul Lodge were particularly concerned with looking after the bridges. As well as doing routine maintenance work, it was quite common for them to be called out to replace the cast-iron spindle of a bridge broken by the impact from a passing ship, and the woodwork of the bridge often needed repairs as well. Two of the bridges were particularly vulnerable to impact because, when in the open position, the woodwork protruded beyond the edge of the stone abutment. While replacing these in the mid 1860s, a new design was introduced which had a simpler wooden structure stiffened by iron tie-rods attached to the top of cast-iron stanchions, and this became the standard for subsequent replacement bridges. In one extreme incident, however, a Dutch galliot approaching Sims Bridge was so far off course that it hit the end of a span, moving it eight feet, and the upper part of the bridge pier was also carried away. Following this, perhaps not surprisingly, the canal pilot in charge of the vessel had his licence withdrawn.

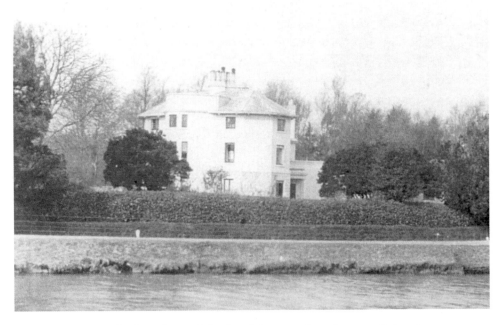

*Saul Lodge – the official residence of the Canal Company's engineer until the 1890s.*

The Saul Lodge men also had to look after the gates and sills of the dry docks, the locks and the entrance at Sharpness. Doing work on the entrance was particularly difficult as stopping the traffic for a period was not an acceptable option. Instead, coffer dams were constructed inside and outside the gates, of modest height such that they would be completely swamped by the big spring tides. Then on each high tide, a limited number of vessels could enter the basin and immediately lock up into the canal, and at each low tide there was about three hours during which the water between the dams was pumped out and the necessary maintenance work carried out. Other tasks for the craftsmen included making new gates, building mud barges, constructing landing stages, shaping piles and doing occasional private jobs for favoured individuals.

As well as the craftsmen based at Saul Lodge, the Canal Company employed about a dozen labourers for a wide range of other maintenance duties, and additional men were taken on when needed. These worked under the supervision of William Tudor of Slimbridge, who had been head ganger since the opening of the canal. One of their regular jobs was maintaining lengths of the towing path seven feet wide using broken stone from Bristol topped with gravel from the Canal Company's own pits at Frampton. They lopped the willow trees which provided wind protection for the lower reaches of the canal, and some of the branches were sold for basket making. They also cut and laid the hedgerows down either side of the canal, they cleared out the culverts and back drains and they disposed of the mud excavated by the dredger.

To maintain an adequate depth of water in the canal, the steam dredger was generally used for 50 to 100 days each year, raising around 15,000 to 35,000 tons of mud. When the dredger was operating near Sharpness, the mud was taken by barge to just above the locks, where it was discharged over the wall into the river. Mud dredged further up the canal was generally dumped on nearby low-lying fields and in local depressions such as former withy beds near the junction of the Cambridge Arm and former brick pits and gravel pits at Frampton. When the mud was deposited on a field, it was often necessary to add extra water to get the mud to run over a wide area, and while these operations were going on, it was sometimes necessary to put hurdles round the edge of the mud to prevent the farmers stock straying on to it. To clear the mud from the tidal basin at Sharpness, the Engineer attached an underwater scraper blade to a boat that could be moved around by means of lines ashore. This was used to scrape mud from the sides of the tidal basin into the centre, from where it could be scoured away at low tide by releasing water from the sluices by the locks.

During the 1860s, increasing attention had to be given to protecting the banks of the canal from the additional wash caused by the steam tugs. This was generally done by facing vulnerable lengths with stone for about one foot above and below the water surface. As this required the water level to be lowered by 18 inches, it had to be done in the early part of the year when the big ships employed in the timber trade were not around. Where there was particular concern about the stability of an embankment, however, added protection was provided by driving in wooden sheet piling. On the other hand, to save expense, some lengths were given more limited protection by faggots of willow branches held in place by willow sticks.

The good work done by the maintenance men was no doubt noted by the Committee on their annual inspection trips along the canal, usually accompanied by the Mayor of Gloucester and many of the leading merchants. At Sharpness, the party might be fortunate to see vessels entering and leaving the basin at high tide, and before returning they enjoyed a good spread of refreshments in a marquee erected in the Pleasure Grounds overlooking Sharpness Point. Unfortunately, however, the character of the Pleasure Grounds changed during the 1860s as the cottage on the site was opened as a beer house and it attracted sailors from vessels moored in the basin below. On one occasion, a number of foreign sailors quarrelled over their drinks and, in the presence of a party of ladies, prepared to settle their dispute with their knives. A sailor returning to his ship fell into the water and was drowned, and another man fell over the cliff and was seriously hurt. To prevent matters deteriorating further, therefore, the Canal Company took a lease on the Pleasure Grounds in 1868, closed the beerhouse and began charging a nominal sum for admission to the Grounds.

At times, the regular maintenance work on the canal was interrupted by a new construction project, such as forming a new wharf on the green-bank side just to the north of Shepherds Patch Bridge. In earlier times, the Canal Company had used this area as a brickyard, once advertising as many as 400,000 surplus bricks for sale. Following a request from Francis Morgan to establish a timber yard and saw mill on the land, in 1868 the Canal Company's men first deposited dredged mud there to

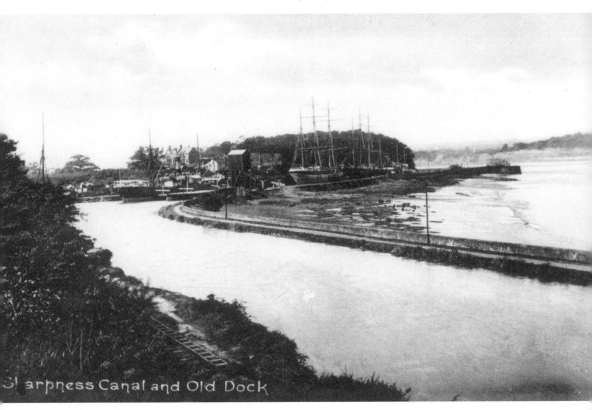

Sharpness Canal and Old Dock

*Vessels moored at Sharpness in the arm of the canal leading to the old entrance c. 1910.*

make a level area. Then they drove in wooden piles to form a quay wall 160 ft long and dredged away the earth in front to allow barges to come alongside. As well as providing for the timber yard, part of the new wharf was let as a coal yard.

Another new-build project was the construction of a dry dock at the Junction. For a time it had been apparent that there was a need for better repair facilities for barges, and some consideration was given to enlarging the existing dock at Hempsted, but the Company's engineer, W.B. Clegram, argued for a new dock at the Junction which could also serve another purpose. The Gloucester Company had long been committed to keeping the first half-mile of the Stroudwater Canal free of mud as a condition of using it as a feeder from the River Frome, and this was straining resources to the limit. The work could only be done with a spoon dredger because the entrance of the Stroudwater Canal was too narrow to admit the steam dredger, and it had to be done soon after the end of the winter rains, which was just the time the men were needed to protect the banks of the Gloucester Canal with stone. Clegram therefore proposed that a dry dock be built across the corner of the two canals, with entrances at both ends, thus providing a route for the steam dredger to enter the Stroudwater Canal and clear the mud much more efficiently. After due consideration, the proposal was accepted and the work was carried out during 1869.

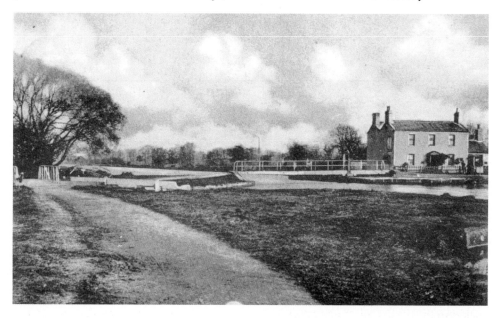

*The junction of the Gloucester & Sharpness Canal and the Stroudwater Canal c. 1900 with the Junction House on the right.*

    After completing the dry dock at the Junction, the Company's men moved on to enlarging the nearby house occupied by the official who opened the Junction footbridge and collected tolls on traffic coming from the Stroudwater Canal on to the Gloucester Canal. When the previous occupant retired in 1869, the Gloucester Company agreed with the Stroudwater Company that their man at the Framilode entrance, Matthew Peyton, would move to the Junction and act for both companies. To recognise the importance of this joint appointment, the house was enlarged by adding more rooms at the rear, and a small office was built on the east end.

    The on-going work of the maintenance men was also sometimes interrupted by the need to deal with an emergency - like when the tug *Moss Rose* crashed into a canal longboat at Two Mile Bend one evening. The longboat had not been tied up properly and had drifted across the line of the canal, so as it started to sink, the bow and stern settled on the sloping sides of the channel, leaving it completely blocking the navigation. The next morning, the Company's men brought planks, chains and winches, and the disabled boat was cradled-up between two other longboats and towed to the Victoria Dock, where the waterlogged cargo of wheat was discharged. On another occasion, the raising of a longboat full of bricks ended in tragedy. Again, two empty longboats were placed either side, and the men had nearly succeeded in raising the boat with winches and chains when a pinion on one of the winches broke, throwing more weight on to the other winches. The men in charge of one of these lost their nerve, allowing the handles to revolve with great rapidity, with the result that one man was badly injured and another was thrown into the water and drowned.

# 5

# Sharpness New Dock

The high level of traffic handled during the 1860s allowed the Canal Company to distribute modest dividends to shareholders as well as to pay off most of the debt originally incurred to finance the completion of the canal. However, there was an increasing trend for ships arriving to be so big that they could not pass through the lock into the canal and so had to discharge all of their cargo into lighters at Sharpness. The resulting congestion in the tidal basin meant that at busy times ships had to wait at the Kingroad anchorage at the mouth of the Bristol Avon until there was space for them to be admitted. In the autumn of 1868, the average delay for large ships was five days, with individual cases as long as 12 and 23 days, and the detention of outward bound vessels was nearly as great. With the expectation that foreign trade would increasingly be carried in steamers that would be even larger in size, there was a growing appreciation of the need for a larger entrance.

While discussions about such an entrance were going on, the current difficulties were highlighted when the schooner *Vigilant* sank in the tidal basin. After several days, it emerged that her insurers were not willing to do anything, and it was the Company's men who had to use all their skills to move her out of the way. A few months later, the *Emily Flynn* was told not to come to Sharpness for fear she would stick in the mud in the basin, as no scouring had been possible due to its continual occupation by vessels too large to lock up. Arrangements were hurriedly made to lighten the vessel in Kingroad, and although this anchorage came under the jurisdiction of the Bristol authorities, they were persuaded not to charge any dues on this occasion.

In the light of these difficulties, the Company's engineer, W.B. Clegram, proposed a new entrance and tidal basin at Holly Hazel Pill, just over half a mile down the estuary, giving access to a huge new dock via a lock that was 320 feet long and 57 feet wide - about twice the dimensions of the lock at the existing entrance. Clegram worked with consulting engineer Thomas Harrison to produce plans in sufficient detail to estimate that the cost would be £150,000 plus an additional £12,000 to provide a dry dock. Taking account of the healthy financial state of the Company and the growth in traffic that the new facilities were expected to bring, the shareholders approved the proposal, and an Act was obtained in 1870 to authorise raising the additional capital needed. The Act also authorised the Company to charge a toll

on the registered tonnage of vessels entering the new dock (as well as on the cargo carried). In addition, the Act changed the Committee of Management elected every six months into a Board of Directors of which only one third had to seek re-election each year, and it tidied up various other financial and administrative matters. The first chairman of the new board was William Philip Price, a leading partner in the timber importing firm of Price & Co., Member of Parliament for Gloucester and chairman of the Midland Railway Company. In practice Price was mainly a figurehead, and it was the corn merchant William Charles Lucy who was the effective leader, taking over as chairman in 1872.

The contract for the new dock was awarded to George Wythes, an experienced contractor who had just completed a dock extension in the Isle of Dogs. Once the land was purchased, mostly from Lord Fitzhardinge, the site was fenced, trees were cleared and excavations began. The site was a natural valley, and a crude railway line was laid along the bottom to carry away the spoil. Gangs of navvies filled barrows and tipped them into wagons, which were drawn away by little puffing locomotives that wobbled about over the rough ground. Some of the spoil was used for making bricks and the remainder was distributed around the periphery of the site. Other lengths of line were laid to move blocks of stone discharged from barges on the canal, some weighing as much as twelve tons. Steam powered cranes were available for lifting the big stones and pieces of iron for the gates. Brick and lime kilns and mortar mills were set up on site and portable steam-engines were used to pump water from the workings. During the first year of the project, the Canal Company built four pairs of semi-detached houses for lockmen and other key workers in what became known as Dock Row, and one of these was initially used as an office for the contractor. The existing houses for

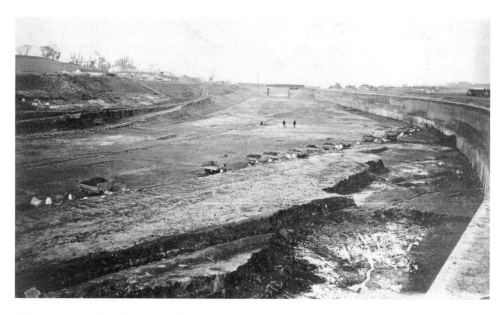

*The excavation for the New Dock at Sharpness in November 1873.*

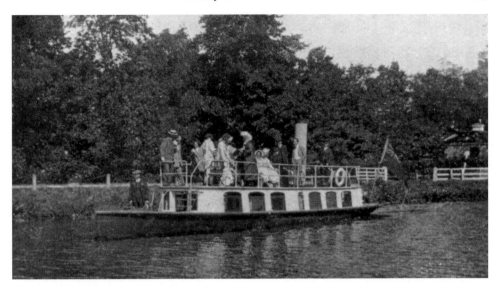

*The Canal Company's steam launch* Sabrina *with a party of directors and their ladies.*

lockmen were demolished to make way for the cut between the canal and the new dock. To help W.B. Clegram supervise all this work, the Canal Company purchased a steam launch from Fielding & Platt of Gloucester in 1871. Named *Sabrina*, this was much used by the Engineer to visit Sharpness and elsewhere from his base at Saul Lodge, and it was also used by the directors who held meetings on board while on their way to inspect the new works.

At various places around the site at Sharpness were rows of huts for the navvies, each row containing from twenty to fifty huts. The walls were of turf up to two feet thick, with openings for windows and doors, and the roofs were made of boards covered by roofing felt, with arrangements for collecting rain water. Each hut had three rooms: a kitchen in the centre for the husband and wife in charge, their sleeping apartment on one side and a bedroom for eight or ten men on the other side. It was usual for each man to bring his own food which could be wrapped in linen and steeped in the communal copper. Local traders quickly established shops selling provisions, but some navvies preferred to take their chances in the neighbouring game preserves of Lord Fitzhardinge. The demand for beer was met by opening the Oldminster Inn in a former farm building and the Shanty or Shant on the cliff overlooking the canal, the name being common for a doss-house cum beer-house for navvies. The bar of the Shanty had portraits of two gentlemen hanging on one wall with two cases of stuffed birds and animals nearby, and there was a large open fire which was much appreciated by the landlord's dog.

Many local men were employed on the works, and they toiled alongside experienced navvies who had moved from other construction projects. Unfortunately, in July 1871, one man from the north was found to be suffering from smallpox, and although he was quickly placed under medical care, several others caught the disease and two

died. It was reported in Gloucester that so many good workmen were driven away by this that the rate of progress was halved, and the Mayor advised people not to visit Sharpness. This prompted the proprietors of the steamers on the canal to point out that the smallpox was not at Sharpness where their passengers disembarked but over the hill at Holly Hazel Pill. They added that the outbreak had been quickly contained and that the reason men had left the site was to gather in the harvest. Certainly, the scare was soon over, and many Gloucester people subsequently travelled on the steamers to witness the progress of the project.

While the dock itself was being excavated, work was also underway on the associated structures. The lock chamber and the abutments for the entrance gates to the tidal basin began to take shape, and the stonework of the dry dock and of the swing bridge at the top end of the dock was put in place. The north west side of the dock was left with a shelving bank, but in a change from the original plan, a huge quay wall was built along the full length of the south east side of the dock. Two great wooden piers over 100 yards long were constructed out on the foreshore, requiring the blasting of holes in the solid rock and the fixing of beams into them with concrete. Further blasting was required to create an entrance channel between the piers. This could only be done at low tide, and the work was delayed in 1872 because the tides did not ebb out as far as usual owing to a large quantity of flood water coming down the river. More delay was caused by men again leaving the work at harvest time, and there was growing concern about the slow progress being made by Finch & Co. of Chepstow in providing the ironwork for the lock and entrance gates. In a second change of plan, it was agreed to provide timber jetties in the tidal basin to prevent vessels getting on the sloping sides.

While the great works at Sharpness were going on, the Canal Company made their last debt repayment to the Pelican Insurance Office, and they embarked on a remarkable programme of investments aimed at promoting and servicing traffic through the new dock. To secure a waterway route right through to the Midlands, in September 1873, the shareholders agreed to purchase the Worcester & Birmingham Canal Company, which had for some years been in danger of coming under railway control. Two months later, the shareholders agreed to invest £50,000 in the Severn Bridge Railway Company, led by the Canal Company chairman W.C. Lucy, which planned to build a line that would bring Forest of Dean coal to Sharpness for export. Also in November, the Company purchased a steam dredger from the Witham Drainage Commissioners that was bigger than the existing dredger and would dredge to the full depth of the new dock. In the following month, to ensure improvements in the towing service on the canal, the directors opened negotiations with Timothy Hadley for the purchase of his tugs. In addition, to ensure the railways around the docks at Gloucester could be used more efficiently, the directors agreed to purchase the lines from the Midland Railway. Finally, knowing that the operation of the new lock would consume much more water, W.B. Clegram drew up plans to take more from the River Frome. To obtain the necessary powers and to authorise raising the finance for all these initiatives, a Bill was prepared for approval by Parliament.

*The Low Level Bridge at the north end of Sharpness New Dock in November 1873. On the left is the caisson gate for the dry dock which also fitted the opening under the Low Level Bridge.*

The proposal to improve the water supply to the canal ran into opposition from local landowners, because Clegram also wanted to raise the level of the River Frome and of the canal in order to allow deeper draught vessels to pass, and this raised fears that neighbouring land would be more susceptible to flooding. Following delicate negotiations with Lord Fitzhardinge and others, Clegram managed to obtain agreement to the canal level being raised by six inches in return for the Canal Company agreeing to keep open certain local drainage channels and pay damages to the owner of Fromebridge Mill for the increased level of its tailrace. To ensure the water did not rise more than the intended six inches, the Canal Company agreed to a maximum height and to minimum widths for the canal's two overflow weirs at Purton and near the Junction. A further condition was the effective removal of the weir at the mouth of the Cambridge Arm, which was of little consequence as traffic on the arm had virtually ceased in any case. Following these agreements, the Act authorising all the additional powers needed was passed in 1874, and the planned developments were mostly carried out in the following two years. Recognising the purchase of the Worcester & Birmingham Canal, the Act also changed the Company's name to the Sharpness New Docks and Gloucester and Birmingham Navigation Company, commonly referred to as the Dock Company.

Meanwhile, at Sharpness, the upper lock gates were in place and water was let into the dock in March 1874 to allow the contractor to use a dredger to clear the bank that had been left between the existing canal and the new dock. After a few days, however, a crack was observed in the massive stone coping of the wall on the north side of the lock. Fearing that failure of the wall would lead to loosing all the water from the canal, W.B. Clegram had the caisson gate of the dry dock moved to close the channel under the swing bridge, which it had been designed to fit just in case of such an emergency. Soon after this was in place, almost half of the massive stone wall on the north side of the lock fell forward with a tremendous noise, and a column of water rose from the foundations with a deafening roar. One of the upper lock gates was torn from its anchors and sluice culverts were severed. The resulting rush of water displaced one of the intermediate gates that was under construction and broke down the dam at the mouth of the tidal basin before it flowed away into the river. To make matters worse, it was realised that the hurriedly fitted caisson at the swing bridge was not watertight, and there were fears that the canal would loose all its water. After the level had dropped two feet, however, someone spotted that the sluice in the caisson had been left open, and once this was closed, the acute crisis was brought under control. Investigations showed that the cause of the failure was leakage of water through fissures in the underlying rock which had been believed to be sound. The remedy was to put a brick invert in the bottom of the lock before rebuilding the damaged wall.

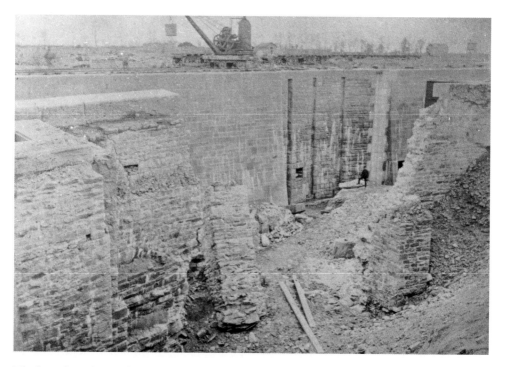

*The breach in the north wall of the new lock at Sharpness in March 1874 with a man standing in the lock chamber.*

Repairs to the lock were soon underway, and by the autumn it was possible to let the water into the dock again while work continued on clearing the channel outside the entrance. Eventually, the formal opening of the New Dock took place in the pouring rain on 25 November 1874. Early in the morning, directors and officials of the Dock Company were joined by several hundred spectators, some of whom had witnessed the opening of the old entrance almost fifty years earlier. As the time of high tide approached, the barques *Director* and *Protector* were seen coming up the river, their yards adorned with flags, each being towed by a tug with another alongside. The *Director* was turned to stem the tide and then brought broadside on to the end of the north pier. After a short delay while the force of the tide eased, the tug *Milo* steamed ahead and brought the *Director* into the tidal basin - to be greeted by the cheers of the spectators. Then it was the turn of the *Protector*, and as she entered, her crew fired a salute from her two guns and again the spectators cheered. Once both were in the tidal basin, the entrance gates were closed, and the two vessels were locked up into the dock. It must have been a proud day for W.B. Clegram who had carried the main responsibility for supervising the design and construction of this major project. The *Director* was later the first vessel into the dry dock.

The general air of confidence that had inspired the great works at Sharpness also stimulated merchants to build more corn warehouses. While the New Dock was under construction, two were erected at Gloucester: the Alexandra Warehouse was built near the large dry dock for J.E. & S.H. Fox, and the huge Llanthony Warehouse was built just south of the Barge Basin for Wait James & Co. Once the New Dock was completed, however, attention moved to Sharpness. W.C. Lucy led the way by erecting the Pioneer Warehouse near the south end of the dock in 1875, and over the next year another big warehouse was built for S.H. Fox & Co. and a smaller store for the Severn Ports Warehousing Company (formed by millers from Wiltshire and Somerset). These were soon followed by two more big warehouses near the north end of the dock for Fox & Co. and Severn Ports. The Sharpness warehouses were fitted with conveyors and elevators driven by a steam engine so that corn could be readily moved from the quayside to any floor. As well as these big warehouses, an iron transit shed was built by the Dock Company, a smaller shed by the Severn Ports Warehousing Company and two sheds for guano by S.H. Fox & Co. Timber merchants were less keen to establish premises at Sharpness, and initially it was only Booth & Co. who leased land there and opened an office. All these premises were served by railway lines owned by the Dock Company that were joined to a new branch of the Midland Railway, and a temporary passenger station was opened on 1 August 1876.

The opening of the New Dock immediately brought an end to the overcrowding of the original entrance and provided ample space for the largest ships of the day to discharge their cargoes. In the first year, sixteen large vessels arrived with over 1000 tons of timber each, particularly from Canada, and nine brought over 1000 tons of corn, particularly from American and Black Sea ports. A further 13,000 tons of corn were brought by seventeen steamers which would have been too large for the old entrance.

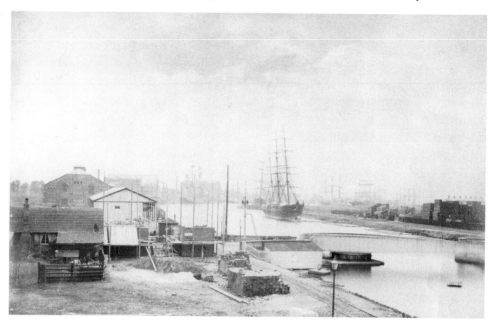

*Ships using the New Dock at Sharpness in July 1877. The Severn Ports Warehousing Company's first store is on the left with Fox & Co's and Lucy's warehouses in the distance. The white building is the Dock Company's iron transit shed.*

Merchants who did not have premises at Sharpness still expected cargoes to be delivered to Gloucester, and for big ships this meant transhipment of at least part of the cargo into lighters provided by Mousell & Co. or by the merchants themselves. Initially there was a great shortage of labour at Sharpness due to its isolated situation, far from any significant centre of population, and many of those who did seek work there had to sleep rough during the week, only returning to their homes at weekends. Consequently, vessels only had enough cargo lightened to suit the depth of water in the canal, and some huge vessels then continued to Gloucester to finish unloading. As ever larger ships arrived at Sharpness, however, so more transhipment was needed, and the greater use of lighters put an added strain on the existing tugs. The Dock Company had taken over five tugs from Timothy Hadley, namely the original three, *Moss Rose*, *Mayflower* and *Violet*, and the later *Myrtle* and *Hazel*. To handle the extra traffic, they purchased *Speedwell* from G.K. Stothert & Co. of Bristol in 1876.

The arrival of larger ships coming from distant continents reduced the number of smaller vessels visiting the port, and this had an effect on the shipment of salt for export. Instead of loading a few hundred tons into vessels alongside their stores at Gloucester, salt merchants increasingly had to arrange for consignments of around 1,500 tons to be delivered to Sharpness for ships sailing to places like India or Australia. These consignments were sent by canal longboat or barge direct from the salt works, providing yet more work for the canal tugs, but the use of the stores at Gloucester declined.

The canal tugs also had to tow Severn trows using the canal on regular voyages between Bristol and the up-river towns, although the number of these was reducing due to competition from the railways. One by one, the carrying firms went out of business or amalgamated with rivals until in 1874 the last two, Danks & Sanders and Fellows & Co., combined to form what became known as the Severn & Canal Carrying Company. The new company had a dozen sailing trows, half a dozen lighters which did not go out into the river and about fifty canal longboats which carried cargoes into the heart of the Midlands. Inward cargoes included groceries, grain, timber and ore, and outward cargoes included bar and hoop iron, hardware and bricks.

Many of the big ships arriving were built of iron or steel which required new skills for repair and maintenance. To meet this need, ship smiths and engineers set up businesses near the dry dock and offered their services when required. When a plate needed replacing, the rhythmic clanging of the hammers could be going all day as one man pushed a red hot rivet through from one side and another hammered it from the other side.

When a big ship arrived at Sharpness carrying grain, dockers were employed to shovel the bulk grain into sacks so that it could be lifted over the side into a lighter or transferred to a warehouse. On a sailing ship, the lifting was initially done by manually operated winches, but some of the labourers would only work when and how they chose. Sometimes they had to be fetched from public houses in a state of intoxication, and the resulting delays led to complaints from ship owners. To alleviate the difficulty, in 1878 John Chadborn introduced floating steam-powered winches

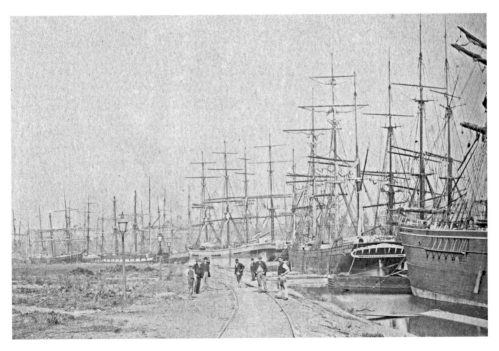

*A forest of masts at Sharpness in August 1880, including the Norwegian barque* Thalassa *(second left) which had brought timber from Quebec.*

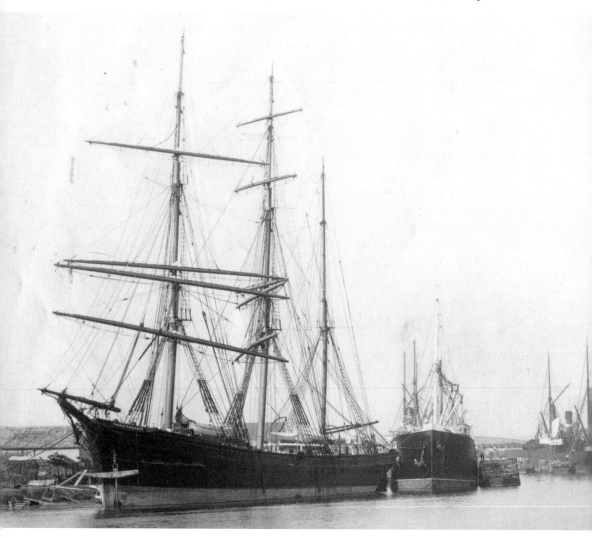

*Ships at Sharpness in September 1898. On the left, the barque* Thomas Faulkner *of Cardiff brought 1750 tons of deals from Canada.*

which could go alongside a ship and use the power of the steam engine to speed up the discharge of cargo. Unfortunately, one such winch called *Argo* met a dramatic end one evening when the boiler had not been properly banked up and the safety valve was set too high. The force of the resulting explosion was so great that parts of the boiler were blown over a steamer lying alongside, one part landing on top of a grain warehouse 70 feet high. Windows in the warehouse were broken, nearby ships were damaged and the *Argo* sank immediately.

The demand for local accommodation at Sharpness had stimulated a number of developments to cater for key workers. In 1876, the Dock Company built a detached house for the Harbour Master at the west end of the existing semi-detached houses

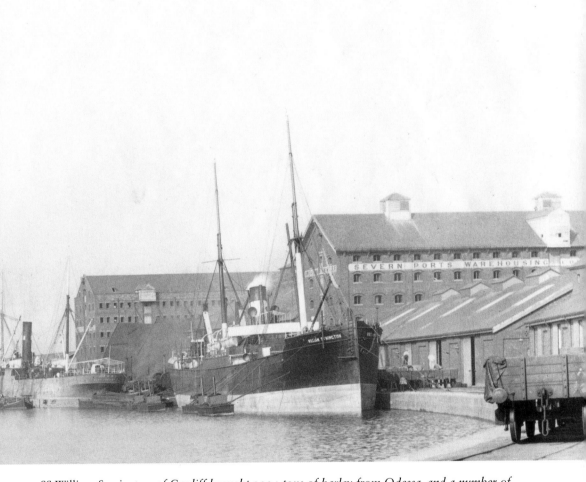

*SS* William Symington *of Cardiff brought 2394 tons of barley from Odessa, and a number of floating steam winches are alongside to help with the discharging.*

in Dock Row, leaving his former house beside the old entrance to be occupied by his deputy. The Company also built a dozen terrace houses at the east end of Dock Row and nineteen terrace houses in Severn Road and Great Western Road on the other side of the dock. Some of these new houses were allocated to Dock Company men, but most were occupied by customs officers and key employees of private firms around the docks. The semi-detached house in Dock Row that had been the contractor's office was set up as the Dock Office and Post Office, with the Dock Company's clerk also serving as the sub-postmaster and living in the other half of the building. These building initiatives by the Company were soon followed by private landlords and individuals building houses to the south of the docks in the area that became known as Newtown.

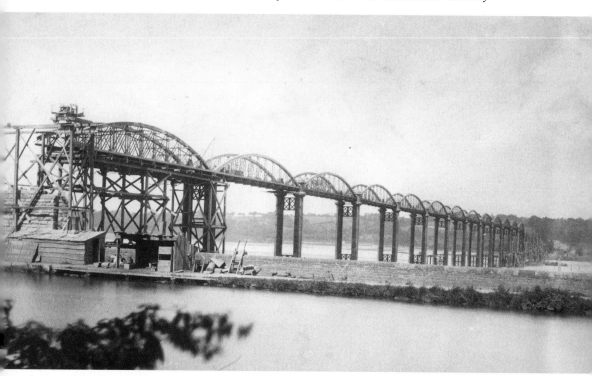

*The Severn Railway Bridge under construction in August 1877 with the canal in the foreground.*

In addition to the houses, new shops and other facilities were also set up at Sharpness. As there was no other gas supply to the area, the Dock Company built their own works beside the junction between the canal and the New Dock. To provide some accommodation for labourers, the Dock Company erected a sleeping house with a dormitory and reading room to the north east of Dock Row. Also Matthew Gardner established the Bridge Coffee House, to the west of the swing bridge over the dock, to provide non-intoxicating refreshment and accommodation for working men. In 1877, an iron church was erected at the east end of Dock Row, and later two non-conformist chapels were opened in Newtown. The former navvies' Shanty became the Sharpness Hotel (although it was still known locally as the Shant) and the Pier View Hotel was built in Newtown. As customers were leaving the Pier View Hotel one evening in June 1878, a fight developed between a group of foreign sailors and several local residents which led to the fatal stabbing of one young resident. At the subsequent inquest, witnesses told conflicting stories, and the jury returned a verdict of murder by a person or persons unknown.

At the same time as the New Dock and its associated community were getting established, work was underway to build the huge Severn Railway Bridge across the River Severn half a mile north of Sharpness to provide the docks with an economic supply of coal from South Wales and the Forest of Dean. The long-standing shortage

of export cargoes made the port of Gloucester unattractive to shippers, and it was expected that a good supply of coal would help to correct this and provide fuel for the steamers that were increasingly coming into service on the ocean trade routes. The bridge contractor established a depot beside the cut from the canal into the New Dock where components were prepared for shipping out to the construction site. The bridge was three-quarters of a mile long with twenty-one bow string spans, supported on cast-iron columns sunk into the river bed, and with a steam-operated swing bridge over the canal supported on a masonry tower. By arrangement with the Dock Company, the eastern abutment of the swing bridge was given an extra arch to provide access along the canal bank to the lie-bye at Marshfield, 700 yards to the north. South of the bridge the line divided, with one branch crossing a high level swing bridge over the cut into the New Dock to serve several planned coal tips. Spoil from a deep cutting between the two bridges was deposited behind the gardens of Dock Row to carry a shunting line serving the coal tips. A second line continued south to a junction with the Midland Railway branch serving the New Dock, and a permanent station for Sharpness was built on this line. The bridge across the river was formally opened on 17 October 1879, when a special train carrying dignitaries stopped on the bridge and the chairman of the Bridge Company, W.C. Lucy, symbolically tightened the last bolt. After the ceremony, 400 guests made their way to a large marquee on the Pleasure Grounds at Sharpness where they enjoyed a luncheon and listened to speeches.

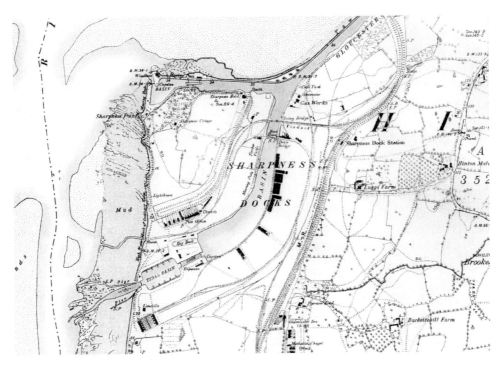

*Sharpness Docks in 1879, showing the four big warehouses end on to the New Dock, the railways, some houses and the trees of the Pleasure Grounds overlooking the old entrance.*

The plan was for the new railway to serve three coal tips on the cliff overlooking the arm leading to the old entrance. To prepare for this, the Dock Company set about widening and deepening the arm, which involved much blasting of the rock. Holes were bored in the rock by men standing on floating stages working levers connected to underwater drills, and explosives were inserted into the holes and set off electrically. Over 40,000 tons of rock were removed, but in the event only one tip was built by the Severn Bridge Company, and this was brought into use in January 1880.

Meanwhile at the Gloucester end of the canal, there was concern each summer about nude bathing in the canal, particularly in the area around Hempsted Bridge. Letters to the editors of the local papers complained that naked men and boys were in the habit of running on the canal banks and swimming round the passenger boats. The Dock Company established a bye-law limiting the time for bathing to early mornings and late evenings, but when six boys were prosecuted for bathing during prohibited hours, the county magistrates considered that the Company's Acts did not give them the authority to make such a bye-law. By chance the Company were seeking Parliamentary approval for various financial matters at the time, and by inserting an appropriate clause in the Bill, the resulting Act in 1879 gave them specific authority to control bathing, and the bye law was re-established.

In early 1881, traffic on the canal was completely halted by a very severe frost, in spite of efforts by the tugs to break the ice. A schooner being partially discharged of cotton cake into railway trucks at Llanthony Quay became trapped in the ice and could not be moved across the canal to continue unloading at Foster Brothers oil mill. To avoid carting the cargo a quarter of a mile, the dockers laid a run of planks on the ice and the cargo was carried across by men. Only a few months earlier, the tenant of a low-lying field called Monk Meadow (on the west side of the canal one third of a mile below Llanthony Bridge) had arranged for a sluice to be installed in the canal bank so that the field could be flooded, and he was able to make good money by providing skating facilities which even attracted parties from Cheltenham. Later in 1881, a timber pond was brought into use at Two Mile Bend where baulks and logs could be left afloat without obstructing the canal. Clay had been dug there over a number of years for use in brick-making, and it only required the dredger to remove the bank between the pit and the canal to provide a valuable new amenity for the timber trade. One merchant who probably made early use of the pond was Samuel Moreland, as he was importing aspen logs to make match splints at his factory in the Bristol Road, and he needed to keep them damp to avoid them drying out and cracking.

# 6

# Set-back and Recovery

The remarkable burst of expenditure authorised during the 1870s resulted in the capital invested by the Dock Company being more than doubled from £475,000 in 1870 to £1,068,000 in 1878. Such was the expectation of future profits that, over the same period, the price of the Company's ordinary shares rose from £23 to £72. For a few years, there was a marked increase in foreign imports reaching Gloucester, but the optimism did not last long as new docks were opened at Avonmouth and Portishead, down river from Bristol. The new docks offered very low charges to attract trade, and in 1881 the Dock Company was forced to announce large rate reductions on corn and timber to remain competitive. After a year, the almost ruinous competition was mitigated by an agreement with the Bristol dock companies, but trading conditions remained difficult, and the Dock Company's share price fell back to around £20 again.

One helpful development during this difficult time was the beginning of a new source of traffic arising from the import of petroleum products from America by two Bristol firms. F.F. Fox & Co. built a large store on the north-west side of Sharpness Dock and a smaller one at Gloucester, and Colthurst & Harding converted the former Droitwich Salt Company's store near Hempsted Bridge. The two firms mainly brought in barrels of lamp oil, but there were some consignments of the more inflammable naphtha. The trow *Resolution* carrying one such cargo was involved in a tragic accident after being moored in the lock at Sharpness overnight. When a lockman came looking for the vessel's watchman in the morning, he heard groans coming from on board. He lowered a lamp into the cabin to see what was wrong and set off a terrific explosion which was followed by a fire. The lockman survived, but the charred remains of the watchman were later found in the burnt out wreck.

Competition from Avonmouth and Portishead at the mouth of the Bristol Avon meant that traffic through Sharpness was not as high as had been expected. Although the New Dock could accommodate the largest ships of the day, deep draughted vessels could only enter around the time of the high spring tides and often had to wait for days in the Kingroad anchorage. To minimise the delays, Mousell & Co. sent down lighters to lighten grain ships enough for them to be able to enter Sharpness, and the Dock Company accepted lower tolls to compensate for the additional costs. Nevertheless, some owners tried to avoid their ships being chartered for Sharpness, particularly steamers which needed to be kept on the move to remain profitable.

*Sharpness dock viewed from the lock in September 1892. In the left distance are the Severn Ports Warehousing Company's A Store and B Warehouse. The stern of the vessel on the left obscures the view of the North Warehouse.*

*In the centre, the four-masted barque* Fort George *of Glasgow is moored near the Albert Warehouse, and to the right SS* Hatfield *of West Hartlepool is moored near the Pioneer Warehouse.*

When large ships were approaching Sharpness, much reliance was placed on the skill of the local pilots. After Albert Everett successfully docked the 2,000 ton steamer *Inchmaree* after the spring tides were past their peak, rather than loose her to Avonmouth, the merchants gave him an engraved silver cup and a purse containing seven guineas.

As the trend towards larger ships continued, more transhipment to barges took place at Sharpness and some cargoes were sent on to the Midlands by rail, leading to concern about Gloucester being bypassed. Even owners of smaller steamers persuaded some merchants to allow discharge at Sharpness to avoid the delay in passing up the canal, but when the owners of the SS *St Hilda* tried this in November 1882, corn merchant W.K. Wait insisted that her cargo was delivered to Gloucester in accordance with the charter agreement. To save unloading time, Wait organised seventy men and three steam winches, and they discharged 600 tons of wheat in one day. Wait later referred to this concern of his to promote the commerce of Gloucester when he was seeking election as Member of Parliament for the city. This stand helped to maintain the practice of ships bringing as much cargo to Gloucester as possible, and only lightening what was necessary at Sharpness, with the consequence that large ships became a more frequent sight in the Main Basin at Gloucester. An extreme example of this occurred in the summer of 1885 when three huge barques, each capable of carrying over 1100 tons, arrived with wheat from Port Pirie in South Australia. Nevertheless, some ships arriving at Sharpness really were too big to proceed up the canal and had to have all of their cargo discharged at Sharpness, and occasionally one was so long that it would not even fit into the normal lock and so needed the whole of the tidal basin to be used as a lock.

The general increase in the size of ships meant that the export trade in coal brought over the Severn Railway Bridge was not as great as had been hoped. Many ships were either too deep when loaded or too long to use the tip in the arm leading to the old entrance. As the Dock Company was therefore loosing money on its investment in the Bridge Company, some of the directors, led by chairman W.C. Lucy, supported a controversial scheme intended to generate more traffic over the bridge. The scheme proposed by the Midland Railway Company was to replace the Thames & Severn Canal with a railway that would link with the bridge and provide a new route for carrying coal to London. However, in 1882 a small majority of Dock Company directors considered that it was more important to keep the Thames & Severn Canal open. This prompted Lucy to resign, and he was replaced as chairman by A.J. Stanton. The new leadership adopted a different approach to encouraging traffic over the bridge by building a new coal tip with a deep water berth on the west side of the New Dock in 1885. However, although this meant that even the largest ships could load coal, not many did so because of concern about a heavily loaded ship being delayed until the next spring tides. The new tip was useful in supplying bunker coal for steamers that were proceeding direct to foreign ports, but the export trade never reached the levels that had been expected.

In the middle of these difficulties affecting traffic through Sharpness, the Dock Company's engineer, W.B. Clegram, was forced to resign in 1885 due to ill health. As

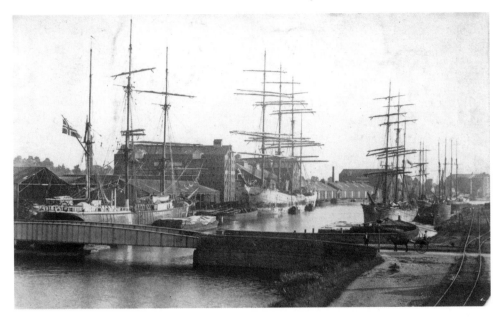

*Sharpness dock viewed from the High Level Bridge with the Low Level Bridge in the foreground and the North Warehouse on the left.*

clerk and then as engineer, he had given invaluable service for over fifty-five years, and he had also become effective general manager as the role of the Company had expanded in recent years. To replace him, the directors appointed his nephew Frank Jones as resident engineer under the supervision of consulting engineer G.W. Keeling, who had been responsible for the Severn Railway Bridge. At the same time they created a temporary post of traffic manager for John Dixon who had been successful in building up trade at the rival port of Avonmouth.

Dixon quickly produced a comprehensive report suggesting developments that would help to increase traffic, including ways of improving access to Sharpness and providing better cargo handling facilities. Meanwhile other voices were advocating unrealistic schemes for a new dock at Shepperdine, five miles down the estuary from Sharpness and for the improvement of the whole waterway route through to Birmingham. Although the Dock Company had little money for implementing any changes in the short term, many of Dixon's recommendations were eventually carried out, at least in part. Dixon was also responsible for introducing regular steamers between Gloucester and Antwerp and Rotterdam, operated by the Bristol Steam Navigation Company. These were close to the limiting size of what could pass up the canal, and they carried large quantities of sugar and a wide range of general cargoes which were a welcome supplement to the traditional imports of corn and timber. These regular visitors contributed towards the cumulative registered tonnage of steamers with foreign imports overtaking that of sailing ships by 1887. Dixon resigned after his two year appointment was completed, and a year later the Company secretary, Henry Waddy, was promoted to the new post of General Manager.

A potentially serious incident occurred in May 1886 when the river at Gloucester rose more than two feet above the level of the canal. The problem was that the stop gates that would normally have been closed to keep the river water out of the dock had been removed, and their replacements had not been installed. As the water rose, there was great concern that the cellars of the dock warehouses and the low lying timber yards beside the canal would all be flooded. However, newly appointed engineer Frank Jones just managed to keep the water out by inserting baulks of timber to prop the lower lock gates closed even though they had never been intended to withstand any pressure from the river. He later calculated that at the peak of the flood the reverse load on the gates was 35 tons, but his emergency measures worked and the gates held.

Over the years, there had been a number of major slips in the banks where the canal passed through cuttings, particularly on the oldest section where the slopes had been dug rather steeply. In these cuttings, the towpath could be ten to fifteen feet above the water level, and in 1887 Frank Jones set about reducing the load on the lower banks in vulnerable places by cutting away material and lowering the towpath to about four feet above water level. The work started with the high bank to the north of Hempsted Bridge and continued with the bank to the north of Sellars Bridge. Initially, the actual work was done by the ballast contractor, George Beard, but after a couple of years the Dock Company took over the work themselves, including the transport of the clay to Sharpness to provide ballast for ships departing without a cargo. Vessels leaving for local ports like Cardiff loaded a weight of this clay equal to about ten per cent of their registered tonnage, whereas for those going deep sea, the figure was usually between twenty and thirty per cent. As well as lowering the towpath north of Sellars Bridge, some of the bank behind was also dug out to be burnt with the aid of coal to produce an inert material for spreading on the towpath. This burning was a smelly process, and it had to be stopped prematurely in 1890 because of objections from Mr Lloyd Baker of nearby Hardwicke Court. The workmen were therefore switched to lowering the towpath in the cutting between Sims and Rea Bridges, although much more material was removed from near Sellars Bridge in later years.

During the 1880s, the Dock Company explored various ways of improving efficiency, and one particularly controversial topic concerned the location of the engineering staff and maintenance workshops. These were nominally based at Saul Lodge, but over the years, additional facilities had also been established at Gloucester and at Sharpness. To reduce manpower and improve efficiency, the directors proposed moving the Saul Lodge staff and workshops to Gloucester, where a rail connection could be provided. This was opposed by the engineers, who favoured retaining a central location, or as second choice a move to Sharpness, but the directors would not listen. After much discussion, Saul Lodge was sold and new workshops were built behind the dry docks at Gloucester in 1891, but the engineers managed to retain a small central maintenance team by basing them at the Junction.

At the start of the 1890s, traffic prospects were looking good again, and thoughts turned towards the provision of more facilities. Learning from the evident convenience of low level storage buildings at Avonmouth, the Dock Company relaxed their

*Deal carriers on the west side of the canal with Foster Brothers oil and cake mill in the background c. 1910.*

former requirement for multi-storey warehouses, and the Severn Ports Warehousing Company built two substantial single storey sheds at Sharpness. Meanwhile, the Dock Co. started to develop land for the timber trade at Monk Meadow on the west side of the canal approaching Gloucester.

To make the best use of the land at Monk Meadow, the Dock Co. arranged for the construction of a short arm off the main canal that was completed in 1892. Most of the excavation was done in the dry behind the protection of a clay bank along the canal frontage which was later removed by the Dock Company's Witham dredger. Thomas Adams & Sons established a timber yard and saw mill on the north side of the new dock, and other timber merchants occupied land to the south. This new development was served initially by a branch of the Great Western Railway, but several years later the Midland Railway also obtained access by building a swing bridge across the canal near to Hempsted road bridge.

The use of the Dock Company's dredger in finishing the construction of Monk Meadow Dock helped Frank Jones to get authorisation for an improved means of

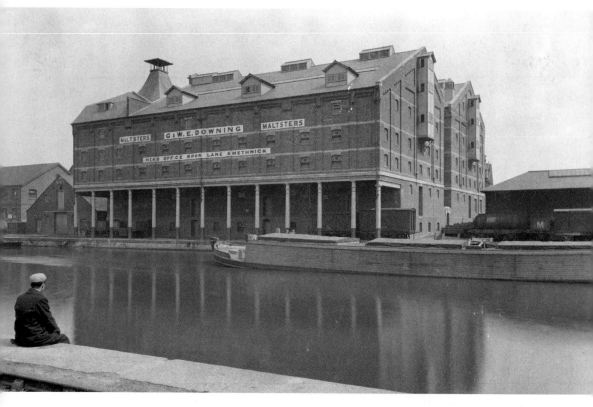

*Downing's malt-house on Bakers Quay when new in 1901. To the right is the huge barge Queen used by Foster Brothers as a floating warehouse for their oil seeds.*

disposing of dredgings. The usual practice had been to take the mud in an open boat to the disposal site, where it was discharged by manual labour. For the Monk Meadow job, following a practice already in use on the Worcester & Birmingham Canal, the Company purchased a pontoon crane from Stothert & Pitt and 36 iron mud boxes, twelve of which could be carried in one boat. With this equipment, it was the boxes that were filled with mud, and then each was lifted out by the crane and tipped at the disposal site, with a very great saving of labour. The method proved so successful that more boats were fitted with mud boxes, and it became the standard means of disposing of dredged material.

Although some recognised the greater long term potential at Sharpness, developments continued at Gloucester throughout the 1890s. Dock Company men were involved in deepening the lock at Gloucester as part of a major programme of improvements carried out by the Severn Commissioners to accommodate larger barges on the river. Timber merchants Price Walker & Co. sold their premises on Baker Quay and expanded their smaller yard further down the canal, where they built a fine new saw mill. To cater for the growth in imports of large baulks of timber that needed to be kept moist to avoid them drying out and cracking, the Dock Company excavated a timber

pond just to the south of Monk Meadow Dock, and merchants rented space there. Price Walker & Co. later formed a channel through their yard, known to the men as the Suez Canal, so that the baulks could be floated across from the pond and right up to their mill. Following Price Walker's move from Bakers Quay, Sessions & Sons built a slate works there and Downing's of Smethwick built a large extension to their existing malt-house. After this, most further developments were concentrated at Sharpness.

As the number of large ships arriving at Sharpness continued to increase, so there was pressure to help vessels navigate the difficult channel in the estuary from the anchorage at Kingroad. A few years after the New Dock was opened, the Dock Company had put up a small lighthouse on the cliff to the north of the entrance and a light on the end of the north pier to show the line of the deep water channel approaching the entrance. Other lights were set up by the Pilotage Board with money from the Dock Company, but with maintenance to pay for and improvements needed, it was agreed to seek approval for a new body that could charge tolls. Thus the Sharpness Lighthouse Trustees were set up in 1889, and in the following year, they evolved into the Gloucester Harbour Trustees who had additional powers to administer other aspects of navigation in the estuary approaching Sharpness. By this means, the lighting was so much improved over the next few years that almost as many vessels arrived and departed on night tides as by day. The Harbour Trustees also went on to lay moorings at Northwick Oaze, to the south of the Aust ferry, where large ships could be lightened more conveniently than in the Kingroad anchorage, and they blasted a channel through the Bull Rocks off Berkeley Pill to allow large ships to reach Sharpness on smaller tides.

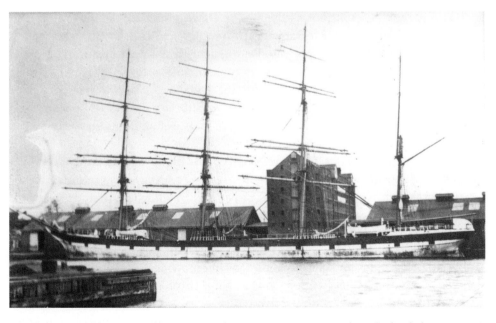

*The four masted barque* Loch Carron *at Sharpness in May 1895 when she loaded 2800 tons of salt for Melbourne.*

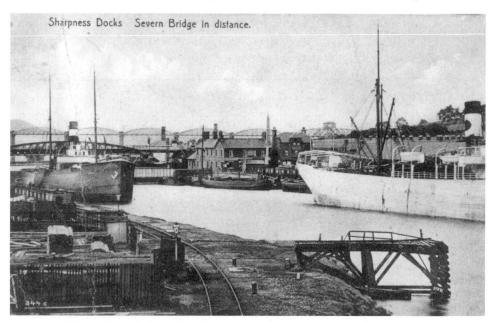

Sharpness Docks   Severn Bridge in distance.

*The north end of Sharpness New Dock c. 1910. The jetty in the foreground was built to serve F.F. Fox's petroleum stores.*

While these improvements were being made in the approach to Sharpness, the Dock Company considered how the entry of vessels into the dock could be done more efficiently. The main difficulty was that the time available for the exit and entry of large vessels could be as little as 35 minutes on a high spring tide, because of the time it took to open and close the entrance gates and the need to maintain a high water level in the tidal basin to prevent vessels grounding. It required four to six men on each side to work the huge gates, taking 15 to 20 minutes to open them and 10 to 15 minutes to close them, and it was only after the gates were closed that the men could start to pass the arrivals through the lock. Once the arrivals were eventually moored in the dock, the men might only get a few hours break before they were needed again to pass out vessels leaving on the next tide.

Harbour Master Capt. Calway considered that these arrangements were not acceptable, and he thought that the situation was likely to get worse as traffic continued to increase. He therefore advocated the provision of hydraulic power which would open and close the gates in two minutes, allowing more time for vessel movements and permitting some men to be working the lock while others were at the entrance. After much discussion, the directors agreed, and hydraulic equipment was installed by Sir W.G. Armstrong & Co. in 1893. This comprised a steam engine and accumulator in a building to the south of the lock, with underground pipes leading to hydraulic cylinders working the entrance gates, lock gates, sluice gear and capstans for moving vessels in and out of the lock. As well as helping with the passing of vessels, this also eased the work involved in scouring the entrance to control the mud that tended to accumulate.

The use of hydraulic power allowed more time for vessel exit and entry, but it was still difficult for ships to turn from the channel into the entrance, particularly if one was needing to enter before high water in order to allow another to follow on the same tide. Large vessels generally aimed to arrive shortly before the peak of the tide, turn to stem the last of the flood and then go alongside the point of the north pier to land ropes there, but it was a difficult operation and much time could be lost in getting it right. The difficulties were highlighted in August 1893, when SS *Louisiana* was stranded on the mud outside Sharpness for one tide following a misunderstanding of the signals between the pilot and the Harbour Master, and again in December when SS *Northern* went on the rocks and tore a hole in her hull. As an interim measure, in response to a request from the pilots, the Harbour Master was authorised to give them, by telephone to Portishead, information about the heights of recent tides and what he expected at the next tide. Then to tackle the real problem, the Dock Company set about extending the south pier further out into the channel, so that it would break the force of the tide flowing past the north pier, and they extended the north pier in a northerly direction so that there was a reasonable length for a vessel to come alongside while landing ropes. This work, completed in 1896, greatly eased the difficulty of entering Sharpness and made it possible for more and larger ships to visit the port in the years ahead.

The successive improvements in the approach to Sharpness in the early 1890s helped the port attract large imports of corn, but this highlighted a shortage of deep water berths in the dock to accommodate the large ships bringing the imports. To meet this difficulty, in 1896 the Dock Company had a new quay built on the north-west side between the graving dock and the new coal tip and also started increasing the depth of the dock to 25 feet. To help with the deepening, another big dredger was purchased from Bristol Docks, and the old Witham dredger was later converted into a lighter. Meanwhile, the original No.1 dredger used on the canal was rebuilt with a new hull by the local engineering company Fielding & Platt.

As business at Sharpness continued to increase in the 1890s, the Dock Company provided 28 new houses in Bridge Road and Dinmore Road to the east of the low level swing bridge over the dock. A new Sharpness Hotel was built on the hill overlooking the arm to the old entrance. This replaced the old hotel nearby that had been the navvies' Shant, and the old name then became associated with the new building. Also a new Post Office and a chemist's shop were built near the church to replace earlier wooden premises destroyed by fire.

Another development in the 1890s was the beginning of pleasure steamer trips in the estuary to places like Ilfracombe, with passengers coming to Sharpness by train and boarding at the west pier of the old entrance. On one occasion, 1600 people were waiting for a steamer which was only supposed to carry 880. In the resulting rush, over 1000 managed to scramble on board, and among those left behind were 250 who were on an excursion organised by Thomas Cook & Son and had already paid for their tickets. Following this incident, Cook & Son refunded money to those who were disappointed and gave them free tickets for another trip, and the master of the steamer was fined for overcrowding.

With corn imports booming, S.W. Lane Round & Co. from Gloucester built a single storey warehouse behind the new quay at Sharpness, and the Severn Ports Warehousing Company built a similar one on the east side. The latter became known as Klondike because it was the time of the gold rush. Unfortunately, soon after these warehouses were built, there began a period of reducing corn imports due to poor harvests in Russia and Argentina, the main sources of supply into Sharpness. This led Severn Ports, who had already taken over all the warehouses on the east side of the dock, to try to eliminate the new competition from Lane Round & Co. In 1898, they notified their customers that in future they would only deal with those who gave all their business to the firm. Lane Round complained about unfair treatment, but their business was eventually forced into bankruptcy and Severn Ports regained the monopoly of corn storage at Sharpness.

Recognising the need to match the turnaround time of steamers at ports lower down the estuary that had longer periods of tidal access, the Severn Ports Warehousing Company, with financial support from the Dock Company, pioneered the introduction of a pneumatic grain elevator in 1900. The Leitrim, a former Irish Channel packet steamer, was fitted with air pumps and pipes that could suck bulk grain out of a ship's hold and discharge it ashore or to a lighter. This was much quicker than the previous practice of dockers shovelling the grain into sacks. As well as operating in the dock, the Leitrim could travel under her own power to the moorings at Northwick Oaze and take out 2000 tons between tides, which could be enough to save a steamer waiting several days for a big enough tide to enter Sharpness. The dockers did not like this development, and about 100 men went on strike, but Severn Ports managed to discharge their ships using non-union labour and office staff until a settlement was reached.

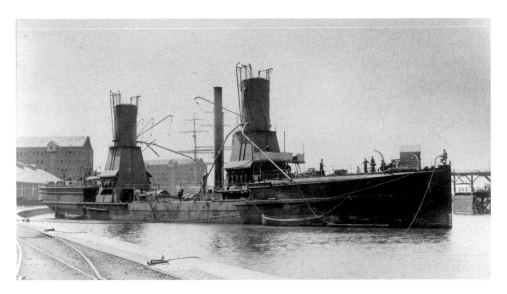

*The pneumatic grain elevator* Leitrim *c. 1900.*

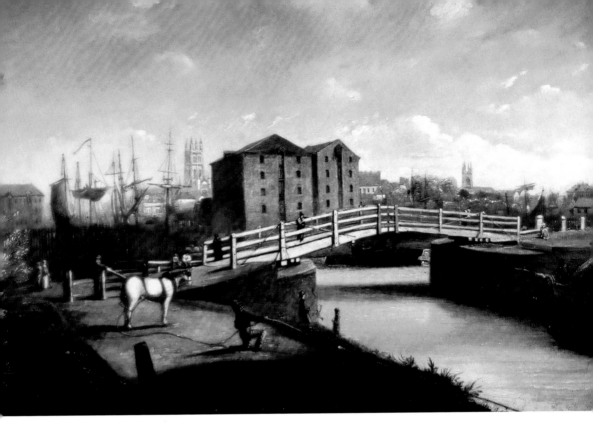

1  *Llanthony Bridge by Edward Smith with Biddle's and Shipton's Warehouses behind (mid-19th century). The horse on the towpath has evidently towed a vessel up the canal.*

2  *Looking south from Llanthony Bridge by John Collier (mid-19th century). The boatman is carrying a shaft used to move his boat around the docks.*

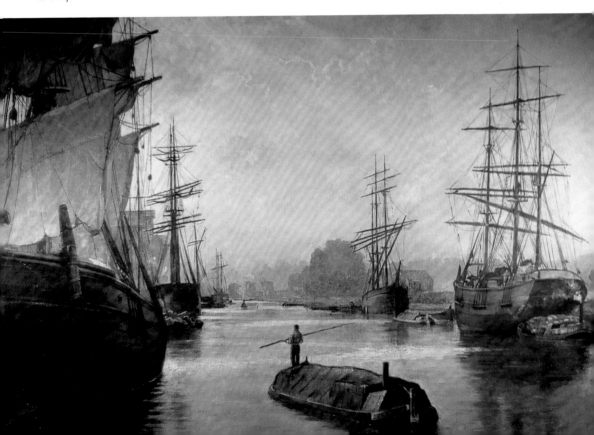

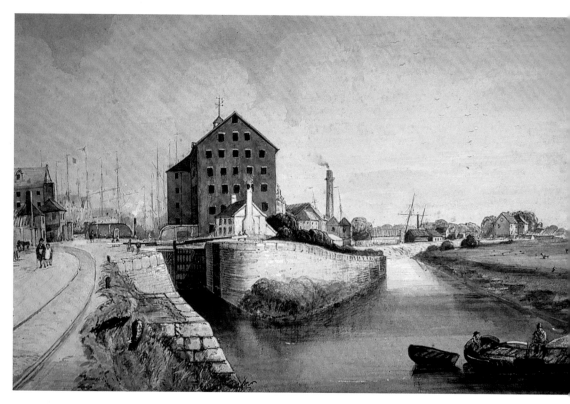

3 *Gloucester Lock viewed from the bank of the River Severn with the West Quay warehouses and the chimney of the pumping engine house behind (mid-19th century).*

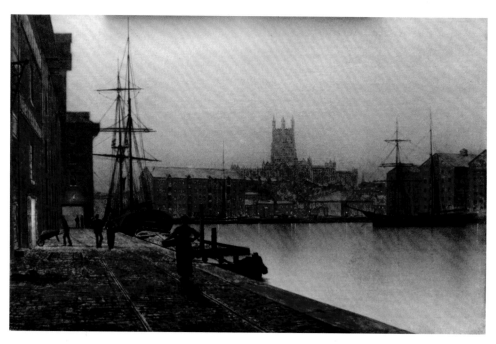

4 *Gloucester Docks at dusk viewed from the West Quay by John Atkinson Grimshaw (late 19th century). The warehouse at the far end of the quay protruded forward and was supported on pillars.*

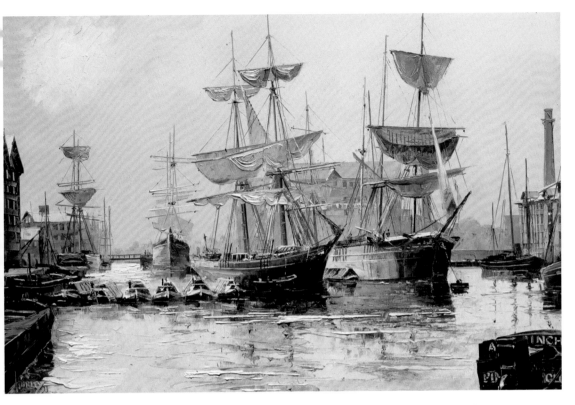

5 *The Main Basin at Gloucester by Harley Crossley. This view looking south is based on a photograph taken in 1883.*

6 *The Mariner's Chapel at Gloucester "as it used to be" by Mick Thurston.*

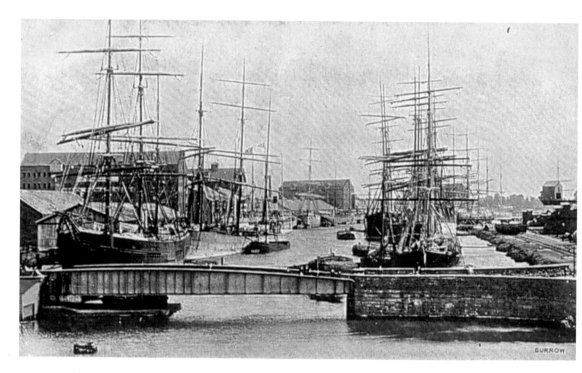

7 *Many sailing ships at Sharpness c. 1900 viewed from the High Level Bridge with the Low Level Bridge in the foreground.*

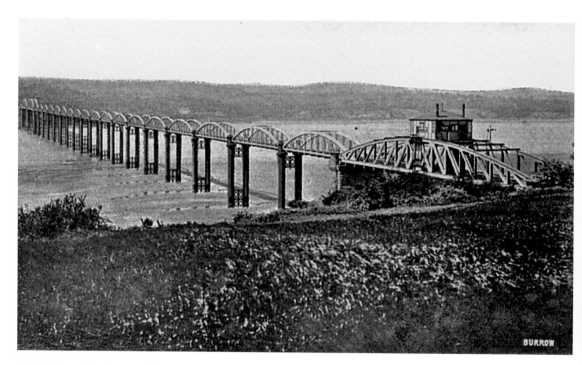

8 *The Severn Railway Bridge c. 1903. The nearest span was turned to allow vessels with masts to pass along the canal which is out of sight below the bank in the foreground.*

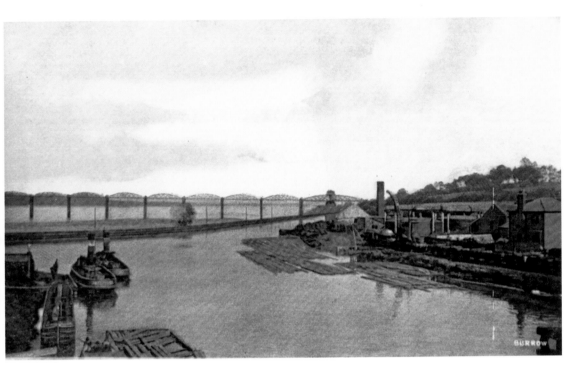

9 *The junction of the Old Arm and the New Dock at Sharpness c. 1903. Note the tug coaling stage on the left, timber rafts in the water and the gas and chemical works on the right.*

Sharpness. The Pier Head.
"Ships that pass in the night"

10 *An artistic view of sailing vessels under tow passing the south pier at Sharpness on their way down the river c. 1910.*

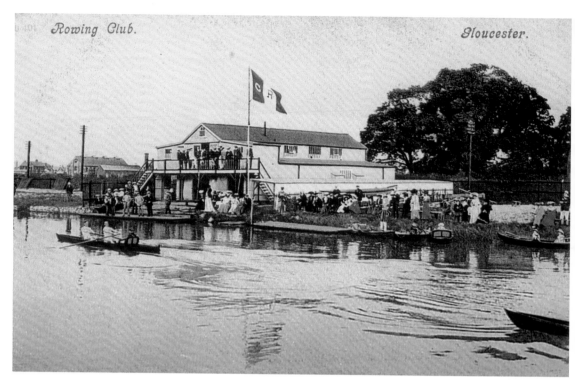

11 *Gloucester Rowing Club on a race day c1905. The pair passing the clubhouse were finishing well ahead of their rivals.*

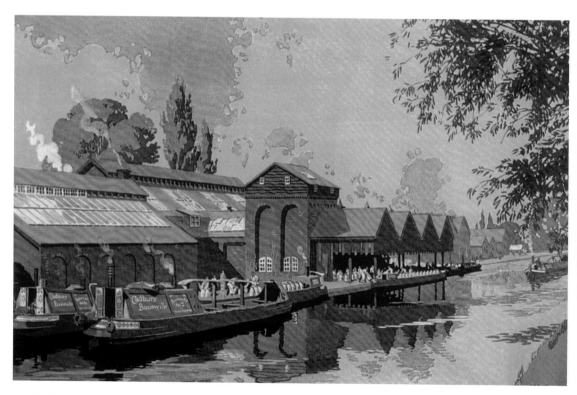

12 *Cadbury's factory at Frampton c1920 with Cadbury's own boats collecting sacks of chocolate crumb to take to Bournville.*

13 *The old coal tip overlooking the old arm at Sharpness in 1966, with the disused Severn Railway Bridge in the distance.*

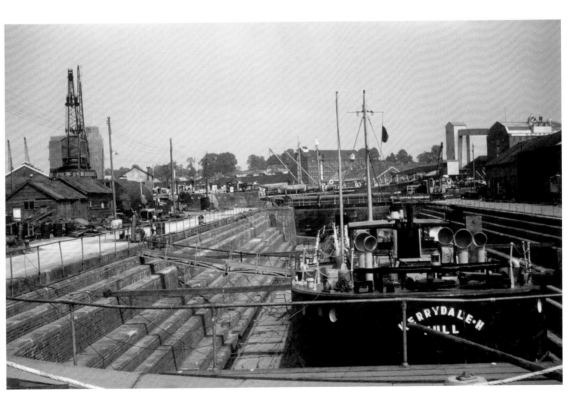

14 *John Harker's tanker barge* Kerrydale H *in the dry dock at Sharpness in 1966 with two of the big warehouses in the background.*

15 *The tug* Primrose *in the corner near Sharpness lock in 1966 after conversion to diesel power. In the background are three big warehouses and the grain silo.*

16 *Birmingham & Midland Canal Carrying Company boats at Sharpness in 1967. They were on a trial run to load timber and carry it back to Warwick.*

17  *Bowker & King's coastal tanker* Borman *passing through the High Level Bridge at Sharpness in* 1979.

18  *Danish MV* Adda *at Sandfield Wharf in* 1976. *The wharf near Sandfield Bridge was developed from a second World War strategic storage facility.*

19 *German MV* Altmark *passing through Sims Bridge in August 1979 bringing a cargo of pig-iron from Lubeck.*

20 *Danish MV* Fylke *in the tidal basin at Sharpness in September 1979 carrying a part cargo of resin from Sardinia.*

21 *Floating crane* Iron Duchess *painted by Eric Aldridge who used her in the 1970s for jobs such as back-filling behind new piles and clearing heavy debris from mud hoppers.*

22 *The remarkable scene during the steel strike in March 1980 when many consignments of pig-iron were sent to Gloucester to try to avoid the more militant dockers at other ports.*

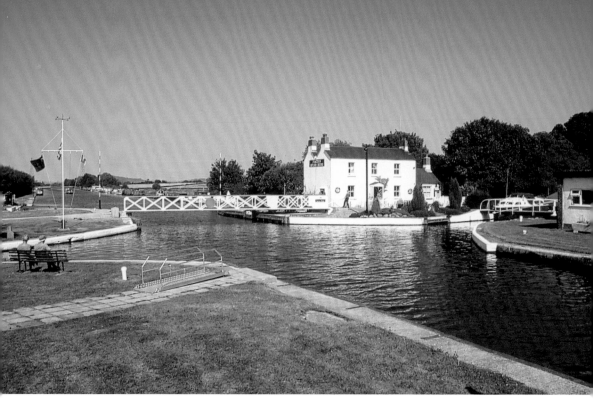

23  *Saul Junction where the Gloucester & Sharpness Canal crosses the line of the Stroudwater Canal.*

24  MV Lapia *passing the Quedgeley oil depot in March 1981 carrying calcium flint from St Valery sur Somme.*

25 MV Lille-Trine *at Llanthony Quay in March 1983 with a cargo of granite sets from Portugal.*

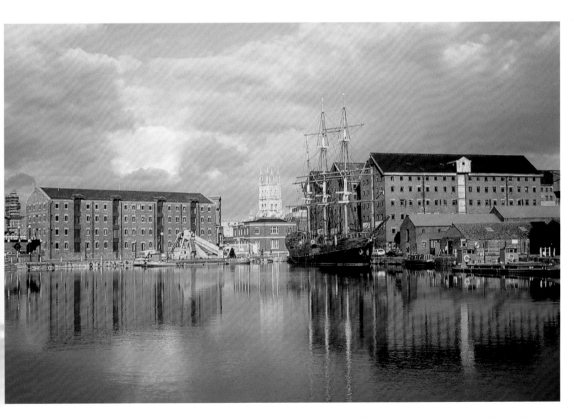

26 *The Main Basin at Gloucester in 1986 when no longer used for discharging cargoes. Note the North Warehouse restored by Gloucester City Council, No 4 steam dredger and the replica tall ship* Kaskelot.

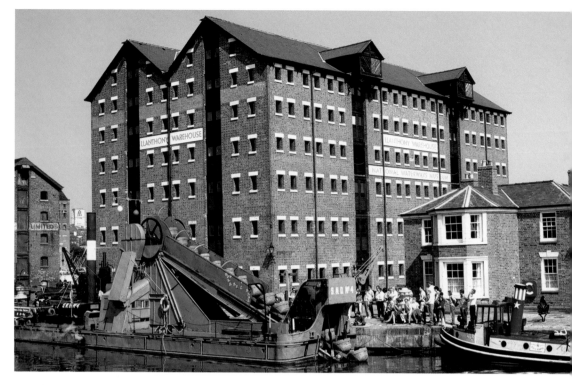

27 *The National Waterways Museum was established in Llanthony Warehouse in 1988 and No 4 steam dredger became a working exhibit.*

28 *The drained section of canal over the failed culvert near Parkend Bridge in June 1990. The straw bales were thrown into the canal to try to block the leak. The pipes along the towpath were installed rapidly to maintain the supply of drinking water to Bristol.*

29 The marina in the Old Arm at Sharpness with the tower of the former Severn Railway Bridge just visible in the distance.

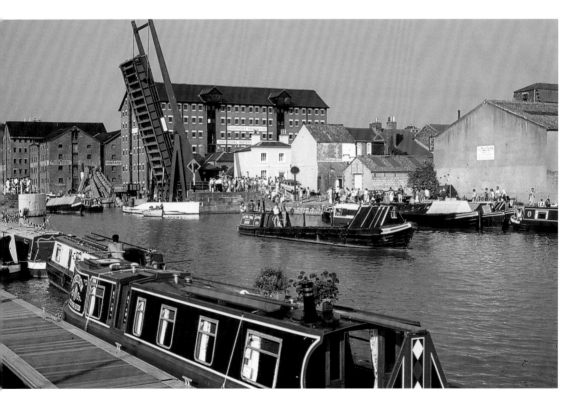

30 Boats attending the 1990 National Waterways Festival at Gloucester with Llanthony Bridge and the warehouses beside the Main Basin in the background.

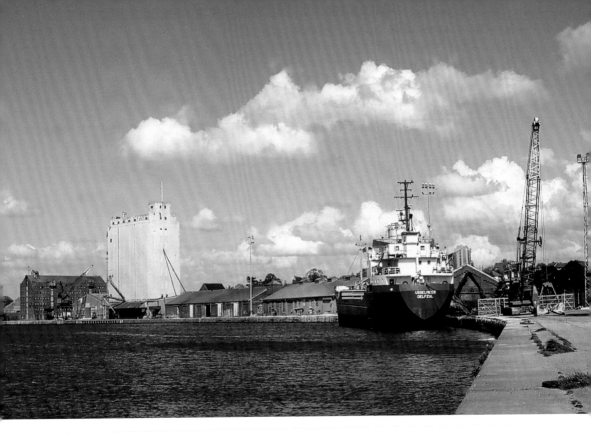

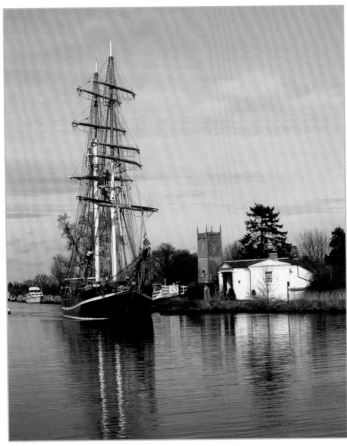

31 *Sharpness dock viewed from the lock in 1994, showing the North Warehouse as the only surviving big brick warehouse, the 1930s grain silo and MV Ijsselmeer loading scrap iron.*

32 *A reminder of times past as Eye of the Wind passes Splatt Bridge with Frampton church in the background.*

# 7

# Early Twentieth Century

At the beginning of the twentieth century, there was growing concern about the delays experienced by coasting vessels leaving Sharpness, following the sale of the only locally based river tug. The Dock Company's tugs *Speedwell* and *Mayflower* had been used in the river occasionally for towing lighters to and from the Northwick Oaze mooring and for helping to turn vessels prior to entering Sharpness, but the towing to and from Kingroad at the mouth of the Bristol Avon was done by tugs based in that area, and they concentrated on the bigger ships. To help the coasting trade, in 1902 the Dock Company allocated *Speedwell* to work regularly between Sharpness and Kingroad, having advised the other tug owners that the Company had no wish to compete for vessels above 300 tons register. Also, the tug *Myrtle* was converted for use in the estuary when needed, to ensure the Company could continue with its existing commitments. At first the Bristol owners started competing for the coasting vessels, but in time they accepted the new service, which also took vessels to and from Lydney.

In the last years of the nineteenth century, timber imports were booming, but the Sharpness stevedores had raised their rates for discharging ships, and, concerned about the effect on future business, the Dock Company set up a Timber Department to take on stevedoring work at the old rates. The new department soon attracted additional imports to Sharpness by organising the landing, stacking and despatch of cargoes for merchants who did not have establishments at Sharpness or Gloucester. In 1902, however, the management were overwhelmed when they were required to handle 20 cargoes in three months. Much timber was initially dumped on the quayside, incurring additional expense in stacking it properly later, and some high quality deals were even thrown into the water to help a ship get away on schedule. Following this debacle, the manager of the Timber Department was forced to resign and J.V. Thomas from the Gloucester office was appointed to take charge of all administration at Sharpness. To suit the importance of his position, a large new house was built for him beside the Harbour Master's house at the west end of Dock Row. Also, a large wooden shed was erected to provide shelter for the higher class of timber while being stored at Sharpness, and other sheds followed in later years as the Timber Department's trade developed.

Although the Timber Department attracted new business and hence more toll income for the Dock Company, the handling operations were running at a heavy loss, and so J.V. Thomas tried to get union agreement to a change from paying dockers by the day to paying for piece-work. No agreement was reached by the time the first ship of the 1903 season arrived, and so the Company imported labour from London and shut the dock gates to keep the local men out. Claiming that there was a public right of way through the docks, the local men forced their way in by pushing the gates down. Although they did not then cause any further trouble, the ringleaders were later successfully sued by the Dock Company, who wished to maintain the principle that their land was private. When the London men visited Berkeley, however, an initial exchange of insults developed into a running fight in the town centre, the local ironmonger's shop was raided for suitable weapons and several of the London men had to be treated in hospital. After three months on strike, terms for piece-work were eventually agreed, and the London men returned home.

In December 1903, a major new source of traffic started with the export of gravel from Frampton to Avonmouth, where Sir John Aird & Co. were building what became the Royal Edward Dock. Aird & Co. indicated that they wanted at least 150,000 tons carried by barge, and this encouraged the Dock Company to buy the tug *Resolute* from the Severn & Canal Carrying Company to do the towing. Aird & Co. built a wooden jetty just south of Splatt Bridge and laid down a railway line from the gravel pit one mile away. Several barges a day were loaded at the jetty and towed to Avonmouth over a three year period. Unfortunately, in the first year of operations, one barge collided with a loaded lighter coming up the canal and was damaged so badly that she sank near Patch Bridge, where she blocked the waterway for several days.

The outward shipments of gravel helped to make 1904-06 the best years for traffic so far. Grain imports were high as supplies from Russia and South America were plentiful again, and more came from India and Australia. Timber imports were also high as Price Walker & Co. were bringing in huge quantities of soft wood from Russia, Norway, Sweden and Canada together with growing quantities of pitch pine baulks from around the Gulf of Mexico. There was also a good export trade in salt as large sailing ships took around 2000 tons each to Australia and New Zealand.

The pitch pine baulks were too big to be man-handled by the dockers, and so they were dropped over the side of the ship, disappearing under the water with a tremendous splash. Most soon came up again, rocking back and forth for a time, but sometimes one stuck in the mud in the bottom of the dock and only bobbed up some time later - perhaps after a ship touched it. Those that were floating were gathered together by two men in a small boat and chained together to form rafts. In due course, these rafts were towed up to Gloucester, but in the meantime they were left at the upper end of the dock or in the lie-bye at Marshfield, just to the north of the Severn Railway Bridge, and at times they caused obstructions. To avoid this difficulty and to encourage the import of more baulks, the Dock Company purchased land beside the canal at Marshfield and formed a timber pond in 1905 where the baulks could be stored afloat out of the way of traffic.

Some of the ships arriving during this busy period came close to the maximum constraints of the port. In September 1904, SS *Katharine Park* of 3078 tons register with wheat from Calcutta was welcomed as the largest vessel to enter Sharpness. This record was soon beaten, however, as in July of the following year the Brocklebank Line steamer *Pindari* of 3696 tons register arrived also with wheat from Calcutta. As such steamers were far too long to fit into the lock, it became increasingly necessary to use the whole of the tidal basin as a lock, which consumed a huge quantity of water. To help maintain the canal level, therefore, a new centrifugal pump was installed in the engine house at Gloucester.

The high level of activity at Sharpness required a large number of dockers, many of whom walked miles from surrounding villages each day, particularly in the summer and autumn timber importing season. For those who walked down the towpath, a small ferry boat made it possible to cross the arm leading to the old entrance and so avoid the long walk via the old locks. The boat had ropes attached to each bank by which the passengers could pull themselves across. Dockers who were short of money were given an advance on their wages in the form of little brass tokens inscribed with a value and the name of a public house. These were used to buy beer, and the value of the tokens was deducted from the men's wages at the end of the job.

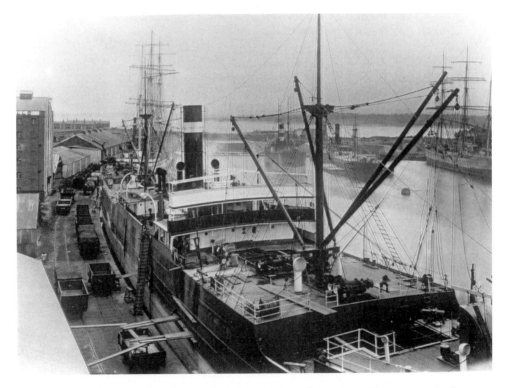

*Steamers and sailing ships at Sharpness c. 1912. The planks on the railway wagon in the foreground were for dockers to walk along carrying sacks of grain that had been lowered by the ship's derrick on to the plank suspended from the ship's side.*

Smaller vessels continued to take their cargoes up the canal to Gloucester. Coastal schooners, ketches and trows brought stone, coal, sand and grain from ports in the West Country, South Wales and Ireland, and they often went out with salt. The coal traffic included regular shipments from Cardiff to the Gloucester Gas Company's wharf at Hempsted. The steamers of the Bristol Steam Navigation Company carried sugar and other goods from Hamburg and Antwerp, while other steamers brought a variety of cargoes from British and continental ports. Other regular traffic on the canal comprised barges and lighters loaded with grain and timber discharged from ships at Sharpness and more general cargoes picked up from Avonmouth and other Bristol Channel ports. Much of this inward traffic continued on up the River Severn for destinations in the Midlands.

Ever conscious of the need to maintain an economic waterway link to the Midlands, the Dock Company directors became concerned about the high rates being charged by the Severn & Canal Carrying Company for towing other traders' boats on the river above Gloucester. In 1906, therefore, the Dock Company started running their tugs *Myrtle* and *Mayflower* on the river in competition, and they bought the *Primrose* to help maintain their existing commitments. The Carrying Company directors pleaded that they needed the profits from towing to finance their carrying and warehousing operations, and after failing to negotiate any compromise, they announced they were

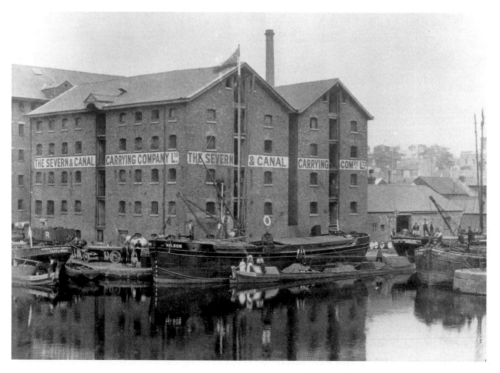

*The Severn & Canal Carrying Company's warehouses beside the Barge Basin at Gloucester where cargoes were transhipped from barges into canal longboats.*

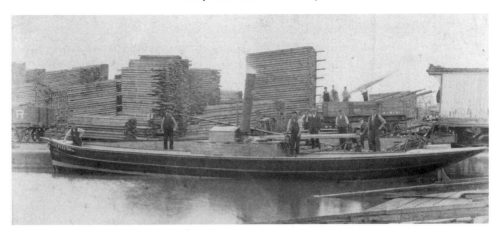

*The steam boat* Lily Byrd *soon after being launched into Monk Meadow Dock c. 1910. The timber piles in the background have some deals protruding so that the piles can be climbed.*

giving up. This paved the way for the formation of a new Severn & Canal Carrying Company, financed initially by local grain and timber merchants and supported by the Dock Company and the Staffordshire and Worcestershire Canal Company. The new company continued to run a fleet of barges and canal longboats which collected cargoes discharged from steamers at Avonmouth, Bristol or Sharpness and delivered the goods to Gloucester, Worcester and other destinations throughout the Midlands.

One of the customers for grain carried inland was Daniel Redler & Co of Worcester, but the business was not prospering, and in 1908 Daniel's brother Arnold moved to Sharpness where he converted the Pioneer Warehouse (the most southerly of the four big warehouses) to become the Elysium Flour Mills. Some years later, Redler noticed that as workmen at the mill were dragging a lifting chain though a heap of grain on the floor, the chain carried the grain along with it. From that, he designed a square chain running in a square box that became a popular means of conveying grain. In due course he closed his mill and concentrated on developing the conveyor system, eventually moving this business to Dudbridge near Stroud.

Although imports were booming in the early years of the twentieth century, revenue was not much higher than before the building of the new dock, because tonnage charges had been forced down by competition from Avonmouth and Portishead, and no dividends could be paid to ordinary shareholders. To try to improve their financial position, the Dock Company directors sought ways of cutting expenditure - initially by reducing the size of the maintenance team, which had risen to almost 100 men, and then by reducing operational and office staff at Sharpness. As part of this exercise, arrangements were made in 1908 to close the old entrance, as the gravel traffic which had been its main use in recent years had come to an end. A further saving was made that year when Frank Jones was forced to retire as Engineer due to ill health, and his position was taken by A.J. Cullis who had worked in the Engineer's Department for seventeen years.

The new Engineer was soon faced with a major challenge when it was realised that a new channel of the River Severn was eroding into the long bank of the canal between Purton and Sharpness. Thinking that the problem was at least partly due to the excess canal water that flowed over Purton waste weir, in 1909 Cullis blocked the weir with baulks. These were designed to be removed if required, although Cullis did not think this would ever be necessary as the top of the lock gates at Sharpness was only two inches above the normal water level and this would serve as a weir 60 ft wide. Cullis also constructed a stone barrier where the new low water channel in the river turned towards the bank by sinking two barges and filling them with stone from Chepstow when the tide and weather were suitable. Three years later, it was feared that these precautions were all in vain as the Severn bank suffered a slip which seriously threatened the safety of the canal. However, investigations showed that this was due to leakage from a forgotten culvert under the canal, and remedial work was done to stop the leak. In later years, many more old barges were dumped along this bank to encourage river mud to accumulate and so build up additional protection against erosion.

The Dock Company had some small steam cranes for operational and maintenance use, but these were of limited lifting capability. To provide for really big loads, such as removing a boiler needing repair, they purchased a travelling steam crane from Stothert & Pitt of Bath that was capable of lifting 30 tons, and this was set up on the quay between the dry dock and the hydraulic coal hoist in 1911. One of the crane's first uses was to help J. Cashmore & Co. in removing heavy components from the obsolete cruiser *Tribune* before the hull was taken out on to the foreshore for final breaking up. A mast from the *Tribune* was purchased from the breakers to provide a mounting for one of the Narlwood leading lights in the estuary off Shepperdine.

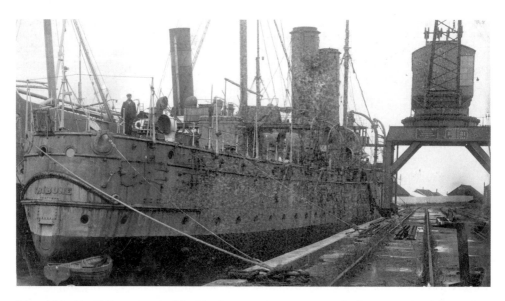

*The old cruiser* Tribune *moored beside the 30-ton steam crane which was used to lift out major components in 1912.*

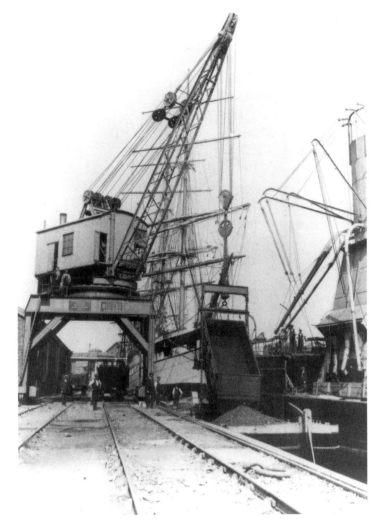

*The 30-ton steam crane at Sharpness fitted with a cradle in 1913 so that it could lift a coal wagon and tip its contents into a vessel's hold. This arrangement was needed for a time to supplement the hydraulic coal hoist in handling contracts for the export of 155,000 tons of Forest of Dean coal to France. To the right is the grain elevator* Leitrim.

In the early years of the twentieth century, there was a marked decline in the number of large sailing ships bringing cargoes to Sharpness, but those that did arrive attracted considerable attention. A tall ship coming up the estuary on the evening tide, escorted by tugs, made a fine sight as she turned against the sunset before entering the tidal basin. Once safely docked, riggers went aloft to take the sails down to be stored in the sail locker, unless the ship was expected to sail shortly. Great interest was also shown when a particularly big steamer was approaching the entrance, and Saturday 5 November 1914 was an especially memorable day as local people witnessed two notable arrivals. On the morning tide, the Brocklebank Line steamer *Assyria* of 4105 tons register was the largest ship so far to enter the port, and in the evening she was followed by the *Clan Macpherson* of 3047 tons register. However, this was the end of an era, as the First World War had started and it would bring great changes.

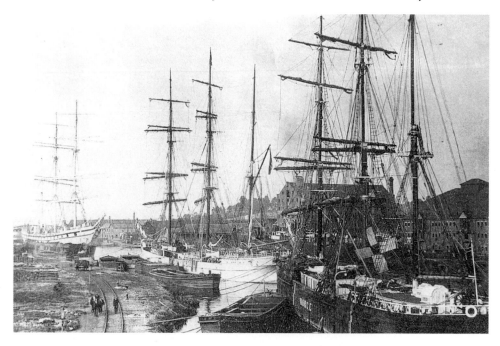

*The French barque* Versailles *(left) arrived with barley from San Fransisco and the Norwegian barques* Som *and* Areola *brought deals from North America in 1915.*

At the outbreak of the First World War in August 1914, there happened to be a German steamer at Sharpness loaded with fancy glassware and musical instruments. The ship was immediately commandeered and the cargo sold off cheaply, with the result that many local children were given mouth organs. Not long after this, however, the trade of the port was being seriously effected because so much of the usual traffic had come from ports that were no longer accessible. This included grain from the Black Sea, timber from the Baltic and the general cargoes brought by the steamers of the Bristol Steam Navigation Company. Total imports into Gloucester and Sharpness fell from 679,000 tons in 1913 to 208,000 tons in 1918, and exports fell dramatically as well. As the war proceeded, arrivals included steamers that had been badly shot up from enemy attack, requiring repairs that took weeks or months, and old sailing ships which had been fetched out of retirement, most sailing under neutral Norwegian or U.S.A. flags. When a cargo of sugar arrived and was piled high in a storage shed, local people were always on the lookout for a spare pound or two, and sometimes it was possible to obtain a few large tins of Irish butter. With less arrivals at Sharpness and less traffic up the canal, the Dock Company were obliged to lay up two canal tugs, reduce the operational staff at Sharpness and severely cut the canal maintenance team. The Lapwing passenger steamer was requisitioned by the Admiralty and its place was taken by one of the steamers that had plied on the river to Tewkesbury. The early morning and evening boats were packed with workers going to and from the munitions factory built at Quedgeley.

The drastic fall in traffic also meant a reduced use of warehouses and timber yards at Gloucester, and in 1916 the Army Ordnance Department of the War Office commandeered land and buildings on the west side of the canal to provide a depot for holding a wide range of materials and equipment for the army. They set up their headquarters in and around the vacant Great Western Warehouse (to the north of Llanthony Bridge), and they developed 24 acres of land around Monk Meadow Dock and timber pond, including Thomas Adams's former timber yard and saw mill. New access roads were made, additional railway lines were laid and sheds and marquees were put up to provide some covered storage. Items held there included various types of road wagons, spare wheels, ammunition boxes, barbed wire and drums of lubricating oil. Many local people were employed at the depot, and to help pedestrian access from the southern part of Gloucester, a rowing boat was used as a ferry across the canal.

Much further down the canal, a rather different kind of depot was established in 1916 on fields to the west of Slimbridge to store cordite propellant for shells. Sixteen wooden buildings, each designed to hold 200 tons of cordite, were put up on concrete foundations spaced 200 yards apart, and each one was served by a rail link to the main line with a branch to the canal wharf at Shepherds Patch. During construction, loads of wood and railway lines were delivered to the wharf, which was specially strengthened for the purpose, and the authorities temporarily commandeered the shed on the wharf that had been built five years earlier to store grain on the way to Draycott Mills at Cam.

*A floating bridge across the canal during the First World War. It provided a link from the Gloucester Wagon Works to the Army Ordnance Department's depot on the west side of the canal.*

A welcome new development in 1916 was the opening of a factory to the north of Fretherne Bridge for Cadbury Brothers. Local milk, ground cocoa beans and sugar were mixed together and baked to give a raw form of chocolate known as crumb, which was then sent to the company's main factory at Bournville for the finishing processes. A warehouse on nearby Frampton Wharf that had been built for corn on its way to Fromebridge Mill became the mess room for Cadbury's workers. The new factory was built beside the canal because Cadbury's were very keen to use water transport as much as possible as a way of limiting the power of the railways. As well as bringing in the cocoa and sugar by boat, the company even used a horse-drawn boat to collect churns of milk left at the canal bridges by local farmers. The chocolate crumb was also sent away by boat, and as occasionally a bag of crumb got ripped open during handling, the boatmen usually had a supply to give out to friends or passers by.

War time construction projects increased the demand for gravel, and in 1917 material from a Frampton pit began to be shipped to Chepstow for the construction of a new shipbuilding yard. Initially, the material was loaded into barges at Frampton Wharf, but when more output was required, arrangements were made to build a jetty below Splatt Bridge and to provide a rail link as had been done a dozen years earlier. Subsequently, the use of Frampton Wharf was stopped as it was found that the heavy traction engines and wagons being used were pushing the central part of the wharf wall forward - as can still be seen today.

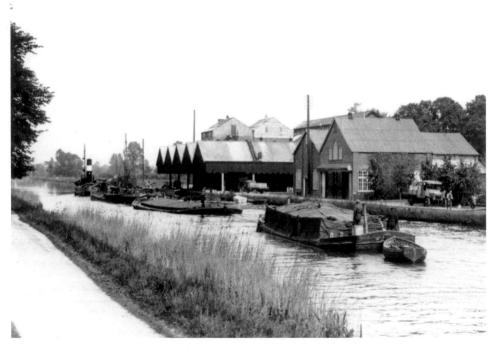

*A tug towing barges past Cadbury's factory near Fretherne Bridge.*

*6000 sacks of oats piled up near the Victoria Warehouse at Gloucester in July 1913, presumably to provide publicity for the sack contractors Hudson & Co. The oats had arrived in bulk from Argentina in* SS Pampa.

In the final year of the war, two slips were laid down on the canal bank just to the south of the dry dock at Hempsted for the building and launching of huge reinforced concrete barges. Ordered by the Admiralty as part of a national programme to replace shipping lost through enemy action, each barge was 180 feet long and designed to carry 1000 tons. The first named *Creterock* was launched broadside into the canal on 23 November 1918 and created a tremendous wave which washed right across the towpath on the opposite side. Five other barges were subsequently launched, but the war was over and there was no longer a pressing need for them.

Following the return to peacetime conditions, the men who crewed the towed barges and lighters began to raise objections to an old practice which required one of them to go ashore to open one side of each canal bridge while the bridgeman opened the other half. When the tow was approaching a bridge, one crewman climbed into a small boat which had a line attached a little way back from the bow so the boat would sheer across to the bank. There he jumped ashore, opened one side of the bridge, closed it again after the tow had gone though and ran on down the towpath to jump back into the small boat and return to his barge. In 1919, the men raised concerns about the risks involved in this way of working, and negotiations with the lighter owners and the Dock Company eventually led to the introduction of a regular passman to accompany each tow, riding a bicycle along the towpath and opening and closing each bridge as the tow

passed through. If two tows were moving in opposite directions, it was usual for the two passmen to turn around when they met and return to their starting point. Otherwise a passman might have to cycle the full length of the canal before returning.

With the return of peace, traffic into Sharpness began to increase again but remained well below pre-war levels for many years. By the early 1920s, much of the old timber trade and the general cargoes from northern Europe had returned, but grain imports were still poor as the new Soviet Government had stopped all exports from Russia, which had been a major source before the war. The importance of the continuing supply from Argentina was highlighted in October 1923 when SS *Wimborne* arrived with 8714 tons of maize and wheat, the largest cargo ever discharged at Sharpness. The number of smaller steamers using the canal also recovered slowly, bringing imports such as sugar, paper, strawboard and miscellaneous goods from continental ports. Some of the sugar discharged at Gloucester was loaded overside into Severn & Canal Carrying Company longboats to be taken down to Cadbury's at Frampton.

In addition to the imports, there was still much coal carried on the canal in spite of growing competition from rail and road transport. Barges were loaded with 40 to 60 tons at the old tip at Sharpness and delivered to Cadbury's factory at Frampton and to the mills along the Stroudwater Canal. Some coal also came from Bullo Pill to Gloucester via the western arm of the Stroudwater Canal. Each barge was usually towed by a mule or a couple of donkeys. Domestic coal was carried in longboats from the Midland collieries (known as "up country") and delivered to a number of small coal yards beside the ship canal and along the Stroudwater Canal. Some owners had their own towing animals while others relied on joining a tow behind a passing tug. One owner had two donkeys, but if he heard a tug coming, he would manage to get the animals on to his boat so they could all cruise down the canal in style! At Hardwicke Bridge, the coal merchant was Jack Taylor who lived in the house at the end of his yard on the green-bank side of the canal. He always expected his boatman to carry a full load of 30 tons, which was not easy given the state of some of the Midland canals. The boat moored by the bank alongside the yard, and two men discharged the coal by shovelling it into a wheel-barrow and wheeling it into the yard. On the Gloucester side of Hardwicke Bridge, a separate wharf was used for discharging road stone for the County Council that was brought by barge from Chepstow.

There were great hopes of additional imports of timber when a new factory was built by the newly formed Standard Match Company in 1921 on the west bank of the canal just south of Hempsted Bridge. The company was started by two former Moreland's employees and was backed by local businessmen who's firms constructed the factory and provided much of the mechanical equipment and ventilation systems. Matches were made and sold under the Lucky Strike and other labels, but the business was not successful. After five years it was taken over by Moreland's and the building was then mainly used as a store, resulting in much traffic passing to and from Moreland's main factory in Gloucester. This led to a request that Hempsted Bridge be made capable of taking heavier loads, but the Dock Company just warned lorry owners that the bridge was unsuitable for heavy motor traffic.

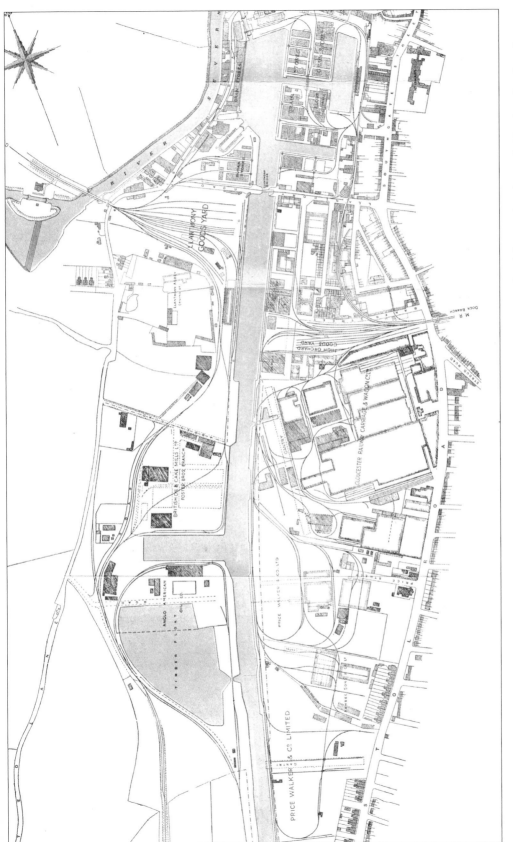

*Gloucester Docks and timber yards in 1926. The timber yards and the Wagon Works were on the east side of the canal with Monk Meadow Dock and timber pond on the west side, all served by a network of railways.*

Meanwhile, there was a slow return of activity around Monk Meadow Dock on the land that had been occupied by the Army Ordnance Department during the war. To set an example, the Dock Company built a transit shed on the south side of the dock. Also Foster Brothers built a bulk store for vegetable oils on the north side, and they began operating a small tanker barge called the *Princess* to ferry the oil across from their main mill on Bakers Quay. A more significant development, however, was the construction of a petroleum depot on the south side for the Agwi Oil Marketing Company, and their first spirit arrived by water in the RFA *Petrella* from the company's refinery at Fawley in May 1923. The depot had facilities for filling cans and 50-gallon drums, and the recently-built transit shed served as a garage for the lorries that delivered these containers to customers and brought back empty ones for refilling.

Over the next few years, similar petroleum depots were established around Monk Meadow Dock by Western Trinidad Lake Asphalt, National Benzole, Russian Oil Products, Shell-Mex, Medway Oil & Storage, British Petroleum and Anglo-Dutch Petroleum, and the Agwi depot passed to Anglo American. Initially the petroleum products were brought in by coastal tankers, but it was soon found advantageous to use tanker barges that loaded at Avonmouth and also delivered to Worcester and Stourport. Some companies used their own barges, while others used barges brought to the Severn by John Harker from Knottingley. Medway Oil & Storage also built some storage tanks beside the tidal basin at Sharpness, where petrol delivered by coastal tankers was loaded into barges for delivery to Stourport. The first of these consignments was brought by SS *Katendrecht* from Thameshaven in July 1928.

Pegthorne (or Packthorne) Bridge, north of the Junction, was only used occasionally by walkers and by a farmer who had a few fields on the opposite side of the canal, and the Dock Company had long wished to abandon it. So when an opportunity arose, the Company bought the fields and let them to a farmer on the same side of the canal, and in May 1925 they transferred the bridgeman to other duties. However, it wasn't long before they received a letter from the local District Council reporting complaints from walkers and asking for the bridge to be reinstated. At first the Dock Company tried to ignore the request, but when the Council threatened proceedings for obstruction, they sought legal advice and were left in no doubt as to the weakness of their case. After some repairs, therefore, the bridge was reinstated, but for walkers only. Even this required the appointment of a bridgeman, but as there was no company house for him, the bridge was not attended at night or on a Sunday. If a vessel was passing at these times, the bridgeman from Parkend Bridge or Sandfield Bridge had to walk along with the vessel and open Pegthorne Bridge as well as their own.

To support the recovery of the coaster trade on the canal, there was a need to ensure an adequate depth of water, but both the Fielding & Platt dredger (No.1) and the Bristol dredger (No.3) were expensive to run and needed frequent maintenance. After much deliberation, therefore, the Dock Company purchased a new dredger (No.4) from the Dutch firm de Klopp in 1925. Supplied with the dredger were two pairs of clogs, one pair for the engine driver and the other for the fireman, who would both be standing on oily plates. The boiler safety valves on No.4 were meant to blow

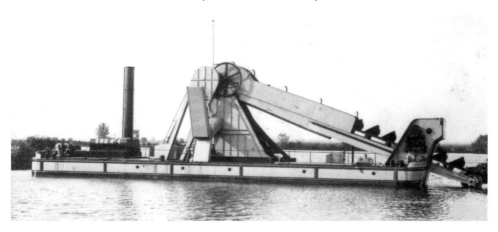

*Steam bucket dredger* SND No 4 *when new in 1925.*

off at a pressure of 140 psi, but initially they were not set properly. One morning it was noticed that the pressure in the boiler was 168 psi, and the captain was so worried that he personally stripped off and raked off the boiler to cool it down. After some teething troubles, No.4 took over all dredging duties, No.1 was hired to the Severn Commission at Worcester and No.3 had the machinery stripped out and was converted into a pontoon known as *Encore*.

In 1926, most of the transport workers took part in the General Strike, so there was virtually no traffic on the canal for two weeks and almost no cargo handling activity at Gloucester. Some ship movements were possible at Sharpness, however, as the lock gate and hydraulic men continued working. Also, the dockers at Sharpness were not so militant as those at Gloucester, and when a group of supervisors and volunteers tried the unload a ship using a grain elevator, the dockers did not interfere and just stood by laughing. After the national strike collapsed, the dockers didn't go back for a few days until a local settlement was arranged by Ernest Bevin, the national Secretary of the Transport and General Workers Union. Even then matters did not return to normal as the continuing miner's strike meant that there was no coal for the dredger, and many of the canal maintenance men were paid off or kept on short time working for several months.

A project which helped to provide employment at this difficult time was the construction of a lie-bye on the green-bank side of the canal north of Parkend Bridge. The Dock Company's men carried out the work in 1927 to provide a deep-water mooring for the steam yachts *Lady Gertrude* and *Verve* owned by T.A. Savery & Co., an engineering company based in Birmingham. Both vessels were fitted with marine engines made by the company, and beside the lie-bye was a workshop and a bungalow for the man who looked after the engines. Other pleasure boats on the canal in the late 1920s included a few motor yachts and a growing number of small motor boats. Some of these were moored to the south of Hempsted Bridge on the green-bank side and others in the Stroudwater Canal east of the Junction.

*A canal-side bungalow and fishing platform above Parkend Bridge.*

At the same time as the growth in leisure boating, there was also a demand for holiday bungalows beside the water, particularly near the Gloucester end of the canal. To meet this, the Dock Company agreed that those who were renting sections of the canal banks for agricultural purposes could start to charge ground rent for plots on which individuals could erect their own bungalows. On the green-bank side, it was usual for the boundaries of the plots to be defined by the poles that carried the Dock Company's private telephone lines. Most of the bungalows were built entirely of wood with roofing felt on the roof, although some did make use of corrugated iron. The earliest ones were just used as weekend and holiday homes, particularly by shopkeepers and tradesmen from Gloucester, but in later years a growing proportion were permanently occupied in spite of having very limited facilities.

A primary attraction of having a bungalow beside the canal was to provide a base from which to do some fishing. In fact some of the bungalows were originally intended just for this purpose and were only later extended to provide space for a whole family. Many owners constructed platforms on the canal bank to make a good place from which to fish. Another popular pastime was swimming, many children having their first lessons on the edge of the canal where there was a shallow shelf. A few families had their own rowing boat or canoe or built a raft from whatever materials they could find. Others were content to make their bungalow a social centre where relatives and friends could be invited for the day or weekend with the added interest of the passing traffic.

While the majority of steamers coming to Sharpness were bringing grain or timber, a smaller number carried a wide variety of other cargoes. These were usually discharged on the short quay on the north side near the dry dock, with the stevedoring arranged by the Dock Company. The big 30 ton steam crane was available for lifting out heavy loads, and to help with this general traffic, the Dock Company arranged for two 3 ton steam travelling gantry cranes to be erected by Stothert & Pitt in 1927 and another 3 ton crane was purchased second-hand. The big crane had a fireman as well as a driver, but on the smaller ones the driver had to stoke the boiler himself, and the boiler was right against his back which was very uncomfortable.

Unfortunately, one of the new cranes was overturned in October 1929 when a train of twelve trucks, partly loaded with timber, was passing underneath. The deals standing up at an angle in the fifth truck just cleared two cranes but fouled the underside of the gantry of the end crane and dragged it along until it came off the rails and overturned. This happened because, on the Dock Company's lines at that time, the only limit on the loading height of wagons was the judgement of the foreman, as wagons were not gauged until they reached the railway company's lines. The crane was subsequently reconstructed with a greater clearance over the railway lines, and the gantry of the other similar crane was also raised.

Before a ship departed, a supply of fresh water was provided by the *Firefly*, a small steamboat that also acted as the local firefloat. The water was usually drawn from an elevated tank near the hydraulic station which was replenished from a nearby well. However, some ships ordered 100 tons of water, which was too much for the well to supply. Then the skipper of the *Firefly* took a sample of the dock water, and if it looked clear, he opened the sea-cock and pumped dock water into the ship. However, if it was

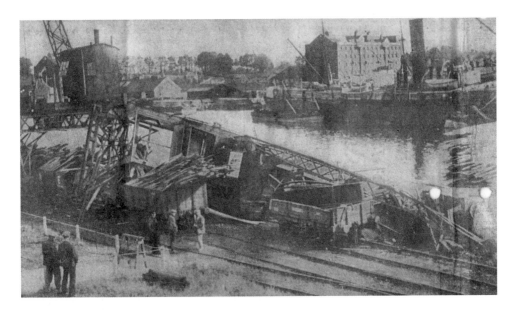

*The mobile steam crane at Sharpness that was tipped over in October 1929.*

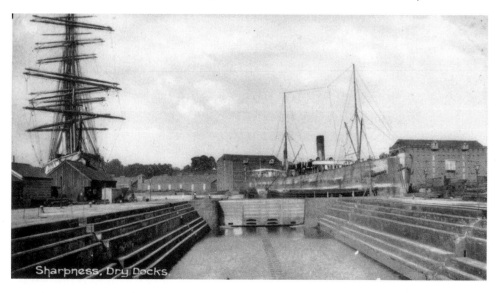

*The dry dock at Sharpness looking towards the main dock c. 1910.*

murky because mud had been stirred up by a ship passing, he took the *Firefly* up the canal to Marshfield where there was a spring that came up in the middle of the canal, and he filled up his tank there to supply the ship.

To ensure that there were adequate ship repair facilities at Sharpness, the Dock Company had for many years leased the dry dock to the Cardiff Channel Dry Docks and Pontoon Company, who offered the services of boilermakers, engineers, coppersmiths and wood shipwrights to any visiting ship. After several difficult years, however, the Cardiff Company pulled out in 1929, and with the encouragement of the Dock Company, local man Ivor Langford took over their role, employing several workers from the Cardiff Company. This change left some buildings vacant on the north side of the lock, and the Dock Company converted one to be their Dock Office in place of the house in Dock Row.

The new Dock Office at Sharpness was the working base for two of the Dock Company's key men, both recently appointed - Dock Superintendent Gordon Harford and Harbour Master Capt. Garnon Owen. Another key man was the Engineer, A.J. Cullis, based at Gloucester, who also assumed the duties of General Manager following the resignation of E. Manning Lewis in 1931. These three managed the company through the 1930s, a period of steadily growing traffic with few innovations. They reported to a board of directors who were mainly senior men from the companies that used the canal and were more interested in keeping down operating costs than in investing in new projects. Some financial and administrative changes were introduced by a new Act of Parliament in 1935, including provisions to drop the word "New" from the title of the company and to alter the name Gloucester & Berkeley Canal to Gloucester & Sharpness Canal, but working life on the canal continued little changed throughout the decade.

# 8

# Memories of Sharpness

During the 1930s, the number of big ships arriving at Sharpness from foreign ports remained well below pre-war levels, averaging around 125 per year, but there was a remarkable growth in coastal traffic - from 1100 to over 3000 vessels per year during the course of the decade. The main foreign imports continued to be corn and timber, and the increase in coastal traffic was mostly due to a growing demand for petroleum products brought from Avonmouth. Other incoming cargoes included sugar, cocoa beans, cement, road stone, carbide and coal, while a few vessels departed with salt. The vessels carrying all these cargoes had to time their arrivals and departures to suit the daily cycle of tides in the river.

As the time of high water approached, the workers in the hydraulic station began to raise steam to pump up the hydraulic pressure needed to operate the massive gates and the lashers (sluices) that controlled the flow of water past the gates. The lockmen appeared and took up their positions ready to operate the machinery and handle ropes, and two men in a small boat were on hand to take ropes from ship to shore in the tidal basin. Vessels that were departing were locked down to the level of the tidal basin and moored temporarily against one of the jetties, waiting for the entrance gates to open.

At the shore end of the north pier was a watch house with a signal mast which had two black balls hoisted to show that the entrance was shut. When the tide was high enough, the entrance gates were opened, one ball was lowered and any powered vessels waiting in the tidal basin departed. Once they had left, the second black ball was lowered to signal that the vessels waiting outside could come in, or at night a red light changed to green when the entrance was clear. When it was foggy, a bell was also rung on the end of the north pier to guide those entering.

First into the entrance could be any powered barges that had arrived well before high water. These would be followed by the regular tug from Avonmouth with its tow of barges and small sailing vessels. The *Resolute* or the *Iris* (which had replaced the old *Moss Rose*) came up and back on every tide, night and day, leaving the crew to sleep on board when they could. Before approaching the entrance, the tug had to swing round to head into the tide, and it was important for the helmsmen in the following barges to steer carefully in order to keep all their towing ropes taut, because

if a rope went slack and suddenly taut again, it was liable to break. The tug then had to punch the tide for a time, and it was essential not to have arrived too early or it would not have been possible to hold the barges against the force of the tide. When the tide eased and the signal was given that the entrance was clear, the tug turned into the relatively slack water between the piers and took its tow through the entrance gates into the tidal basin. Usually the tug had to go straight back down the channel, so once in the basin, the tug slipped its tow and the barges' momentum carried them on into the lock. The lock men threw down a line, with which they pulled up a heavy rope and put it on a post so that each barge could be brought to a stop.

If a big steamer was also due to enter, the pilot timed his approach to coincide with the last of the flood tide. The steamer was usually accompanied up the channel by two tugs - one at the bow and the other at the stern. At the swinging light, half a mile below the entrance, the bow tug went to port and the stern tug to starboard to swing the steamer round to head into the tide. By the time the turn was completed, they were usually about level with the entrance. Then, while stemming the last of the flood, they gradually edged sideways towards the North Pier and a rope was thrown to men waiting there. When the pilot gave the signal, the bow tug began to pull the steamer round the knuckle of the pier, helped by the stern tug towing her stern out and by the spring rope on the pier. With the tide still coming up the river, it set the steamer on to the pier, and as she came against it, there was always a slight roll because the pier had a sloping face. Then very slowly, the steamer turned the corner, often rubbing along the pier on her way into the entrance.

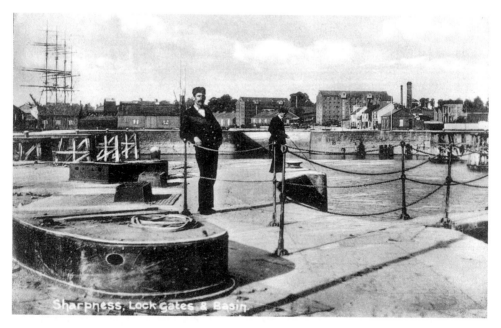

*Lockmen beside the entrance to the tidal basin at Sharpness c. 1910. In the foreground is the cover for one of the hydraulic lock gate mechanisms.*

*Harbour Master Frederick Field supervising the arrival of a steamer c. 1910.*

Big ships were expected to be right on the knuckle of the North Pier at ten minutes to high water. If a ship was late, the Harbour Master might decide that there was a risk she would get stuck on the entrance cill as the tide began to fall. That did happen once to a collier from Lydney, and she lay there balanced amidships until the next tide, but fortunately she was strongly built and floated off with no real damage. If that had ever happened to a big ship, she would probably have broken her back and blocked the entrance. So the Harbour Master or his deputy was always on the north pier watching the tide gauge and the ship's draft marked on her bow.

When the Harbour Master thought that the risk was too great, he would refuse entry by shouting instructions to the pilot. This happened to the SS *Camogli* in 1934 after a rope parted while swinging, and the resulting delay meant that she was late approaching the entrance. With the tide falling, it was not possible to take the ship back down the river, and so she just had to settle on the mud between the piers. She docked safely on the next tide. When the SS *Souliotis* was approaching the entrance in 1935, the Harbour Master left it to the last minute before refusing entry, and as the ship's engines were put into reverse and the stern tug pulled her back, the lashers (sluices) at the lock were also opened to help her stop by creating a reverse flow of water. Then the authorities became concerned that after settling on the mud, with 7000 tons of cargo, she might not lift off again when the next tide came. So before she went down, wires were passed underneath which could later be pulled to and fro to break the suction. It was touch and go again when the SS *Andriotis* arrived with 7,200 tons of grain in 1936, but this time there was no delay, and the Harbour Master later received a letter of commendation from the Severn Ports Warehousing Company for a successful docking.

Once a ship came through the entrance into the tidal basin, two men in a rowing boat carried ropes from the ship to the shore, and the Harbour Master took up a position near the lock where he could give orders to the men handling the ropes and to the captain of the ship. One winter's day when a gale was blowing, a steamer came into the tidal basin much too fast because of the wind behind her. Concerned about the steamer ramming the lock gates, the Harbour Master yelled at the captain to let go both anchors, and this just helped to bring the ship to a halt in time. Normally a ship went straight into the lock, but if the lock was occupied or if a ship was so big it needed the whole tidal basin to make a level with the canal, the ship moored alongside the jetties. Once a steamer was safely tied up, the channel pilot went ashore and a canal pilot usually took over. It was also at this time that customs and health formalities were completed.

The lock and entrance gates were opened and closed by under-water chains worked by hydraulic cylinders in the wall, and other cylinders operated the lashers which controlled the flow of water past the gates. As the lashers were raised, they pushed up hinged half-lids like slow jack-in-the-boxes which always fascinated young onlookers. Movement of each unit was controlled by two removable levers - one to engage the clutch and the other to open the control valve. At night when it was quiet, the sounds of the men trying to engage the clutch or dropping the levers after they had finished with them could be heard clearly from the houses as far away as Newtown. Also to be heard was lock foreman Tom Powell, who had a voice like a foghorn, shouting "Heave 'em up" to tell his men to open the lashers.

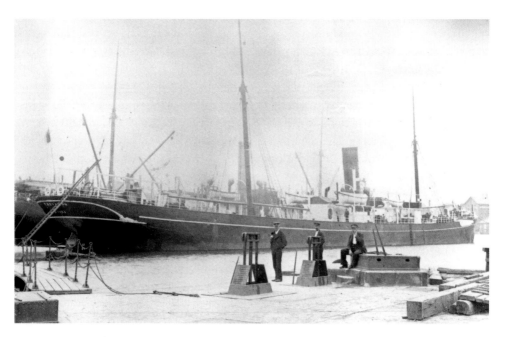

*Lockmen beside the upper lock gates c. 1905. On the right can be seen the levers of the hydraulic mechanism that opened the gates, and on the left the lashers are raised to allow water to fill the lock.*

Vessels were helped through the lock by one of the local tugs, and any large ship was taken to her berth while smaller craft continued up the canal to Gloucester. The big grain ships moored on the south side of the dock where most of the warehouses were, and the timber ships moored on the north side. When the dock was busy, a ship could be moored on what was known as the buoy berth with her stern on the wall by the lock and her bow on a buoy in the middle of the dock.

Once movements through the lock were over for that tide, a floating boom was pulled across above the upper gates to stop them being rammed by a ship. The boom was made of big baulks of timber fixed together with iron bands so that the overall section was about two feet square. Children enjoyed walking across this, rather than across the lock gates, as it moved under foot. The more adventurous could make it rock back and forth, and some even managed to roll it right over!

The discharge of a ship was organised by one of the two local stevedore firms, Chadborn Son & Taylor or G.T. Beard, or by the Dock Company itself. Each firm had a small permanent staff who handled the ships papers and worked out how the discharge needed to be done, and they recruited the men needed for a particular job from the crowds of dockers that presented themselves each morning and afternoon for selection. During periods of high unemployment, men walked or cycled for miles from the surrounding villages in the hope of getting work. The stevedore foreman called out the names of the men he wanted, and the rest had to go to the Labour Exchange to sign on for the dole. The dockers' start, finish and break times were marked by the blowing of the whistle at the hydraulic station, which could be heard all over the docks. As dock work was casual, dockers often also had other occupations. In fact as Sharpness was in a country area, many were needed on the land at harvest time. Some spent part of the year in the mines of the Forest of Dean while others went lave-net fishing for salmon in the river when the tide was right.

The grain arriving at Sharpness included wheat, oats, barley and maize, and oil seeds came for Foster Brothers. Grain warehousing at Sharpness was wholly in the hands of the Severn Ports Warehousing Company who had storage capacity for 1¼ million bushels (28,000 tons). Mostly the grain arrived in bulk in big ships that had to be discharged at Sharpness, usually by means of floating pneumatic grain elevators. Severn Ports had three elevators, *Leitrim*, *Dunkirk* and *Cardiff*, with a combined discharge capability of 300 tons per hour. When a big ship came in, all three elevators were normally used for a quick discharge.

The *Leitrim* had big air pumps powered by horizontal steam engines, and when she was pumping the whole vessel moved forward and back. With two pipes in one hold of the ship, the grain was sucked up into the top of a tower on the elevator. This process created a lot of dust, especially from barley or maize, and if the wind was in the wrong direction the dust went all over the nearby houses. Sometimes the cargo arrived in sacks, or some sacks were included to stop a bulk cargo shifting. Then the dockers had to cut the strings and empty out the grain so that the elevator could discharge it, and a boy collected the empty sacks, filling one with nineteen others to make bundles of twenty. In the tower of the elevator was a tipper which fed four weighing machines. A boy pulled

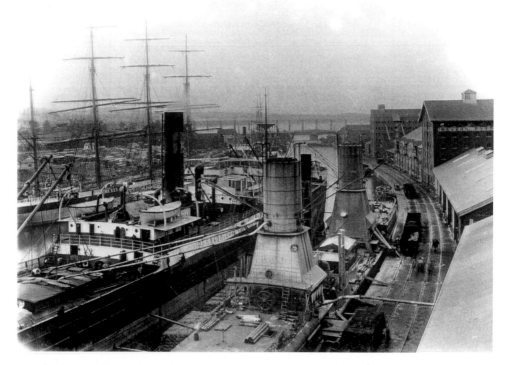

*The Greek steamer* Efstathios *alongside the pneumatic grain elevator* Leitrim *in September 1915. Note the pipes for sucking the grain from the ship's holds and pumping it into the warehouses.*

a slide to let the grain go into one machine, and when it had nearly the right weight he pushed the slide in again and moved to another machine. Meanwhile, the checker came behind, added a bit more to get the correct weight and released the grain. They kept going like this from one machine to another with the checker recording each batch, writing down four vertical strokes and one across. When the grain was released, if it was going into a big warehouse, it came down a pipe into a temporary hopper feeding a conveyor belt running under the  railway lines along the quay. Inside the warehouse, a bucket elevator carried the grain up to the required floor. To put grain into the smaller sheds, there were moveable conveyor belts that were fed via a hopper. Alternatively, some grain was discharged direct into a barge to go on up the canal to Gloucester or the Midlands.

If a grain ship destined for Sharpness was too deeply laden to pass over the cill of the entrance gates, she moored on the buoy at Northwick Oaze, and the *Leitrim* was sent under her own steam to take out some of the cargo. She could carry 500 tons herself, and she was usually accompanied by a tug towing the barges *Toujours Pret* and *Morrison*, which could carry another 650 tons between them. While at the buoy, the suction pumps were kept working continuously for two or three days, so the men had to work long hours and even though there were cabins in the bow, they were not able to get much sleep.

In the big warehouses, the grain was stored in bulk, piled high in the centre of each floor with less towards the sides, and there were holes in the wooden floors every so often which could be opened to allow grain to run down to the floor below. While one such transfer was in progress, an old man got his foot jammed in a hole, and as grain from the floor above came pouring down he was suffocated. From the big warehouses, there were pipes going down into the smaller sheds, and these had conveyor belts in the roof to take the grain along to wherever required. When the grain was to be sent away, a pneumatic elevator could be used again to transfer it in bulk to a barge, or it could be put into sacks for despatch by rail or in a longboat.

On the evening of 5 November 1934, the local community were treated to an awesome spectacle after fire broke out in Warehouse B belonging to the Severn Ports Warehousing Company. The local volunteer fire brigade soon had their fire float on the scene and the Gloucester and Thornbury fire brigades were also summoned, but the inferno spread to the neighbouring store to the north, and huge flames leapt high in the night sky. The big warehouse contained maize, wheat and barley, and as the pitch pine floors burned and collapsed, the grain fell down to form huge heaps that smelled horrible, and there seemed to be thousands of rats running all over the place. The firemen used eight jets to try to stop the fire spreading to any other buildings, but they were considerably hampered by the risk of falling masonry. At one stage, the whole end of the store collapsed because the water pumped in had caused the grain inside to swell, but fortunately the firemen in that area just managed to jump clear in time. Although the warehouse and store were completely gutted, the efforts of the firemen were largely successful in preventing the fire spreading further, and the two neighbouring buildings escaped with only minor damage. Much of the spoiled grain was tipped over the wall by the Severn Railway Bridge, and thousands of ducks came to eat it.

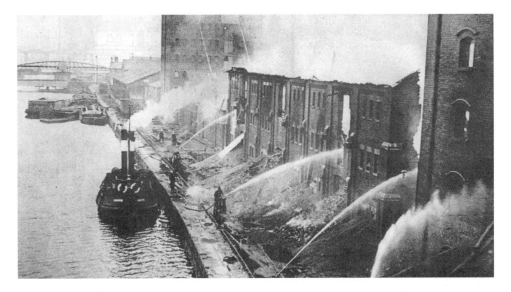

*Firemen damping down the ruins after the fire in November 1934.*

Only a year before the fire, the Severn Ports Warehousing Company had been reformed under the joint ownership of Bristol based corn merchants Henry Hosegood & Sons Ltd and five milling companies that were supplied through Sharpness. To replace the lost storage capacity, the new company made arrangements to clear the site and build a concrete silo that could hold 10,000 tons of maize , and this was brought into use in 1937. In a parallel development, Hosegoods established Severn Mills in the Pioneer Warehouse near the southern end of the quay and produced animal foods sold under the trade name Sharpex.

Memories of earlier times were reawakened when the Finnish four-masted barque Viking arrived on 10 June 1937 with 4000 tons of wheat from Australia. She was escorted up the river by three Bristol tugs, and a large crowd assembled to see her arrival. While she was in dock, visitors were welcomed on board at weekends, and during the first two days over one thousand people took up the opportunity. On the following Saturday, visitors included five motor coach loads of shipping enthusiasts from Bristol, and a week later a public dance was held on board with the proceeds being divided between British and Finnish seamen's charities. Once her cargo was discharged, Viking spent some time in dry dock being repainted, and she left Sharpness on 7 July.

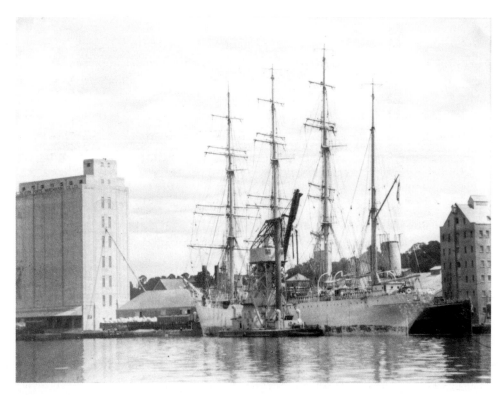

*The four-masted Finnish barque* Viking *being discharged by the pneumatic grain elevator* Cardiff *and* Leitrim *in June 1937.*

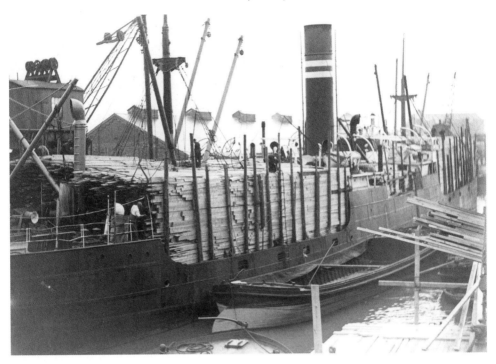

SS Everonika *arrived at Sharpness on 2 September 1936 with 1987 standards of deals from* Finland.

Ships bringing timber usually discharged on the north-west side of the dock where there was just a shelving bank, although other berths also had to be used at busy times. The main timber importing season was between May and December when the exporting ports were free of winter ice. Most of the timber was sawn softwood in the form known as deals, battens and boards between 10 and 20 feet long from countries like Russia, Finland, Sweden and Canada. The usual unit of measurement was the Petrograd standard, which was 165 cubic feet and weighed about 2½ tons. A big merchant like Price Walker & Co. might order a full ship-load of one or two thousand standards, but other merchants used smaller ships or shared a cargo between them. There were also shipments of aspen and basswood logs for Moreland's to make into matches and match-boxes.

As timber is a light cargo, as well as filling a ship's holds, part of each shipment commonly arrived piled up on the deck. Only the poorer quality grades of deals were carried in this way as the timber was liable to become soaked during the voyage. If a loaded vessel had been stuck in the ice during the winter, the deals could be all frozen together, and then the dockers had the miserable job of prizing them apart before they could be discharged. The dockers had what were called tompaw hooks to help manipulate the pieces of wood, and they made up sling-loads that were lifted off by the ship's derricks. Once the deck cargo had been cleared, gangs of six men worked in each hold until the whole cargo was discharged.

Much of the timber was transferred to lighters that came alongside in the shallow water between the ship and the shore as well as on the deep water side. Each piece was stowed carefully, with alternate layers along and across the lighter so as to form a stable pile. As the pile built up above the sides of the lighter, care was taken to avoid any side projections that might catch on the bridge abutments during the journey up to Gloucester. One special cargo caused particular difficulty as it consisted entirely of long lengths and did not include any pieces that were short enough to fit across a lighter. These were needed to ensure the piles were stable, and so the head stevedore cut up some of the long lengths. When the timber merchant heard of this, he was furious at having his specially ordered lengths of wood cut up, and he summoned the stevedore to Gloucester and gave him the sack. All ended well, however, as the merchant was later persuaded to change his mind and the stevedore was reinstated.

As well as timber being transferred to lighters to go up the canal, the Dock Company arranged for considerable quantities to be landed at Sharpness, often for London Merchants. As the ship was moored by a shelving bank, a standing barge was positioned between the ship and the bank to provide a base for a line of planks for the dockers to run along, balancing the deals on their shoulders. The men wore special leather pads to protect their shoulders, and the load was steadied with one hand on top to hold the front end tipped down slightly. In this way they managed to balance and turn the lengths of wood with apparent ease, although it was very hard work and only suitable for men who were fit. If a customer wanted the timber immediately, it was loaded directly into railway wagons. If not, the better grades were put into sheds, and the rest was stacked in tall piles that occupied large areas around the dock in the season. As the height of a pile increased, so the running planks had to be raised on trestles until they could be over twenty feet above the ground, and the dockers required considerable skill to maintain their balance as the planks swayed and flexed under their weight. Even some of the timber that was destined to continue by lighter had to be stored temporarily at Sharpness at times, if the ship needed to be unloaded quicker than the lighters could move it. Then it was sometimes necessary to dump the timber anywhere initially and only run it to pile later. This also happened when the dock was so busy that there was no free berth and unloading started while the ship was moored against the jetties in the tidal basin.

When a lot of timber needed to be landed at Sharpness, the Green in front of Dock Row was one of the places where the excess was stacked. As usual, the piles had various lengths protruding, and these provided an overhang under which children could play houses or sit out of the rain. Boys liked to swing from them, use them like spring boards or jump from them, each vying for the highest leap. However, great care was needed when climbing the side of a stack, as when a boy was nearly at the top he had to reach over and grasp a plank well in from the edge. If he hung all his weight on the edge plank it could slide off on top of him with potentially serious consequences. Another favourite game was to balance a long stout deal across a good sized trestle to make a first rate see-saw which would take several children on each side.

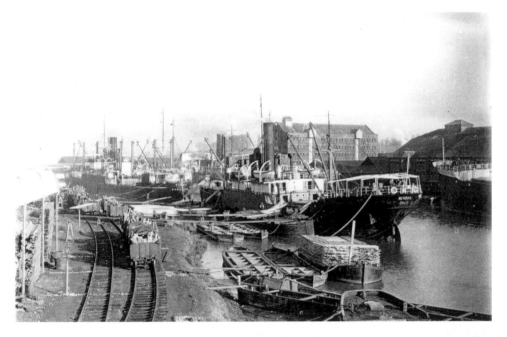

*Norwegian steamers* Rendal *and* Vinnie *moored by the shelving bank on the north-west side of Sharpness dock in December 1929. Note the lines of planks resting on lighters along which the dockers carried the deals that were going ashore.*

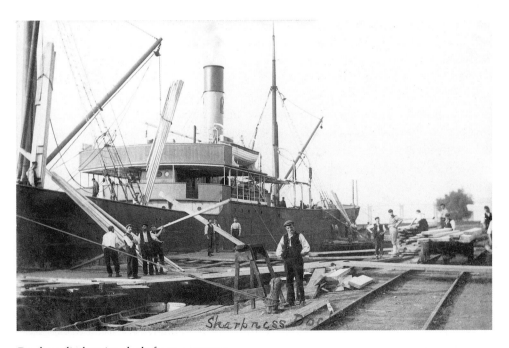

*Dockers discharging deals from a steamer.*

As well as the main cargoes of corn and timber, a wide range of other goods came into Sharpness, usually being discharged by the steam cranes on the quay near the dry dock. Steamers from France brought steel which was transferred into railway trucks and taken across the Severn Bridge to Lydney tin-plate works. A sugar boat came from London every fortnight with 500 tons of sugar in sacks for Cadbury's. This was loaded into barges and canal boats to go to Frampton and Bournville, and with two cranes lifting out ten bags at a time, the cargo was discharged in a day and a half. Severn & Canal Carrying Company barges came from Avonmouth loaded with crates of machinery from Canada, and these were put into lorries for Lister's at Dursley. Many other commodities were off-loaded direct into railway wagons, and the Dock Company also maintained special stores for cargoes like calcium carbide and nitrate of soda which could then be sent on in smaller quantities as required. If calcium carbide gets wet it forms the inflammable gas acetylene, so when a drum of it fell into the dock one day, the divers were sent down in great haste to avoid the chance of leakage and the risk of an explosion.

The shunting and marshalling of railway trucks was organised by the Dock Company using their own tank locomotives working from an engine shed behind the hydraulic station. Each one had a plate on the side of the cab with the letters SD (for Sharpness Docks) and its number. The sounds of steam puffing and buffers impacting seemed to go on all day, as wagons loaded on the quayside were shunted to join others going up north or down west or wherever. Then several times a day, a big locomotive came from Gloucester with empty wagons and took away the loaded ones. The Dock Company also had thirty of their own wagons, each painted with the letters SD, which were just used for moving timber around the dock.

The railway lines that ran down either side of the dock were linked by a line over the Low Level Bridge at the top end of the dock. This required two men to open it, both standing on the bridge and turning the same handle, and even then it was hard work. The nearby High Level Bridge carrying the line from the Severn Railway Bridge to the coal tips only needed one man to open it. Having put the gates across on each side and unlocked the bridge, he put a crank into a hole and walked round and round many times in a circle until the ends of the bridge came over the dolphins in the canal, which were there to prevent any vessels hitting the ends of the bridge when it was open.

The old tip beside the Old Arm was mainly used to load barges taking coal up the canal to Cadbury's factory at Frampton or to places along the Stroudwater Canal. It had a hinged platform with a counterbalance weight on each side, and as a loaded wagon came on to the platform, the operator used a brake to allow it to tip slowly. When the coal was discharged, the counterbalance weights lifted the empty wagon back up again. The coal went down a chute, and after so much had been loaded into one part of the barge, the barge was moved along and some more coal was tipped. Once a barge was fully loaded, it was pushed across to the towpath side and a rope was put on to a donkey to tow it up the canal. Between jobs, the donkeys were housed in the stable beside the old locks. Sometimes coal was tipped into vessels going to Bristol or to Ireland. Normally these loaded at Lydney, but when it was neap tides they couldn't leave there fully loaded, and so they came to Sharpness instead.

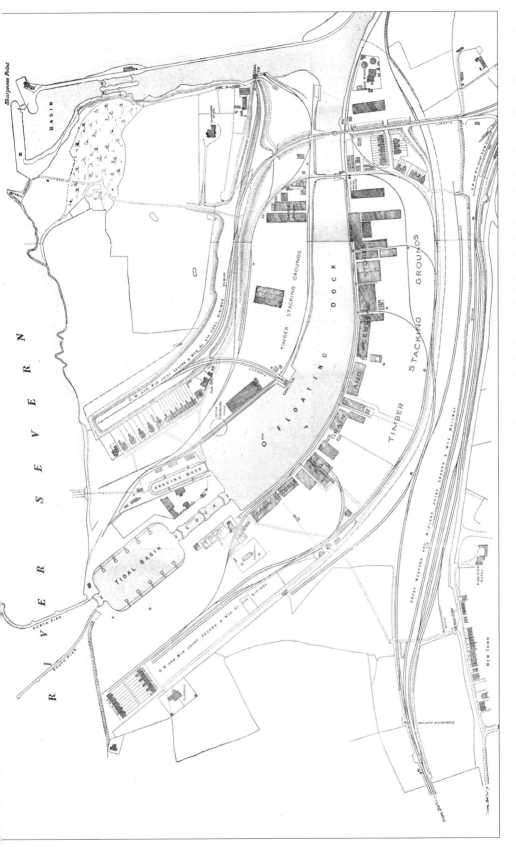

*Sharpness Docks in 1926. Note the warehouses and sheds on the east side of the main dock, the dry dock beside the lock, the low-level railway lines running along the quays and the higher level lines serving the coal tips.*

*The new coal tip beside the main dock at Sharpness with a Princess Royal colliery wagon ready to be tipped.*

At the new coal tip beside the main dock, wagons were rolled down one at a time on to a cradle, which was tipped by hydraulic pressure from the hydraulic station on the other side of the dock. The operator had two chains linked to control valves - one for down and the other for up. Occasionally, if the coal had been left standing in a wagon for a long time, it would not slide out when the wagon was tipped. Then the operator had to climb on top to loosen it, running the risk that he would end up in the ship with the coal. Normally, steamers just wanted three to four hundred tons put into their bunkers after their cargo had been discharged. This was always done at night, which allowed the navvy gang that looked after the railway lines to earn a bit of extra money. Eight of them went down into the bunkers, and as the coal was tipped down, they had to shovel it away twenty feet or so and build it up like walls all the way round. It was hard work, and when they had finished they were covered all over in coal dust.

An important facility at Sharpness was the dry dock were vessels could have repairs carried out before returning to sea. Steamers went into the dock for jobs like scraping the hull and repainting, replacing a plate or maintenance of the rudder or the stern tube. The entrance to the dock was closed with a single floating gate which could easily be moved when the dock was full of water. When closed, the gate was protected from impact by a floating boom made from four slightly curved timber baulks with spacers near the centre, all held together by iron bands. This had originally been made as a ballast boom used to stabilise a sailing ship while cargo was being unloaded. In the old days, one of these booms was floated along each side of a ship and lashed in position.

Then as the cargo was removed, the two beams rose out of the water with the ship, and their weight helped to stabilise the ship until another cargo or ballast was loaded.

At various places around the dock estate were shops that supplied the needs of local workers and visiting seamen. On the south side of the lock was a ship chandler whose premises smelled of tarred rope and linseed oil. Next door was Gassers the butchers, who supplied ships with half-carcasses and other foods. Some crews ordered live animals and had a ceremony on the deck before the animals were slaughtered. The Pier Restaurant provided refreshments for dockers as well as for sailors, and local children called in for sweets. Then came a cobbler who also made footballs for the children, and Evans the newsagent also sold tobacco, stationery and books. There were other shops and refreshment facilities near the Low Level Bridge, and the post office and a chemist's shop shared a building near the church at the end of Dock Row.

For those seamen who remained with their ship while it was in dock, the main recreational activity was to visit the local pubs. This led to a certain amount of trouble after the pubs closed, but the police made few arrests as they preferred to use tact and persuasion. There was a rough cider drink called Stun'em which only cost two pence a pint, and after a couple of pints of that most strangers were flat out. It was common to find men lying fast asleep in the road, sometimes dangerously close to railway lines, and there were many cases of men falling into the dock while trying to stagger back to their ship. Seamen were normally welcomed at the weekly dance at the Church Hall in Newtown, and there were several cases of visiting seamen marrying local girls and settling down in Sharpness. On one occasion, however, when a group was refused entry because of their intoxicated condition, it led to a street fight involving about fifty men. One further activity was playing football on the recreation ground to the east of the dock which was really meant for dock employees, and as many as fifty Scandinavian seamen were seen playing there at one time - all in one game!

*SS* Plawsworth *with a cargo of aspen logs for S.J. Moreland & Sons to make into matches.*

During the depression at the beginning of the 1930s, a number of steamers were laid up at Sharpness because there was no work for them. Some were put out of the way in the Old Arm, but SS *Dundrennan* was tied up on the north-west side of the New Dock and remained there for five years. Local people called her the *Dunrunnin* because they thought she'd never run again. Eventually in 1935, she was sold to a Greek owner and left Sharpness under the name *Argentina*, but her troubles were not over. In December of the following year, she was returning with a cargo of grain when, while turning to enter the tidal basin, the rope from her bow tug parted and she went on the rocks above the north pier. She remained there for six weeks while much of her cargo was transferred to barges, and then she was floated off with the aid of eight tugs and towed into the dock.

Since the old entrance had been closed, mud had been allowed to build up in the tidal basin from the repeated washing in and out of the spring tides. In fact the mud was so firm that children regularly played on it. The former Harbour Master's house on the north pier was occupied by Jack Brinkworth, who acted as assistant to the Harbour Master at the new dock. It was a very exposed location, and during one severe gale the roof of the wash-house was lifted off in one piece and blown away completely. Waves sometimes came over the quay wall and hit the house, so there was a heavy wooden storm door that could be pulled across in front of the main door.

Adjoining the old tidal basin, the disused ship lock became a swimming pool where local children were given lessons. There was wooden staging at each end, leaving a fifty yard length that was used for races and for water polo, and beside the lock was a big wooden diving board with three tiers. The local swimming club organised an annual gala, when the surroundings were decorated and crowds came to watch the sport. As well as races, diving and water polo, there were some acrobatics and people threw coins into the water to be collected for Berkeley hospital. Unfortunately, all this had to stop when the Dock Company became concerned about the condition of the wooden gates and built a steel piling dam across the head of the locks in 1933-34 to ensure the security of the canal. After that, children went swimming on the corner of the canal near the gas works. Some adventurous ones dived off the High Level Bridge, but this was not approved of.

On the hill above the old entrance were the Pleasure Grounds with attractive trees and fine views over the river. Refreshments were served in former railway carriages, ice cream stalls were formed from old wooden boats cut in half and stood on end and there were swings for children. The grounds were looked after by Joseph Sturge, his wife Hester and later their daughter Mrs Collie. They lived in Plantation House and made a small charge for admission. The grounds were mostly visited by parties that came down on the boats from Gloucester, but local groups also held events there. Once a year a church group went over in procession, and the children had sports and went on the swings. At the Co-Op fete, the children were given a tin of polish and some brushes, and the one who could polish his shoes the best won a prize. There were also band contests, and people came across the Severn Bridge and from Gloucester to hear the music. However, after the passenger steamers ceased plying on the canal, the number of visitors declined, and in 1937 the house and land became a small farm.

# 9

# Memories of Canal Traffic

In the 1930s, there were a few steamers using the canal, but most of the traffic comprised barges, lighters and some longboats that were towed by the Dock Company's fleet of steam tugs. These included *Mayflower, Hazel, Speedwell, Primrose* and *Iris* with *Violet* and *Myrtle* being replaced by *Stanegarth* in 1933. However, not all of these could be used for towing at the same time as the Company did not maintain a full set of crews, and one or more of the tugs might be needed to help *Resolute* in the channel or *Mistletoe* with the dredger. The canal tugs were based at the north end of Llanthony Quay, where there was a small office for the Tug Superintendent who arranged the crew's duties. One tug normally left Gloucester every morning and returned from Sharpness in the afternoon. If the trade required it, another tug left Gloucester after lunch and returned the next morning, and in very busy times a third tug might be needed or one tug might have to do a third trip in a day. Depending on where they finished at the end of the day, crews often had to sleep on board or cycle home all the way along the towpath.

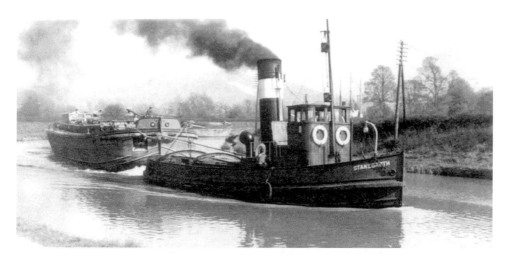

*Steam tug* Stanegarth *towing empty lighters around Netheridge Turn near Two Mile Bend. The first lighter is on short crossed ropes close behind the tug to help it steer round the bends.*

A typical tow was three or four barges and lighters with perhaps two or three longboats on the back. Most were empty on the way down the canal and so were towed on short ropes because light boats do not steer well and if they were too far apart they dragged along the bank when going around bends. Steering empty barges was particularly difficult if there was a strong cross wind, and if a helmsman was not careful going through a bridge-hole, he could knock the bridge off it's pivot. One time a bridge was knocked right off on to the barge and was carried down the canal for a bit. On other occasions, the tug had to stop before a bridge because the barges were just dragging along the bank. If there was a loaded boat in the tow, it was usually put at the back on a longer rope because it's helm was more effective and it could help control the empty ones.

When meeting a vessel coming in the opposite direction, normally the tug skipper blew his whistle twice and kept to port (left), but if either vessel needed to keep to starboard (right) for some reason, the skipper blew once. If a tug wanted to overtake another vessel, the skipper blew one long whistle and a short one, and the other skipper blew a long and two shorts to acknowledge. In fact it was rather difficult to get by, as there was not a lot of space and there was a suction between the boats. The whistle of each tug had its own particular characteristics, and local people could readily recognise each tug from the sound it made.

When the tug skipper wanted to change the speed of the tug, he had to communicate with the engineer by means of the engine room telegraph. On one occasion, as the *Mayflower* was going down the canal, the wire of the telegraph broke, and a crewman was told to go and mend it. While he was getting into position alongside the boiler, the engineer happened to fall asleep (as he suffered from an illness that caused this quite often). Unfortunately, as the crewman pulled the two ends of the wire
together, he made the telegraph bell sound for full astern. This woke up the engineer, who put the engine full astern - with the result that the first barge in the tow crashed into the stern of the tug!

At Sharpness, each barge and lighter had to be dropped off wherever it was needed. Some went alongside ships that were being discharged, while others moored up near to the lock ready to go on down to Avonmouth on the next tide. If needed, the tug could pick up coal at the yard near the corner of the Old Arm, and then the skipper called at the office beside the Low Level Bridge to be told what barges needed to be towed back to Gloucester.

The return journey to Gloucester with loaded barges was comparatively slow, and with a long tow at busy times the tug could only creep along at less than walking speed. Ideally the position of craft in a tow was determined by the order in which they would be cast off, but it was sometimes necessary to compromise. For example, if one was known to be particularly difficult to steer, it was desirable to have it first behind the tug. The big barge *King*, which carried oil seeds for Foster Brothers, was so difficult to steer that she needed a hobbler on the bank to put a check rope on a post to help her get round Two Mile Bend. As she came round the bend, the crew had to ease off the rope, and this generated so much heat that a man had to pour water over it from a bucket to stop the rope catching fire.

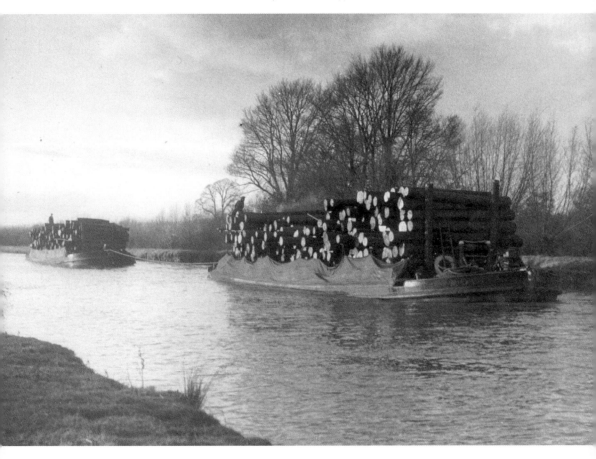

*Two lighters carrying aspen logs for S.J. Moreland & Sons. The helmsmen are standing on elevated platforms so they can see over the top of the cargo.*

Back at Gloucester, the barges and lighters were dropped off where required, some by the timber yards and others going right up near the lock to be ready to continue up the river the next day. Sometimes it was possible to cast off the last ones while approaching Llanthony Bridge and let them drift up to the lock on their own, but if it was a slow tow or there was a badly shaped barge, the tug had to pull them up into the dock. The big tanker barge *Shell Mex 7* would easily go all the way to the lock, but Chadborn's timber lighters slowed very quickly after the tug stopped towing. Once the barges had been cast off, the tug tied up by the tug office just below Llanthony Bridge.

At intervals along the canal, the tug and its tow had to pass through seventeen low-level bridges, of which fourteen were road bridges with two half-spans that could rotate on pivots to let vessels pass. Each half-span was built with wooden beams and decking, but the original all-wood design had evolved to include a single cast-iron stanchion each side to which were attached diagonal bracing rods. The pivot was

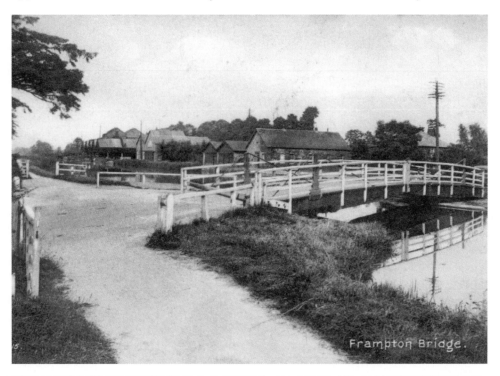

*Fretherne Bridge c. 1930 with the warehouse on Frampton Wharf in the background.*

formed by a cast-iron spindle mounted in a stone pier, and a ring of iron rollers was also fitted on the spindle to help the half-span rotate easily. Each half was balanced by putting lumps of pig-iron underneath the tail. Where the two halves came together, the towpath side had a convex shape which fitted into a concave shape on the other side, and a cast-iron wedge on one side fitted into a slot in the other side to ensure the levels matched.

Most of the bridges had a resident bridgeman who was expected to be on duty from 7.30 in the morning to 7.30 in the evening, and he could also be called out to open the bridge at night for a small extra payment. In his spare time, he had to keep his bridge clean and in good working order and look after about fifty yards of bank on either side of the bridge. On one specified day of the year, he had to close the towpath to the public to prevent it becoming a public right of way. At eight of the bridges, the Company had built classical-style houses which originally had only two rooms and a scullery. These had later been given additional rooms, either by an extension on the level or by using the original basement which was built into the canal bank and so was always very damp. Some bridge houses were provided with a well in the garden, but at others the inhabitants were expected to drink water from the canal that was passed though a simple gravel filter. Some of the bridge houses that were on the green bank (or off) side of the canal were linked by the Dock Company's private telephone system.

When a tug was approaching a bridge, the skipper normally blew his whistle twice to signal he needed both halves of the bridge open. The bridgeman went to the green bank side and waited for the passman to come along. Because of the curvature where the two half-spans met, the passman had to open the towpath side first and then the bridgeman could open his side. Conversely, once the tow had gone through, the bridgeman closed his span first, and then the passman closed his side before cycling on to the next bridge. If the tug was travelling without a tow or only had a single line of longboats, no passman was provided and the skipper just blew once to signal he only needed one side of the bridge open. It could be quite difficult to start swinging the bridge open, particularly if there was any adverse wind, and in the winter the two halves sometimes froze together. Then it was necessary for the tug to help by giving the bridge a nudge or by using a rope to pull it open.

The maximum load permitted to cross a normal canal bridge was six tons, but arrangements could be made for heavier loads to cross Sellars Bridge and Fretherne Bridge as these carried more important roads serving several villages. Sellars Bridge looked like all the others, but under each half-span was suspended what was known as a falling frame. When a heavy lorry needed to cross, the bridgeman lowered the frames down on chains and fitted them into slots in the wall of the abutments. These added support to the middle of the bridge so it could carry up to about twelve tons. At Fretherne Bridge, there was a pontoon that could be floated under the bridge when needed. This had two large baulks which could be jacked up under the bridge, allowing the weight limit to be raised to fifteen tons.

*Splatt Bridge and house in the 1950s.*

*Steam lorry in the canal at Hempsted Bridge in August 1930.*

The limited capability of the other canal bridges was highlighted by a serious accident in August 1930. A steam lorry laden with sacks of flour went across one half of Hempsted Bridge, but as it continued, the other half of the bridge tipped down under the weight and the lorry ran backwards into the canal. The driver and his mate managed to clamber out, but concerned about a possible boiler explosion if it sank into the water, the driver climbed back into the cabin and released the pressure. Sacks of flour from the lorry ended up floating all over the canal, and a large crowd gathered to witness the unusual scene. The following morning, the Dock Company's diver fitted a sling to the rear of the lorry so it could be lifted by a salvage barge while the lorry was dragged up the slope by two traction engines.

Many of the barges being towed up the canal were carrying grain from Avonmouth or Sharpness to the mills at Gloucester, Tewkesbury, Pershore and Worcester, with some being transhipped into longboats at Gloucester to be taken on further into the Midlands. Many of the towed barges were former sailing trows owned by individuals or small firms like Jacob Rice & Son, but in the 1930s several of the mill owners started providing their own steel barges, and some of these were motorised and so did not need towing.

In the main docks area at Gloucester, there were two flour mills run by Priday Metford & Co. and  J. Reynolds & Co., each having a suction plant to discharge the wheat and each having their own limited storage accommodation. Some of the other warehouses were also used for grain, but this role declined as many of the local mills

without direct access to water transport closed down. Thus some warehouses were left vacant or let to builder's merchants or other firms who made no direct use of the canal. At Foster Brothers' mill on Bakers Quay, linseed and cotton seed were crushed to extract oil and the residue was distributed as animal food. The mill also processed peanuts and locust beans which were both popular with local children. When word spread that such a cargo had arrived, boys scavenged on the quayside for any that were spilt, and the more adventurous would get under the tarpaulin of a barge if the watchman was not alert. At Downing's malt-house, also on Bakers Quay, barley was brought by barge and made into malt for local brewers.

As well as the grain barges, there were many lighters that carried timber between Sharpness and Gloucester and sometimes went on up to Worcester or Stourport. Mousell Chadborn had over forty lighters carrying for Price Walker & Co., and G.T. Beard Ltd. had a similar number used by the other timber merchants. The Chadborn lighters were mostly steel, but Beard's were mainly former wooden sailing barges which tended to leak, and the crews often had to throw a mixture of ashes and sawdust over the side in the hope that it would be drawn into the leaking seams. Timber is a light cargo, so not only was the hold of each lighter filled, but timber was stacked up solidly eight or ten feet above deck level. To allow the helmsman to see over the timber, planks were left protruding at the back of the pile for him to stand on, and he had an extra long tiller that reached up to his position. Even so his view was restricted, so there had to be a man on the forward end of the cargo giving him directions when it came to passing through bridges or entering locks.

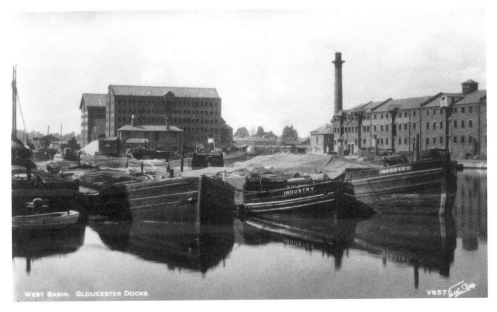

*Wooden barges that had once been sailing vessels in the Main Basin at Gloucester.*

*Gloucester Lock with the warehouses around the Main Basin in the background. The open gates in the foreground could be closed to divide the overall chamber into two adjoining locks which could pass a small vessel with less usage of water.*

A tug was occasionally required to tow rafts of pitch pine baulks secured by chains up the canal to Gloucester, although this traffic (and the use of Marshfield timber pond) had almost died out by the 1930s. There was no means of steering the rafts, and so they were kept close behind one another on short crossed ropes with men on them that could fend off when going through a bridge hole. Sometimes a baulk would break adrift, and then the tug had to stop while the men recovered the stray and refixed the chains.

The timber yards at Gloucester stretched for three-quarters of a mile along the east bank of the canal, with Price Walker & Co's main yard at the northern end, and then Ashbee Sons & Co., Price Walker's lower yard, Meggit & Jones, Nicks & Co. and Joseph Griggs & Co. When each lighter arrived, the wood was unloaded quickly by men who balanced one or more pieces on their shoulder and ran along a series of planks to the pile in the yard where their size of wood was being stacked. Each man had a leather pad to protect his shoulder, but the skin there could still get sore until it hardened up. As the piles went higher, so the running planks were raised up on trestles to a height of twenty feet or more. The men worked hard as they were paid by the job, and only men who were fit were chosen to join a gang. When the wood was sold, each piece had to be man-handled again to load it on to railway wagons. These were marshalled into trains along the line that ran through all the yards beside the canal. Price Walker was the largest importer, handling about 70,000 tons a year, mainly supplying wholesale merchants who took 100 to 150 tons at a time. The other merchants imported about as much again between them, and they distributed to smaller customers.

Further down the canal towards Two Mile Bend was a long yard used by S.J. Moreland & Sons who imported aspen and basswood logs for making matches and match boxes. The yard was known as Riga Wharf after the port in Latvia from which much of the early aspen was shipped. Although some logs were delivered direct to the wharf in small coasters, most came in big ships to Sharpness or Avonmouth and were brought up the canal in lighters. The logs were discharged by two steam cranes that ran on railway lines along the canal frontage. Most logs were stored in big piles in the yard and were sprayed with canal water in dry weather, but the drier ones were put into the timber pond at Two Mile Bend because it was important that the logs did not dry out and crack. In the middle of the yard was a saw mill which cut the logs into 22 inch long billets to suit the machines in the firm's main factory in Bristol Road. There the logs were peeled to produce a veneer which was cut up to make splints that eventually became matches.

The canal bank opposite Riga Wharf was a popular place for leisure activities. With easy access for Gloucester people via Hempsted Bridge, on fine days the towpath was crowded with people fishing, swimming, picnicking or just enjoying a walk. There were places where the bank had eroded leaving a shallow area where children could learn to swim, while the more adventurous liked to go across the canal and into the timber pond. The logs there were often packed in so tightly that it was possible to run across them like lumberjacks. The pond had a barrier of wooden posts with planks across to prevent the logs coming out into the canal, but boys found ways of getting a log through the barrier, and then three or four sat on it and used their hands to paddle it around.

*The men discharging timber lighters at Gloucester required a steady nerve to carry the deals while walking along narrow planks high above the ground.*

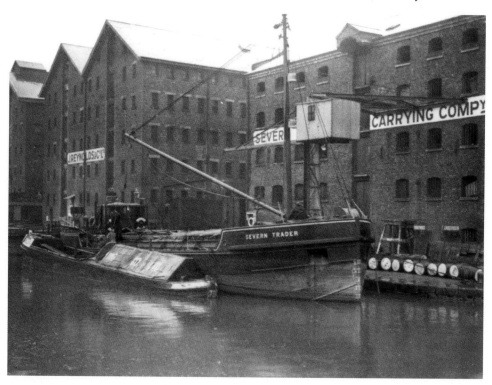

*The Severn & Canal Carrying Company's motor barge* Severn Trader *beside Biddles Warehouse at Gloucester. The barge's derrick is being used to transfer cargo to the longboat alongside.*

Quite independent of the grain and timber traffic, the Severn & Canal Carrying Company had a fleet of barges that carried a wide range of other cargoes collected from ships discharging at Bristol, Avonmouth and the South Wales ports. In the 1930s, the Company shortened it's name to the Severn Carrying Company and developed an efficient service transporting higher value goods, such as metals and groceries, on which higher rates could be charged. Cargoes destined for waterside sites in the Midlands were transferred to longboats at Gloucester using the electric crane on Biddles Warehouse on the corner of the Barge Arm. Increasingly, however, the trend was towards barge traffic to Worcester or Stourport with final delivery by road. With the help of investment from Cadbury Brothers, the Company introduced a new type of steel barge that was seaworthy enough to go to Swansea and could also navigate up the Severn as far as Stourport. Some like the *Severn Trader* were motor-barges while others were towed. As well as these dry cargo barges, the Company had a number of tanker barges that carried petroleum products from Avonmouth to Stourport. A few of the Company's longboats that normally took imports through to the Midlands were also to be seen on the canal, usually carrying raw materials to Cadbury's factory at Frampton or taking chocolate crumb from there to Bournville.

During the 1930s, there was a massive growth in the quantity of petroleum products carried on the canal, and the early use of coastal tankers was generally superseded by barges that loaded at Avonmouth. By the end of the decade, there were over twenty barges doing six to eight trips per month, many operating in pairs, with a motor barge towing a dumb barge. Some of these delivered to the depots around Monk Meadow Dock while others continued up the River Severn to serve depots at Worcester and Stourport. Most were owned by John Harker Ltd. of Knottingley or by the Severn & Canal Carrying Company, but a few were owned by petroleum companies.

One particularly large tanker barge was *Shell Mex 7* which carried 200 tons of petroleum and was always towed by a tug. One of her crew liked to have a wash before reaching Gloucester and often dived overboard to swill the soap off. Sometimes he started his swim by trying to walk along the tow rope towards the tug. One time he had a bet with the tug skipper that he could walk all the way, but after a good start, the tug skipper slowed his engine deliberately and the crewman ended in the water. He always left a rope trailing over the stern so that he could pull himself back on board, but he was often confronted by the tanker skipper's dog and usually had to splash water in the dog's face to get him out of the way.

One day when the Severn was in flood, there was a need to pump more petrol into a barge in Monk Meadow Dock to ensure it would go under one of the fixed bridges up the river, but in doing this irregular operation, some petrol was spilt into the dock.

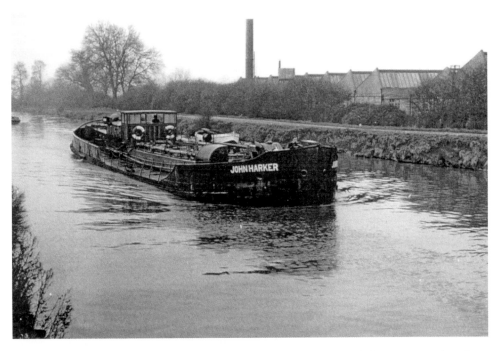

*Tanker barge* John Harker *passing the Standard Match Factory just below Hempsted Bridge.*

This spread across the surface of the canal, and when by chance someone in a timber yard on the other side was lighting a cigarette and threw away the match, the whole canal burst into flames! The lorry drivers in the depot at the time rushed to take their vehicles away, but fortunately the fire on the water quickly burned itself out.

There were some movements of coal in the 1930s, particularly the barges from Sharpness to Cadbury's factory at Frampton, but most of the small canal-side yards handling domestic coal were forced to close in the face of competition from rail and road transport. Some horse-drawn longboats were still used by Charlie Ballinger, an independent carrier who took cargoes like Moreland's matches and wheat to the Midlands and returned with coal for the bridgemen and other Dock Company employees. Longboats did not require the higher level bridges (Sims, Rea and Sellars) to be opened, but as the horse walked along the towpath, the bridgeman did have to take the boat-end of the rope from the boatman, walk across the bridge and drop it back to the boatman. Another local traffic was the collection of crude tar from local gasworks by the motor-barge *Kathleen*, which had a full-length deck with deck-mounted loading and discharge valves. She carried the tar to Butler's tar works at the Upper Parting, about two miles up the river above Gloucester, where it was distilled to provide a range of valuable chemicals. Butler's also had the larger barge *Carbolate* and a couple of longboats that were used for this work when needed.

Although most of the traffic on the canal in the 1930s comprised barges and lighters, by the end of the decade there were still two or three steamers each week bringing cargoes like sugar, cement, oil seeds, aspen logs and stone chippings for the roads. The maximum size of steamer was ultimately limited by whether it's straight sides and flat bottom would fit through the rounded under-water shape of the bridgeholes. With this shape of hull, there was no longer any need for the full 18 feet depth in the centre of the canal, intended for the deep-keeled sailing ships, and it had become usual only to dredge to a depth of 16 feet. However, constraints on the dredging programme meant that even this depth was not always available, and there were times when vessels drawing as little as 14 ft could be dragging along the bottom in places. Sometimes it was a vessel's beam that was a more limiting factor, and at least one ship had to be towed back to Sharpness after failing to fit through Purton Lower Bridge.

Most steamers going up the canal took a canal pilot who was licensed by the Harbour Master at Sharpness, and they always had two hobblers on the canal bank to take ropes when needed. The steamers proceeded very slowly and were difficult to steer in the narrow waters of the canal. If a ship went off line or needed help getting round a bend, the pilot could order a hobbler to put a bow or stern rope, as required, on to one of the many checking posts along the towpath, and the crew used a winch to help control the movement of the ship. On one occasion, however, the strain was so great that even a steel wire broke. The severed end flew back, cutting though the towpath hedge, and it was fortunate that there was no one standing nearby.

As well as putting a line ashore when needed, larger steamers were accompanied by a tug to help them steer round the bends and get lined up for the bridge-holes. The most difficult operation was rounding Two Mile Bend, as this involved a considerable

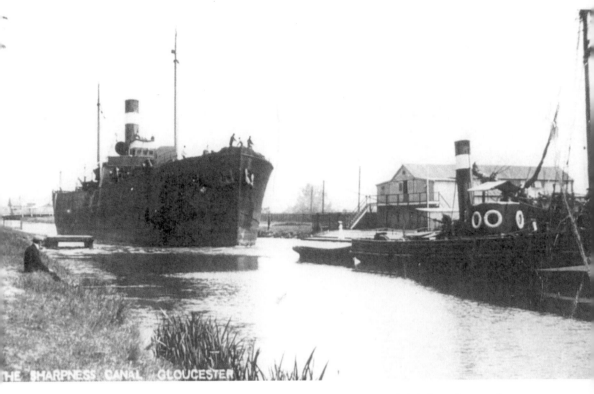

*Steam tug* Mayflower *assisting SS* Sappho *past Gloucester Rowing Club below Hempsted Bridge.*

sideways pull on the tow-rope which made the tug lean over. One time when *Mayflower* was towing SS *Abbas Combe* with a big deck cargo of bags of apples for Hereford, the bridle that constrained the tow-rope broke. For a moment, the rope went slack, allowing *Mayflower* to roll back upright and surge ahead, but when the tow-rope suddenly came taut again, the tug was pulled over even more than before and nearly capsized.

Particular care was needed when passing through a bridge hole as any contact with one of the open half-spans was likely to fracture its cast-iron spindle. Normally if this happened, the bridge was only moved sideways slightly and it was a routine job for the maintenance men to put it back into operation, but a more difficult recovery was required in 1933 after Sims Bridge was first damaged by SS *Otterhound* and then the displaced bridge was hit by SS *Pass of Ballater* and pushed right into the canal! Care was also needed when two steamers travelling in opposite directions were going to meet, and the pilots were warned what to expect from messages that were passed to the bridgemen via the canalside telephone line. When nearing the expected meeting point, one ship pulled into a lie-bye and the hobblers took lines and made them fast to mooring posts. Then the pilot blew a long blast and two short ones to signal the other vessel to come on by.

*Families beside the Cow's Drink, an inlet in the canal bank below Fretherne Bridge. A glimpse of Saul Lodge can be seen amongst the trees in the background.*

The steamers of the Bristol Steam Navigation Company were so big that it usually took them more than one day to travel the full length of the canal, pushing the water in front of them. When one came to a bridge-hole, the ship sank down and virtually came to a stop due to the water rushing in the opposite direction under her hull. Eventually, as the water came round her again, she rose up and started to move forward, but the pause allowed ample time for the pilot and the bridgeman to exchange news and views as she went through. A big steamer pushed so much water ahead of her that observers noticed a rise in level long before she came in sight. This was particularly apparent at the Cow's Drink, a sandy inlet on the green bank side below Fretherne Bridge where families enjoyed picnics and many local children learned to swim. Noting how the edge of the water moved relative to a stick pushed into the shelving sand gave considerable advance warning of a steamer approaching.

At Gloucester, the cargoes were discharged on the North Quay, the Western Wall (Llanthony Quay) or at the premises of the receiver. The Dock Company acted as stevedore, recruiting a gang of ten to fifteen men and providing one or two steam cranes as required. Occasionally a steamer discharged barrels of calcium carbide into the former salt warehouse near Hempsted Bridge. The warehouse was supervised by the Hempsted bridgeman, and he had to record what was delivered and what was taken away by lorry. When mixed with water, calcium carbide produces the highly inflammable gas acetylene, which was needed for oxy-acetylene welding and as a feedstock for the chemical industry. Occasionally a barrel was damaged and some carbide escaped. If the local boys spotted this, they liked to put a little in a bottle with some water, close the top and throw it in the canal causing a tremendous explosion!

One further group of vessels trading to Gloucester comprised small schooners and ketches that still used their sails when out at sea. Their numbers were steadily diminishing as motor barges became more common, and most eventually had auxiliary motors fitted for use when entering and leaving harbours. They usually arrived with loads of sand, gravel or road stone, and they left with salt which they took to the bacon factories in Ireland. Those without auxiliary motors usually accepted a tow along the canal, and hard-pressed masters would buy a tow-rope from a tug skipper, not realising that it had been thrown away by its previous owner. The master of the *Brooklands* was most annoyed when his recently purchased rope broke going round Two Mile Bend, but the tug skipper who had sold it consoled him with the thought that he could still make fenders out of it! To save the cost of the tug, some masters were known to do without a tow and use their sails instead, although this was strictly forbidden by the Bye Laws. Many of the owners and masters of these sailing vessels had their homes in the villages around Saul, and when they retired they liked to gather at the Junction, sitting on the beam of the lock gate having a good yarn about the old days. Among the last sailing traders to Gloucester in the early 1940s were the *Camborne* and the *Ryelands*, both owned by Capt. Shaw of Arlingham.

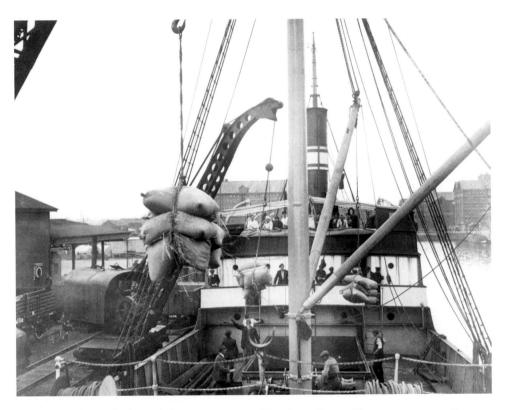

*Sugar sacks being discharged from a steamer at Llanthony Quay, Gloucester c. 1925. Two steam cranes are transferring sacks to railway wagons for the Midlands while the ships derricks are loading a longboat (off picture) for Cadbury's at Frampton.*

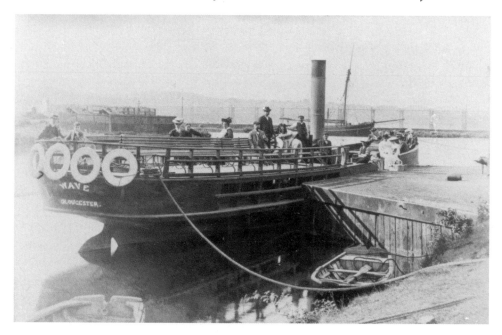

*Passenger steamer* Wave *at the landing stage at the north end of Sharpness Dock c. 1905.*

The growing use of road vehicles in the 1930s had a serious effect on the steam packets that carried passengers up and down the canal. The original *Wave* and *Lapwing* had been retired in the early 1890s and replaced by vessels of the same names. Under the management of a third generation of the Francillon family, these had continued to run regular services between Gloucester and Sharpness, stopping when required at any of the bridges to pick up and set down passengers. Gloucester people enjoyed a day out visiting the Pleasure Grounds at Sharpness, and inhabitants of the villages en route travelled to Gloucester for shopping. Sadly, these much loved vessels could not compete with the new motor buses, and they stopped running in the early 1930s.

In marked contrast to the big commercial vessels, the canal was also used by the boats of the Gloucester Rowing Club. At one time based in a shed on the canal bank opposite the Gloucester Wagon Works, the club built a fine new clubhouse just below Hempsted Bridge c1900. In the lower part of the clubhouse were stored racing boats and pleasure boats for use by members, and upstairs was a long changing room. On weekday evenings, practice sessions were held near to the clubhouse, while at weekends, the fours might row down to the Pilot Inn by Sellars Bridge or further on to Frampton, stopping for a pub lunch before returning. The Pilot Inn was also popular with pleasure rowers and their ladies, and a wooden landing stage was provided for them with steps leading up to the inn garden. If a rowing party encountered a big steamer, they needed to be careful because the steamer's propeller drew so much water from the side as it passed that the rowing boat was liable to end up aground on the ledge at the side of the canal for a time!

In the 1930s, the Rowing Club's annual open regatta was held on the long straight reach north of Parkend Bridge. The races finished near the bridge, and tents for officials and for the bar were erected on the green bank side where most of the spectators gathered. Senior crews brought their own veneer shells, but Junior and Maiden crews rowed in boats provided by the regatta organiser. As well as local crews from Worcester, Ross, Hereford and Monmouth, the event often attracted visitors from as far away as Birmingham, Cardiff and Liverpool. The organisers were warned when to expect any commercial boats coming through the course, and the programme was arranged accordingly. A particular highlight every few years was a race for the solid silver West of England Challenge Vase, which several clubs took it in turns to stage at their annual regatta.

In 1935, the boys of Wycliffe College at Stonehouse started rowing on the canal, and in the following year the college built a clubhouse at the Junction. For practice, the boys rowed up as far as Parkend Bridge and down through Fretherne Bridge. They always enjoyed going down the canal because at Cadbury's factory they used to go close to the side, looking exhausted, with the result that they always had a few lumps of chocolate crumb thrown out to them. On some outings, the rowers encountered a string of barges under tow and knew to keep well to the side of the channel. Normally, they could easily overtake, but if they were approaching a narrow bridge-hole, this was not possible, and so the boys developed the art of slipping in between two barges underneath the tow rope and then pulling clear again when through the bridge.

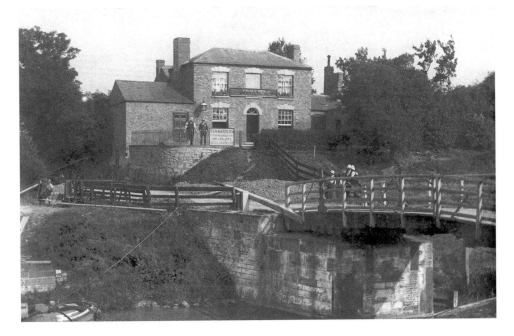

*The Pilot Inn beside Sellars Bridge c. 1910.*

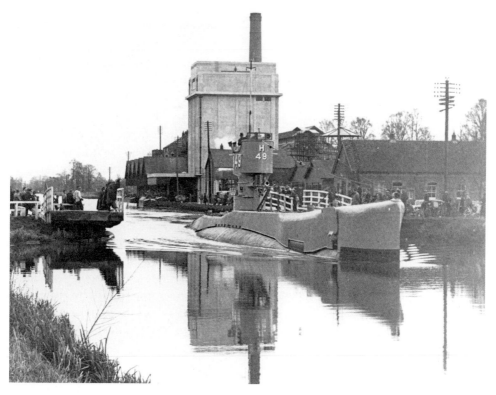

*Submarine H49 passing through Fretherne Bridge after a courtesy visit to Gloucester in March 1937. In the background is Cadbury's factory.*

# Memories of Maintenance Work

In the 1930s, the Dock Company employed over one hundred men on the maintenance of the canal and the dock estates. The main team was based around the engine house at Gloucester where the workshops had facilities for the blacksmiths, platers, fitters and carpenters who looked after the Company's main plant. Much of their work involved regular maintenance on the tugs and the dredger, making use of the nearby dry docks. The dry docks were also used for work on commercial cargo barges, and in 1939 the large dry dock was granted exclusively to Gloucester Shipyard Ltd, set up by John Harker and the Severn Carrying Company to maintain their steel barges. Other jobs for the Dock Company's Gloucester men included maintaining the dock railways and the warehouses and helping with major jobs anywhere on the canal when needed. Also, the foreman was occasionally asked to find someone to go and dig the Engineer's garden or do some fencing!

Another small team was based at the Junction, sharing an area on the green bank side with Bob Davis's boat repair yard. The Dock Company had a large wooden carpenter's shop, with work benches and a treadle-operated lathe, and a smaller blacksmith's shop with a hearth having hand operated bellows. They also had a saw-pit for cutting up trees and an open area for assembling lock and dock gates. The small group of craftsmen based here were responsible for maintaining and repairing all the wooden structures on the canal, such as the  bridges and the gates for the locks and dry docks.

When the craftsmen received a call that a bridge had been knocked off its pivot by a passing vessel, they took all their equipment to the bridge in a hand cart or by bow-hauling a small boat. If the bridge was not badly damaged, the first step was to jack it up on wooden blocks which included wedges at the top that were lubricated with soft soap. These wedges were then hit with a heavy hammer to move the bridge back over its proper position, the broken spindle was replaced with a new one and the jacks were lowered to leave the bridge on its new spindle. Normally, the men could manage all this entirely with their own hand tools, but occasionally a bridge was displaced so badly that they had to call for the assistance of the Company's wrecking barge. When a completely new bridge was needed, the beams were cut to shape in the saw pit at the Junction, and the joints were formed in the yard. Then the components were taken to the site of the new bridge and assembled there. While a bridge was out of action, the

bridgeman was given a heavy punt that he used to ferry pedestrians across the canal. If a repair was going to take more than a day or two he put a rope across the canal so he could pull the boat from one side to the other.

The craftsmen at the Junction were also responsible for making new lock gates, dry dock gates and stop gates when required. The stop gate beams were cut twelve inches square from oak that was as green as possible, as minimum buoyancy was needed. The beams were shaped and assembled in the yard at the Junction, the larch planking was added and the complete gate weighing about eight tons was launched into the canal and left to soak. When two were ready, they were towed to their site, tilted upright by a floating crane and guided into position by a diver. If the gates ever had to be used, any small leak could be choked by churning up the mud and dropping in sawdust, but the effectiveness of the gates relied very much on the skill of the makers, and much importance was attached to ensuring that they were of the highest standard. When one old gate was dismantled, it was found that the joints had been so well made that a page of newspaper in one joint was dry and quite readable in spite of having been under water for eighty years or so.

Sharing the site at the Junction were Bob Davis and his shipwrights who were mainly involved in repairing wooden barges in the dry dock. They had a big pile of trees supplies by Workman's saw mill at Ryeford, and Davis chose the pieces that had the shapes he wanted for the job in hand. These were cut roughly to size on the saw pit and finished with an adze and a plane.

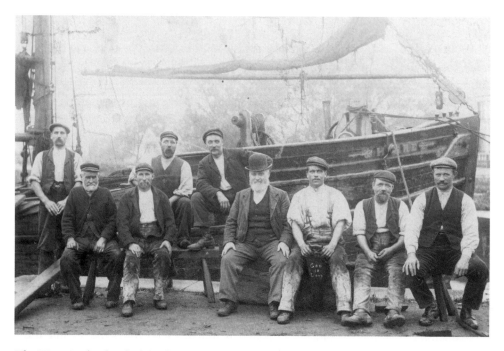

*The* Higre *in the dry dock at the Junction c. 1920. The men in the foreground are boatyard workers, members of the crew and probably the owner in the bowler hat.*

*A 40-ton flat (maintenance boat) in the dry dock at Saul Junction. The vessels in the background are on the Stroudwater Canal and the building was originally the boathouse for the Dock Company's ice boat.*

Before fitting a new plank to a barge in the dry dock, the plank was drilled to take the spikes and then put into a steam chest to make the wood pliable. When the plank had soaked for a time, it had to be moved quickly into position with bits of sacking wrapped round where it was held because it was so hot. Everyone had to work together, driving the spikes in at one end, bending the wood round and hammering in more spikes at the other end. Later, all the joints had to be caulked with oakum. The oakum was pushed in to the joint with a caulking iron that was hit with a caulking mallet, and this made a distinctive ringing sound that could be heard hundreds of yards away. As well as repairing barges, Davis's men also did work on pleasure craft, for which some use was made of the boathouse adjoining the Stroudwater Canal that had originally been built for the ice-boat.

The dry dock at Hempsted was another facility for the maintenance and repair of cargo barges, and it was also used for the annual inspection of passenger boats. The dock gate was a single flap hinged along the bottom, and after a vessel went in, the gate was lifted up into position, but it was never a good fit. As the dock was being drained, it was necessary to spend time pulling up the mud from the bottom of the canal in the hope that it would accumulate in the cracks and stop the water leaking in. The dock drained into a stream that ran in a culvert under the canal and on down to the River Severn. Unfortunately, the drain valve did not work in reverse so that when the Severn was in flood, the stream tended to back up, and water rose in the dock bringing repair work to a halt.

A third group of Dock Company men looked after the operational facilities at Sharpness and many of the buildings on the dock estate. Regular jobs included maintenance of the hydraulic system, the steam cranes, the wooden piers and the dock railways. Every few years there was a need to take out and service one pair of the iron lock or entrance gates. The lower lock gates and the entrance gates were of the same size, and these were replaced in turn using a spare pair that had once been intermediate gates in the lock. Before removing a gate, the holes normally present in the upper chambers were first sealed to increase buoyancy, and then it was relatively easy to lift the gate clear at high water. Putting in the replacement was more difficult because a pintle on the bottom of the gate had to be fitted into a cup, requiring guidance from a diver to those controlling the lift, and there was only about forty minutes to do this even on a very high spring tide. The replaced gates were put in the dry dock, cleaned, tarred inside, painted outside and made ready to be used again. While the gates were awaiting re-use, it was not unknown for adventurous boys to squeeze into one of the foul smelling interiors in spite of the almost asphyxiating atmosphere! For the upper lock gates, there were no replacements, and so while these were being serviced it was necessary to use the whole tidal basin as the lock, which required much extra pumping at Gloucester.

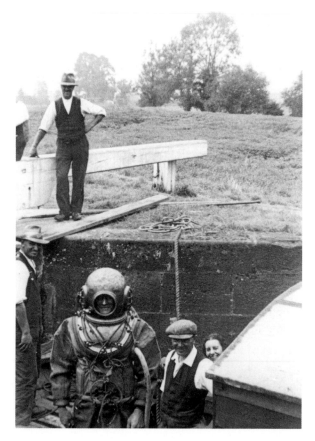

*The Dock Company's diver, Joe Lane, in the lock at Saul Junction. The diver regularly checked lock gates and sills and carried out repairs when needed. He also worked on dock walls, stop gates, culverts and bridge abutments, and he assisted with the raising of sunken vessels.*

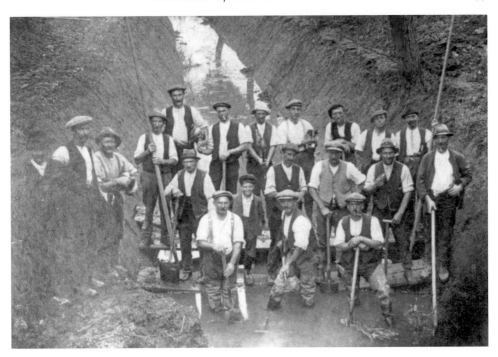

*The bank gangs combined to clean out the channel of the River Frome in the 1920s.*

For the routine maintenance of the canal banks and towpath, there were about twenty men divided into three gangs covering Sharpness to Frampton, Frampton to Parkend and Parkend to Gloucester. Additional men from Gloucester were available for special jobs. Each gang had a wooden boat to carry tools, with a hut on it to provide a mess-room, and this "houseboat" was moved from one place to another by bow-hauling. The bank foreman rode along the towpath two or three days each week, and he told the men in charge of each gang where to go next after they had finished what they were doing. As well as being used by occasional horses, the towpath was regularly used by cyclists (particularly the passmen who opened the bridges), and it was kept in good condition by spreading small stones or burnt ballast. The ballast was produced by mixing slack coal with clay in a huge pile covered with turf and keeping the pile burning for months. The ballast was burned at Hempsted and at Purton, and it was taken to wherever it was needed in a 40-ton flat (maintenance boat).

Every summer the grass was cut with scythes, and the hay was taken by boat to be made into a rick on the wide area by the towpath north of Sandfield Bridge. Hedgerows were cut regularly, and willows were pollarded from time to time. In the ditches that the Dock Company was responsible for, such as those created at the time the canal was built, the undergrowth was kept under control, and the grill on the entry to each culvert was cleared of debris to keep the local field drainage in good order. Clearing the Black Brook near the dry dock at Hempsted was particularly unpleasant, as the water was polluted with waste from the gas works that could ruin a pair of

boots. One consolation, however, was that the wife of the bridgeman who lived in the nearby house liked to give the men a supply of her home-made wine.

Over the years, the wash caused by passing vessels eroded the banks in places, and where this threatened to cut into the towpath, there was a need to carry out remedial measures. If the affected area was small, a line of well-spaced vertical willow stakes was driven, bundles of willow branches were laid down and clay was filled in behind. Where a longer length of bank needed more permanent protection, this was provided by driving piles made from a very hard red wood called jarrah, and the space behind was back-filled with mud from the canal using a grab on the floating crane *Briton Ferry*. A certain amount of steel piling was also driven, particularly along the frontages of the timber yards near Gloucester. Initially, this was done by building a guide frame on the bow of the *Briton Ferry* and hanging a steam hammer from the jib, but later a special piling flat was built with its own boiler. When the rig was working, the repeated pounding of the hammer on the piles could be heard over a wide area. There was also renewed concern about erosion of the long bank between the canal and the River Severn below Purton due to a change in the position of the main river channel. Over the decade, more barges were put up on the bank and more stone was deposited to try to prevent further erosion.

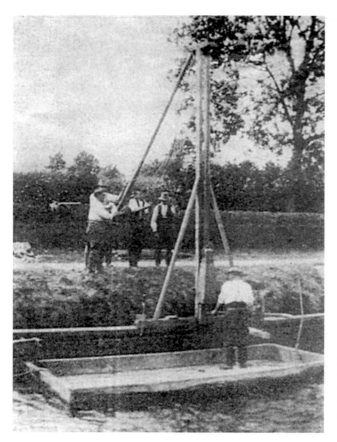

*Driving wooden piles with "the monkey up the stick". Two men each side pulled on ropes to lift the hammer and then let it drop, and this they repeated time and time again until the pile was in place.*

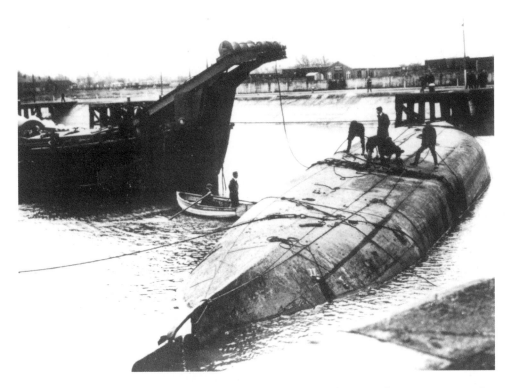

*Preparing to right the tanker barge* Severn Carrier *in the tidal basin at Sharpness in 1939. On the left is the Dock Company's wrecking barge* Europa.

In case any vessel sank in the canal, the Dock Company had a old wooden wrecking barge that had been officially renamed *Retriever*, although the men continued using its original name *Petrus*. This was condemned after it helped to recover the lorry that went into the canal at Hempsted Bridge, and in 1931 a former steel grain barge called *Europa* was fitted with the out-riggers and winches from *Petrus* and ballasted with stone sets that had been removed from Southgate St. This was used successfully for raising various barges and workboats, and it was sometimes needed to lift a badly displaced bridge-span. Perhaps its most difficult operation was in righting the tanker barge *Severn Carrier* that had overturned in the river outside Sharpness. On the night of 4 February 1939, *Severn Carrier* and two other tankers got into difficulties after a tow rope parted on a strong spring tide. In the confusion, they were carried past Sharpness Point, collided with a pier of the Severn Railway Bridge and six crewmen were drowned. *Severn Carrier* was found the next day upside-down and was towed back into the tidal basin at Sharpness. In due course, wires were put round her and attached to *Europa*, but the exercise was fraught with difficulties and it took four attempts before she finally rolled upright again.

The *Europa* was also used out in the estuary when the Harbour Board's mooring at Northwick Oaze needed attention. At low tide, the barge could lift the various

components of the mooring and bring them back to Sharpness for maintenance. On one lift, however, some rivets from the side of *Europa* fractured with loud bangs and flew past the crew like bullets. They managed to finish the lift, but it broke her back and she was not used much again. The Dock Company's men also did all the maintenance work on the lights in the estuary on behalf of the Harbour Board. The nearer ones were reached by rowing boat, leaving Sharpness three or four hours after high water and coming back on the first of the flood. For the two more distant beacons marking the Shoots channel (below Beachley), a tug was also provided, and a period of spring tides was chosen as the water went out further at low tide. For a job near Sharpness, the spring tides were not a good time because there was so much water coming down the river at low tide, and for the lowest water it was best to choose the third shooting tide (ie three tides after the lowest neap tide). The work done included changing gas bottles, painting and repairing damage. If a beacon had been knocked down, a gang of eight men went ashore with a telegraph pole to act as a lifting pole, and they used ropes and pulleys to set up the beacon again before refixing the chains. They only had a limited time to do the work and always kept an eye on the tide.

Maintaining a proper depth of water in the canal required a regular programme of dredging using No 4 steam dredger. When at work, the position of the dredger was maintained by three wires, extending ahead and to each side, which were attached to convenient checking posts or bushes on the banks. The bucket ladder was lowered to the required depth, and with the buckets turning, the skipper could use on-board winches to move the dredger from side to side across the canal and edge it forward between sweeps. The centre part of the canal was usually dredged to a depth of about 16 feet so that, even after some subsequent silting, the canal could accommodate vessels up to 12 ft. 6 in. draught. The excavated mud came down a chute into a 40-ton flat (barge) containing 14 or 16 open-topped mud boxes. When one adjacent pair of mud boxes had been filled, a flap on the chute was closed while the flat was moved along, and then the mud was directed into the next pair of boxes. When all the boxes in the flat were filled, the men cleaned off the surplus mud and replaced the full flat with an empty one. If any traffic needed to pass, the dredger had to suspend operations and slacken off the wire across the canal. An approaching vessel drawing more than 11 feet of water gave two long blasts and a pip on her whistle as a warning, and when all was clear the dredger sounded one long blast and two short. In some remote parts of the canal, the crew could be working with little supervision for days at a time. On one occasion, while dredging below Slimbridge, the skipper used his shotgun to shoot a goose that was flying over and then went and collected it from a nearby field.

Normally the dredger just excavated mud that had accumulated in the bottom of the canal, but occasionally it was required to remove harder material from the sloping sides of the canal or where the bank had slipped. The worst thing to dredge was clay, such as at Two Mile Bend, as it could build up in the buckets and had to be dug out with a long-handled spade. The dredger also found hard sand near Sandfield Bridge, stretches of peat from Patch Bridge to Purton and rocky sides around the Purton bends.

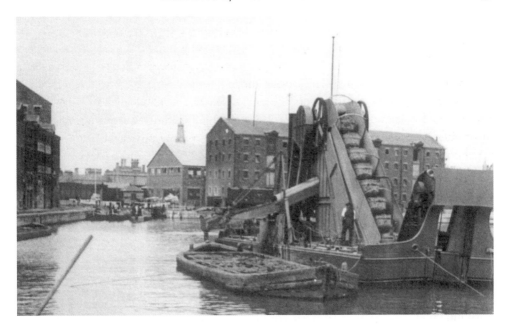

*No 4 steam dredger at work in the Main Basin at Gloucester.*

When working in Sharpness Dock, it was not easy to lay out the wires at the beginning of the day because of the width of the dock. As a crewman sculled the boat with the wire across the dock, it became more and more difficult as the wire dragged in the mud on the bottom, and sometimes it was not possible to get right to the other side. Then it was necessary to tie a rope to the end of the wire, get that ashore and use it to pull the wire in the remaining distance. The lower part of the dock was dredged to a depth of 24 feet to accommodate the big ships, and the depth of the upper part gradually reduced as it merged into the canal. Sometimes the buckets brought up a bit of red material, indicating that they were scraping the marl at the bottom of the dock, and occasionally they hit a lump of hard rock, making the whole dredger shudder so badly that it was necessary to stop the engine. When working at Sharpness, one crewman who cycled down the towpath from Slimbridge did not like the long detour via the old locks and so he improvised his own ferry across the old arm. Using a heavy plank about one foot wide, he crouched on the plank with his bicycle on his shoulders and paddled himself across!

There were various awkward corners, such as around dock or lock gates, where it was not practical to use No 4 dredger. Instead, the material was removed by fitting a grab to the floating crane *Briton Ferry*. This method was also used to remove mud from the small dry dock at Gloucester. This was particularly needed after a dry summer, as the dock received all the water sucked in from the River Severn by the pump in the adjoining engine house, and the silt suspended in the water tended to settle out in the dock. Another role for the *Briton Ferry* was to clear mud from the chambers under the canal stop gates, which were regularly checked to ensure they could be closed in the event of any emergency.

Dredging operations typically removed 35,000 to 40,000 tons of mud from the canal and docks each year, and this was disposed of by tipping into the River Severn or on to fields adjoining the canal. When the dredger was working near the Sharpness end of the canal, the 40-ton flats carrying the mud boxes were taken to the lock at the old entrance, where each box was lifted by a floating steam crane and the contents tipped over the sea wall and down a wooden chute on to the foreshore. When the tide was out, a local resident made a habit of walking along the shore below the chute, and he often found things like coins and watches that had been tipped with the mud.

When the dredger was working nearer the Gloucester end of the canal, the steam crane tipped the mud on to fields adjoining the canal. In earlier years, the Dock Company had had agreements with farmers to use fields beside Stonebench Turn and at Whitminster, and they had purchased land near Pegthorne Bridge. In the 1930s, the Company used a field below Hardwicke Bridge and bought more land near Pegthorne Bridge. At whichever site was being used, the mud was tipped into a wooden chute from which it spread over the field, and the chute was moved along from time to time so that an even wider area was covered. Where necessary, banks were formed to stop the mud spilling into the local drainage ditches. So much mud was dumped on some fields that the new surface ended up several feet above the original ground level, and this was particularly helpful in the Pegthorne area as it reinforced the massive canal embankments that had long been a worry to successive Engineers.

Initially, the dumped material was so soft that it was of no use to the farmer, but it was very fertile and many different plants grew naturally. These included large quantities of gooseberries and tomatoes that came from seeds deposited in the canal by the primitive sewage arrangements on boats at that time. In an area near the seven mile post from Gloucester, hundreds of willow trees came up, and cuttings from these were made into bundles for repairing the canal banks or taken home as bean sticks. In later years a number of very rare marsh warblers were spotted in the willow plantation, and for a time it became a bird sanctuary.

No 4 dredger was designed to remove 350 tons of mud per hour and was capable of more, but this potential could not be utilised as the crane discharging the mud boxes could only handle about 300 tons per day. To try to overcome this limitation, two large hopper barges with opening bottoms were hired from the Llanelly Harbour Trustees in 1934 and used to dump mud in the river outside Sharpness. On each tide, they were taken out of the entrance and round behind the Old Dock, where the bottoms were opened and the mud released. Over the four weeks of the trial, the average disposal rate was about 1000 tons per day, and this success persuaded the Dock Company to order two new hoppers from Charles Hill & Son of Bristol to continue the good work. In June 1937, however, the channel pilots complained that the dumping of mud in the river was causing the shifting of sand banks, and they gave notice that until it was stopped they would allow an extra margin on the depth of water required to dock a vessel. The Dock Company's Engineer argued that the changes in the sand banks were actually due to natural fluctuations in the amount of fresh water coming down the river, but it was considered prudent to humour the pilots and the dumping was stopped.

For clearing mud from the tidal basin and the entrance at Sharpness, it was usual to employ the scraper boat. This had a vertical pole over the stern with a big wide blade on the bottom that was lowered down into the mud, and it had winches to pull itself around using wires attached to the shore or to the piers. The procedure was to scrape the mud towards the middle of the basin and then open the lashers to let the water wash the mud away.

In the early years of the Second World War, a major programme of dredging was started at Sharpness in connection with the construction of new quays along the west side of the dock where there had formerly been just a shelving bank. This work had to be done to a schedule, in spite of the blackout conditions and the wartime shortage of crew members, and it required long working hours for the men involved. A continuing difficulty was that the rate of dredging in the dock was still limited by the capability of the discharge crane by the old lock. This was eventually overcome in 1944 by the provision of a suction plant for emptying hoppers, designed by Assistant Engineer Tom Askew. Two pumps were installed on a floating pontoon that was moored at Purton. One pump put water into a hopper to liquefy the mud while the other pump sucked out the slurry and pushed it over the sea wall and on to the Severn foreshore. With the purchase of additional hoppers, this plant could match the output of No 4 dredger, and it became the means of disposing of all future dredgings. Rather than leave spare hoppers moored nearby, vulnerable to the wash of passing tanker barges, a new entrance was made into the former Marshfield timber pond opposite, and unused hoppers were put in there out of the way.

*The floating suction plant at Purton. The liquefied mud was pumped into the river through the horizontal pipe (upper left).*

*A mud hopper being pumped out by the suction plant at Purton but leaving some material that was too lumpy to be picked up by the pump.*

When the dredger was working in the docks at Sharpness or Gloucester, the hoppers just contained soft mud that had come from the river, and this was easily removed by the suction pump. When the dredger was working on the sloping sides of the canal, however, the hoppers often included lumps of material that could not be readily pumped out, and this gradually accumulated in the bottom. When this accumulation became a nuisance, a floating crane with a grab was used to remove the debris and dump it over the sea wall near the Severn Railway Bridge. Sometimes, other things were found in the bottom of the hoppers. In the early days, these included a number of bombs that had presumably fallen into the dock at Sharpness during transhipment. One man recovered a Timex watch that was still in working order, and while he was washing the mud off it, his mate said "Don't do that - you'll get it wet"! Some years later, the suction plant was used to recover jewellery stolen from Mann's shop in Gloucester which had been dumped in the Victoria Dock while the thief was being chased by police. Mud from the bottom of the dock was grabbed out by the floating crane *Iron Duchess*, and the hopper containing the mud was pumped out at Purton under close police supervision.

During and after the Second World War, there was much concern about the accumulation of mud around the entrance at Sharpness, and as the scraper was no

longer in working order, various other means were experimented with to try to keep the channel clear. Initially, the dredger was used, working shifts to suit the tides, and the crew slept on board when it settled on the mud between tides. On one occasion, the crew had a bad fright when they awoke to find water pouring in through the port holes, as the flat bottom had stuck in the mud when the tide came up. The crew quickly got the buckets turning and the agitation was enough to break the suction, but after this scare, wooden baulks were fitted under the dredger to stop it happening again. Another idea was to lower a mechanical contrivance with a shield down on to the mud, with the idea of it pushing the mud into mid channel so it could be scoured away, but the machine broke down just as the tide was beginning to make, and it was completely overwhelmed! A string of explosive charges was put into the mud bank, but when the man in charge pressed the plunger, nothing happened! Better progress was made after a floating crane was created by running a railway crane on to the pontoon *Endeavour*, and this picked up mud with a grab and dropped it where it could be scoured away. Even better results were achieved by arranging a number of partly loaded hoppers across the entrance as the tide went down so that, when the lashers were opened, the hoppers deflected the scour where required.

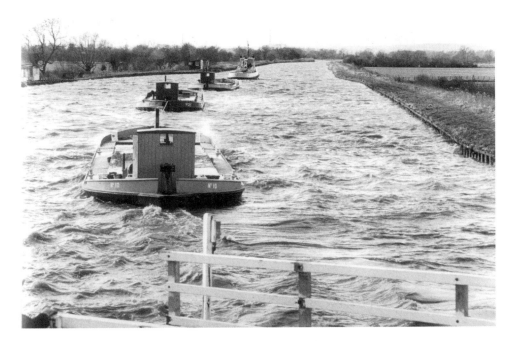

*Three loaded mud hoppers under tow below Parkend Bridge.*

# II

# A Late Flowering

The outbreak of the Second World War brought great changes to those working on the canal and led to a new period of improving facilities. During the previous decade, the directors had been happy to oversee a huge growth in barge traffic with the only significant investment being the modernisation of the hydraulic mechanisms for operating the gates and sluices at Sharpness. This had involved replacing the ageing boilers and water pipes with an oil system powered by electric pumps in 1937.

The first obvious development was the arrival at Sharpness of the former sailing ship Vindicatrix in June 1939. She was moored in the arm leading to the old entrance to provide accommodation for the staff and boys of the Gravesend Sea School, as their original premises were thought likely to be a target for bombing. The role of the school was to train boys as deck hands and stewards for the merchant navy, the courses lasting two to three months. Initially, the ship was the school's only accommodation, but later a camp of huts was built nearby and then the ship was primarily used for tuition. Life on board was made a close reproduction of the conditions of sea service, with watches kept night and day, time signalled on the ship's bell and navigation lamps trimmed and lighted. The boys were taught ropework, boat handling, signalling, knowledge of the compass, cleaning and serving in the mess, and when they left they were found employment on a ship.

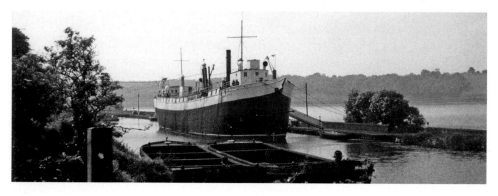

*The training ship* Vindicatrix *in the Old Arm at Sharpness in 1966.*

The outbreak of war in September 1939 had a marked effect on the number of steamers using the canal and docks as much of the previous trade from European ports ceased. However, the steamers that did come to Sharpness needed to be discharged quickly, and with reduced manpower it was frequently necessary to extend working hours from eight to twelve or even to eighteen a day. Much shipping was diverted from London and Southampton due to bombing, and the lower Bristol Channel ports had to take on a much larger share. To ease pressure on the railways, as much use as possible was made of water transport to get the goods dispersed inland, and six new *Sabrina* barges were built for this traffic. The dry cargo barges and the tanker barges working out of Avonmouth were pooled into two groups, each run by a controller, and the crews worked round the clock with the men sleeping on board when they could. Storage was at a premium, and warehouses at Gloucester which had not been properly used for years were filled with grain again. Discharging operations were occasionally interrupted by air raid warnings, but the only actual damage to Dock Company property was in November 1940 when a bomb destroyed part of the towpath near Hardwicke Bridge and put the Company's private telephone line out of action.

Early in the war, one side of Pegthorne Bridge was knocked off its pivot by impact from a passing vessel. The damaged span was taken to the Junction maintenance yard - supposedly for repair but in fact nothing was done. As had happened in earlier years, there were some complaints from local walkers, but during the war it was possible to ignore them, and the bridge was never replaced. Although all traces of the bridge were later removed, the bridgeman's shelter survived, being 7 feet by 6 feet with a small fireplace, a door and two 5 inch square squint holes so the bridgeman could watch for approaching vessels.

Soon after the outbreak of war, the Government took control of most imports, and former merchants became agents who handled goods for a fee and sold at a fixed price to those who had a licence. Grain and timber continued to be carried up the canal for the mills at Gloucester and further inland. To reduce the risk from enemy action, stocks of timber were dispersed from the big yards near Gloucester to small sites on the canal banks and elsewhere, and this allowed parts of the former yards to be requisitioned by the Government for other purposes. Thousands of tons of coal from South Wales were brought into Sharpness and dumped in huge piles as a strategic reserve, and when the Americans came, they liked to drive their jeeps over the top of the piles for fun. Other dry cargo imports included metals, foodstuffs, carbide, fertilizer, paper and tobacco. At the same time, there was a huge growth in the carrying of petroleum products on the canal, much of it needed for service vehicles and aircraft.

To help cope with the additional traffic being handled by the Bristol Channel ports, the Government provided financial assistance for a number of improvement schemes. The main development at Sharpness was the construction of 1100 feet of quay wall along the north west side of the dock with additional railway lines and eight electrically operated cranes. The work was carried out by the Demolition and Construction Company in two phases between May 1940 and November 1942, although the dredging of deep water berths was completed later.

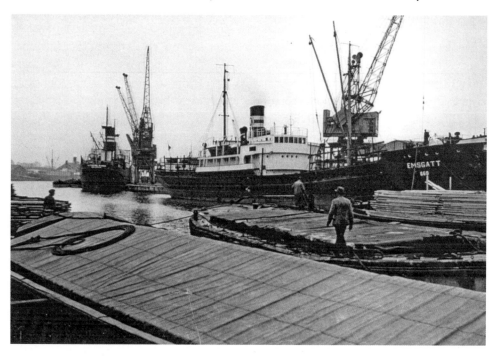

*Electric cranes discharging timber from steamers moored beside the new quay at Sharpness in 1952.*

The role of the barges in moving cargoes inland was considered so important that new gates and lasher gear were fitted to the old entrance at Sharpness so that it could provide an alternative access to the docks and waterway in the event of the main entrance being damaged by enemy action. This scheme included the demolition of the original part of the former Harbour Master's house and it's replacement by a single-storey kitchen and bathroom. A further development at Sharpness was the construction of a new access road to the west end of the docks in 1941, which became known as the Burma Road.

The additional facilities at Sharpness helped the port to play a significant role in the war effort. For the first time, ships bringing timber could moor by a quay wall, and the electric cranes speeded up the discharge of cargoes. As well as timber, the crane drivers soon found they were handling all kinds of supplies for the American troops that were gathering in Britain. Many of these supplies were stored in the timber sheds under the guard of a detachment of American troops camped near the football field. For a few shillings, it was possible for local residents to buy almost anything from jars of jam to pairs of trousers. Stocks of weapons also accumulated, and then in connection with the North African invasion, 40 ships were loaded with about 30,000 tons of shells, bombs, food and general stores. To help keep the additional barge traffic moving, the steam tug *Addie*, which had been tied up at Gloucester for years, was bought by the Dock Company and fitted with a powerful diesel engine in 1943.

Along the canal, there were three major war-time construction projects financed by the Government. Near to Sandfield Bridge, two large sheds were built in 1942 as strategic food stores and a jetty was constructed for the use of barges. Just above Hempsted Bridge, six huge tanks were buried in the hillside in 1942-43 to form a strategic reserve petroleum store. A pipeline provided a link from the Shell-Mex depot at Monk Meadow, and another ran across the fields to a can-filling plant at Elmore, but in the event these facilities were never commissioned. The third project was a silo for 5000 tons of grain that was built at Monk Meadow in 1943-44. This was used to dry and store the produce from local farmers, who were encouraged to grow as much as possible to help reduce imports, and some wheat from the silo was shipped out to Swansea.

From spring 1943 to autumn 1944, the Wycliffe College boat house at the Junction was taken over as an outstation of No. 238 Maintenance Unit which looked after new RAF boats prior to them going into service. The largest were air-sea rescue launches with three powerful engines and two gun turrets. Other boats included air-sea rescue pinnaces and seaplane tenders and bomb-scows for servicing flying-boats. The boats were moored along the Stroudwater Canal, on which commercial traffic had died out a few years earlier. The unit's job was to keep the boats clean, run the engines and test the electrical equipment to ensure everything was in first class order for when they were required. The College boathouse served as a workshop and store with a mess-room above.

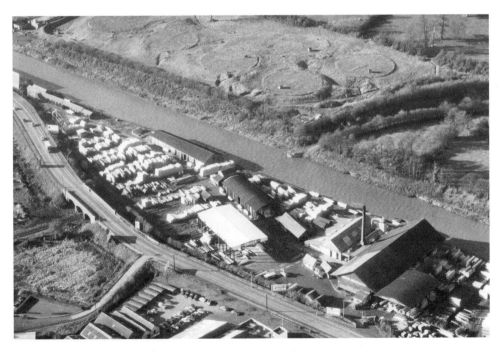

*Joseph Griggs & Co.'s timber year near Hempsted Bridge with circles on the bank opposite marking the sites of underground petrol tanks. Also to be seen is the cutting for the Midland Railway line that once crossed the canal on a swing bridge.*

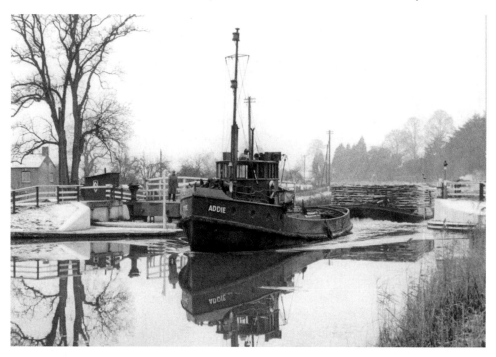

*Diesel tug* Addie *towing timber lighters through Fretherne Bridge in January 1962.*

Special war traffic at Sharpness reached its climax in 1944, when the familiar cargoes were supplemented by a wide range of military stores destined for the American forces during the invasion of Europe. Some arrived by ship, some came down the canal and much arrived by train. Large areas were set aside for the storage of petrol in jerry cans prior to shipment, and dockers worked long hours to load the material into ships that were recorded as "On His Majesty's Service". Over a period, some 50 ships were loaded at Sharpness with about 50,000 tons of petrol, ammunition and general military stores destined for the soldiers fighting in France.

Following the end of hostilities in 1945, traffic into Sharpness quickly fell back to pre-war levels. In October that year, a particularly severe storm did much damage to the entrance piers, the sea wall and other property. The waves in the river were so bad that after vessel movements were completed the lockmen were not able to close the entrance gates to the tidal basin. The waves came right into the basin, and as the wind had also increased the height of the tide, there was great concern about flooding the shops beside the lock. The waves were also preventing the discharge of cargo from a ship moored to the jetties in the basin as the lighters were being tossed up and down so badly. After several attempts, a rope from the ship was attached to a lighter, but when the lighter went down into the next trough the attachment was torn away from its mounting. With the tide ebbing and concern growing that the ship might be stranded, the lockmen eventually managed to close the entrance gates, and much relief was felt as calm returned to the tidal basin.

The weather created a different problem in March 1947 when a rapid thaw of snow accompanied by heavy rain caused large volumes of water to flow into the canal from the various feeder streams. All sluices at Sharpness were opened, including those at the Old Dock, and water was running over the top of the main lock gates. The waste weir at Purton was lowered by knocking bricks out with a sledge-hammer, the nearby dredging suction plant was used to pump water out of the canal and water was also run out through the sluices at Gloucester Lock. In spite of all this, the level rose to eighteen inches above normal, and water began to seep over the canal bank at Pegthorne and near the Marshfield timber pond. Fortunately, the level then stopped rising and no serious damage was done. While this was going on, it was not possible to use the lock at Sharpness because so much water was running over the upper gates that the lock could not be emptied to allow the lower gates to be opened. Craft which had arrived from Avonmouth had to remain in the tidal basin for 24 hours, and another locking was missed on the following day.

As traffic movements at Sharpness gradually returned to normal, concern moved to the river at Gloucester which was being affected by melting snows further north. As the river rose over the next few days, additional planks were added to the top of the flood gates at the lock and a sandbag wall was built at each side of the lock up to the level of the nearby Severn Road. If the river had risen above the road, nothing could have been done to stop it flooding into the canal. In order to prepare for the worst, the canal water level was lowered by one foot to provide a reservoir to take any flood water, and pumps were provided to canalside firms who relied on canal water for their steam engines. In the event, the river water came part-way across Severn Road, but then the level started to subside and the canal authorities could breathe again.

Only a few days after the floods at Gloucester began to recede, a new incident diverted attention back to Sharpness. As the SS *Stancliffe* was swinging prior to entering Sharpness on 2 April 1947 carrying about 3,000 tons of logs, she went aground off the north pier. Some of her cargo was removed, but initial attempts to refloat her were not successful, and when she split into two parts, she was abandoned by her owners. As she was impeding the entrance to Sharpness, the Harbour Trustees called in salvage experts from Falmouth and Ivor Langford's local ship repairing company. Langford's men made the two parts of the hull watertight, and in due course each part was towed to Cardiff where they were joined back together in the dry dock. Langford was involved again, four years later, when SS *Ramses II* grounded on a sandbank between Sharpness and Lydney. After refloating attempts failed, Langford's men helped to discharge 6,000 tons of maize and later cut up much of the superstructure for scrap.

In the years immediately following the war, canals and docks were in great need of new investment, and the government of the day believed this could best be achieved by bringing most of them under a new central authority. In 1948, therefore, the Sharpness Docks & Gloucester & Birmingham Navigation Company was nationalised, and its property and employees came under the control of the Docks and Inland Waterways Executive of the British Transport Commission, which later evolved into the British

Waterways Board. The new management also took over the dry-cargo barges of the former Severn & Canal Carrying Company and had some new ones built. These barges and the tugs that towed them, as well as the dredger and other maintenance craft, were maintained to a high standard by the men who worked in the Repair Yard at Gloucester. Initially, this continued to be run much as it had been under the old Dock Company - with a great reluctance to spend money. Rather than buy a big bolt, a blank was made by the blacksmith and a screw thread was cut in the machine shop. Instead of buying sarking felt to seal a riveted joint, the plates were painted with a mixture of tar and horse manure collected from a local field. In due course, however, new methods were adopted and new equipment provided, and there was an increase in the number of supervisors and office staff. It also became the practice that after each vessel underwent a refit, the crew was issued with a new teapot.

In the 1950s, the nationalised dry cargo barges were kept very busy carrying a wide range of general cargoes from Avonmouth through Gloucester to Worcester and Stourport, particularly metals like aluminium, copper and zinc. Other barges and lighters carried wheat and petroleum from Avonmouth and timber from Sharpness to Gloucester and beyond. As in previous years, though, there was seldom anything for them to take back on the return journey. Some foreign imports came to Sharpness in big steamers, but the quantities were well down on pre-war levels, and the trend was towards ships carrying less than 1000 tons. Even the smaller steamers usually

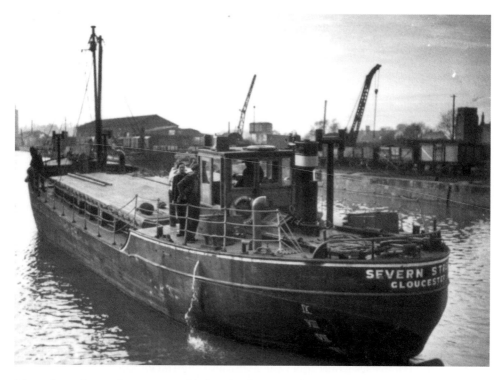

*Motor barge* Severn Stream *was added to the dry cargo fleet in 1951.*

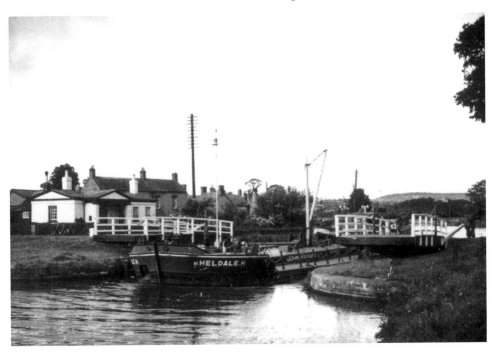

*John Harker's tanker barge* Wheldale H *passing through Purton Upper Bridge.*

discharged at Sharpness because the dredging of the canal had not been maintained fully during the war years and the depth was only twelve feet in places.

The large amount of barge traffic on the canal meant that a bridgeman might have to open and close his bridge twenty or thirty times a day. As well as the tugs towing barges and lighters, there was a growing number of motor barges, particularly those carrying petroleum. Usually the tankers came two or three together, and they had a couple of passmen - one to open the towpath side of each bridge while the bridgeman worked the green bank side, and the other to close the towpath side. The approach to Sellars Bridge from the south could be a problem because the bridge was on a bend, and several tankers that were travelling too fast ended up hitting the abutment. When the Westerndale did this, the impact was so great that all the crockery in the cabin went everywhere! Many of the tanker barges discharged at Monk Meadow Dock, where the petroleum products were pumped into storage tanks for subsequent delivery by road tankers. Esso had a depot on the south side, Regent at the top end and National Benzole and Shell-Mex & BP on the north side. Other tankers continued up the River Severn to depots at Worcester or Stourport.

Following the return to peace time staffing levels, it was possible to start catching up on the backlog of dredging. Initially the dredger was called to clear places where even the tanker barges were touching the bottom, but in due course it was possible to undertake a systematic programme dredging the whole canal to a depth of 16 feet which took a period of 12 years. This was not a full time activity as it was still

necessary to break off from time to time to clear troublesome areas, such as where natural streams carried silt into the canal or where silt-laden water from the River Severn was pumped into the basin at Gloucester. Allowing for some silting over lengths not dredged recently, it was reckoned that the average depth of the canal was about 14 feet over a width of about 25 feet, and this could accommodate vessels with a draught of up to 12 feet. As the dredging improved the navigable depth of the canal, the management began to encourage more coasters to carry cargoes right up to Gloucester, and their efforts were increasingly successful.

While the dredging programme was underway, the new management also started to replace the old double-leaf wooden bridges with single-leaf steel bridges. This change was partly to save on maintenance costs but mainly to save the cost of having a passman to open the towpath side of each of the old bridges. As Purton Lower Bridge was in particularly poor condition, it was the first to be replaced in 1951. It was designed to carry a maximum load of five tons, based on an earlier legal ruling that a canal company was only responsible for providing bridges suitable for the traffic of the district at the time the canal was constructed. The new bridge was easier for the bridgeman because it was moved by turning a handle, but it could still be difficult in a wind, and it was part of the bridgeman's job to keep the mechanism well oiled and greased.

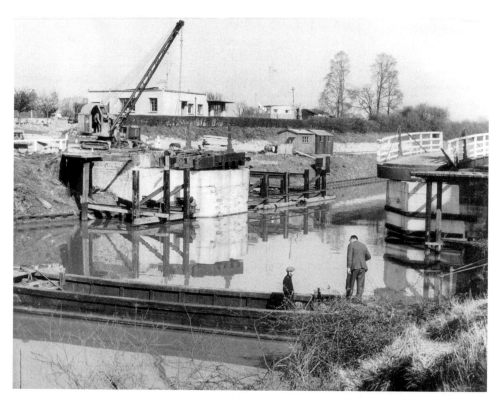

*Work in progress on rebuilding Rea Bridge in March 1961. In the foreground is the ferry boat for pedestrians operated by the bridgeman.*

The next to be replaced was Fretherne Bridge, after the old bridge collapsed under the weight of a lorry carrying grain in March 1954. The driver was going to the grain store at Sandfield Bridge but he had lost his way. Unfortunately he stopped on the second leaf of the bridge and, as it tipped down, the lorry rolled backwards and he was crushed to death by the end of the other leaf pushing into the back of his cab. As this was an important road, the County Council agreed to pay the extra cost of making the new bridge strong enough to carry 22 tons. Two years later, a series of accidents highlighted the vulnerability of the remaining wooden bridges. First, one leaf of Sellars Bridge was knocked into the water by the coastal tanker *Azurity*, and it had to be towed to Sharpness to be lifted out. Three days later, Parkend Bridge was pushed off its spindle by a tanker barge, and three weeks after that Hempsted Bridge was badly damaged by a heavy lorry which just managed to get across in spite of one leaf dipping down into the canal. Again the County Council contributed to making the replacement Sellars Bridge suitable for lorries, and the east pier was extended slightly to the north with sheet piling to improve what had been a nasty double bend in the road. To get pedestrians across the canal while the bridge was out of action, the bridgeman was provided with a work-flat that he pulled over using a rope stretched across the canal. If a vessel came along, he had to slacken off the rope which was weighted so that it would sink. He was expected to be available at any time from early in the morning until the Pilot Inn closed at night, and it was a particularly miserable job in the winter as the rope got covered in ice. The remaining wooden bridges were gradually replaced over the next seven years. The tops of the side-railings were originally given a curved shape reminiscent of the shallow arch of the former wooden bridges, but some replacement railings have lost this attractive feature.

Another improvement started in the 1950s was the systematic piling of the canal banks. Some piling of short lengths had been done in previous years, but the wash from the growing number of tanker barges was causing more widespread erosion which reduced the width of the towpath and contributed to the silting of the canal. Initially, use was made of interlocking steel piles that formed a virtually watertight barrier. These were driven in by a steam hammer mounted on a floating pontoon, and the repeated pounding could be heard over a wide area. However, the Waterways chairman, Sir Reginald Kerr, favoured the use of concrete piles which were cheaper and thought to last longer. In practice, these were not popular locally because they were more difficult to drive, they were liable to be broken by impact from a vessel and they did not form a totally watertight barrier, so that wash from passing vessels pushed through the cracks between the piles and still caused some erosion. Furthermore, as they were of limited length, when driven in to a proper depth, they only protruded a few inches above the water, and so wash was liable to lap over the top causing more erosion. To overcome this, bags full of soft concrete were later laid along the top of the piles and allowed to set in place. Another cheap option was to use wooden piles which were capped with concrete to avoid the usual problem of rotting at the waterline. Meanwhile, steel piles continued to be used where long lengths were needed or where the subsoil was too hard for driving concrete or wooden piles.

*The piling rig in action below Splatt Bridge in the 1950s.*

   Once a line of piles was in place, the space behind was back-filled using a floating crane to grab material from the bottom of the canal. In some places, this involved filling ten or even twenty feet behind the piles. The worst place was about one third of a mile above Sellars Bridge, where erosion had cut right through the towpath and even removed a length of the hedge. In other places, the piling was set back from the original bank of the canal, making the canal wider than it had originally been. As well as filling in the erosion, material grabbed from the canal was also used to build up the height of the banks where needed.

   As the traffic in petroleum products continued to grow, there was a need for more facilities than could be provided at Monk Meadow, and Shell-Mex & BP opened a new canal-side wharf and storage depot a short distance above Sellars Bridge in September 1960. The depot had storage tanks for a range of products from petrol and kerosene to diesel and heavy oil for industrial boilers. The products were delivered by tanker barges and the occasional coaster, and they were distributed by road tankers to customers within a 25 mile radius. Initially there was only a small turning bay opposite the depot, and coastal tankers had to be taken all the way up to Gloucester to turn. To save time, the pilots sometimes turned empty tankers by driving the bow up on to the bank of the timber pond at Two Mile Bend. On one occasion when people walking along the Bristol Road stopped to see what was going on, the mate on the bow shouted "Is this the right way to Gloucester?" Later, the turning bay opposite the Quedgeley depot was enlarged so that coastal tankers could turn there.

Soon after the new depot at Quedgeley opened, all connected with the canal were deeply shocked by a tragic accident in the river outside Sharpness. On the night of 25 October 1960, *Arkendale H* loaded with heavy fuel oil and *Wastdale H* carrying petrol were on their way up to Sharpness when they suddenly encountered dense fog. They were carried past the entrance by the strong tide, became locked together side-by-side and collided with a pier of the Severn Railway Bridge. The impact brought down two spans of the bridge and caused an explosion and a fire. For a time it seemed that the whole river was ablaze, and five of the eight crewmen lost their lives. The hulks of the two tankers ended up on a sandbank about three-quarters of a mile up-river, and after much deliberation about possible restoration, the bridge was eventually demolished several years later.

Most of the coasters using the canal took on a pilot at Sharpness and two hobblers who took the ropes when there was a need for checking the course of the ship or for mooring up while another passed. The pilot took the wheel and did his best to keep the ship in the centre of the narrow channel. If the ship's stern got too close to one bank, the flow of water created a suction which pulled the stern even further over (known as smelling the bank), leaving the ship heading for the opposite bank (known as taking a run). By the time the pilot had turned the wheel to counteract this, if he was not careful, the same thing could be repeated in the opposite direction. Sometimes the pilot was forced to let the ship run against the bank and then make use of the hobbler's check ropes to bring her back to the centre of the channel before proceeding. Ships that were particularly liable to this behaviour could take seven hours to go from Sharpness to Gloucester, whereas others might make the passage in only four hours.

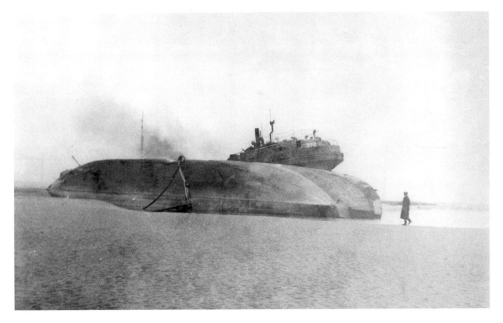

*The wrecked tanker barges* Wastdale H *and* Arkendale H *in October 1960.*

*Tug* Mayflower *towing the bank gang's houseboat past* MV Ijsel *c. 1952.*

*MVs* Anna-Elizabeth *and* Tynehaven *at Gloucester in October 1957.*

Particular care was needed when meeting vessels coming in the opposite direction. Ever since the 1850s, the canal had been unusual in requiring vessels to keep to the left, but in the 1960s this was changed back to the general rule used on other waterways of keeping to the right - so that vessels passed "port-to-port". A coaster could pass a tug with a tow of barges almost anywhere on the canal, but if another coaster was coming in the opposite direction, the pilots arranged beforehand that they would meet at one of the lie-byes. The first coaster to arrive at the agreed point moored up and waited there until the other one passed. There were occasions, however, when two coasters met in a narrow part of the canal - usually because one was not using a pilot and the skipper had not notified the Harbour Master he was on the move. Then there was a long delay while a tug was brought in to tow one of the coasters backwards to the nearest lie-bye to let the other one go by.

Going down the canal, many of the coasters were empty, and with a shallow draught it was comparatively easy to make good progress, but there were occasional difficulties. The worst problem was a cross wind, and this could be particularly bad between Fretherne and the Cambridge Arm where vessels were exposed to the south-west, especially after the willows had been lopped. Another difficulty was going through Purton Lower Bridge when the tidal basin at Sharpness was being levelled for a ship that was too big to fit into the lock. After a time, the flow of water through the bridge hole was enough to create a dip in level, like at a weir, and the flow could deflect the stern of a ship unless the pilot maintained good steerage way through the water.

MV Dollard *passing the Junction yard in September 1962 with a cargo of zinc ash.*

To help coasters navigate the canal more easily, work was carried out to ease the worst bends. In 1961, the inside corner of Two Mile Bend was dug out by a dragline, and the earth was dumped to the north-west of the bend in the valley of the Daniels Brook, after first providing a culvert for the stream. At the same time, the former culvert under the canal was abandoned, the brook was made to flow into the east side of the canal and a small overflow weir was provided to the west to maintain a supply of drinking water to the cattle in the neighbouring fields. At nearby Netheridge Turn, extra-deep piles were driven in around the outside of the bend so that dredging could be done closer to the bank and so allow coasters more space to swing their sterns. Similar improvements were made at Four Mile Turn near Stonebench. Following this work, coasters could be taken round the bends without needing a check-rope ashore.

The various improvements to the channel and banks of the canal helped to increase the number of coasters travelling to Gloucester from 63 in 1956 to 187 in 1961. To meet the resulting demand for additional discharging facilities, Llanthony Quay was purchased from British Rail (who had inherited it from the Great Western Railway), the surface and railway tracks were improved and two big sheds were built on either end of the existing transit shed. Two mobile cranes were transferred to the refurbished quay, and the first cargo was discharged there in September 1961. The new sheds for the first time allowed cargoes such as fertilizer to be stored in bulk at Gloucester. Although several berths around the Main Basin continued to be used for several more years, the refurbished quay (generally referred to as the Western Wall) soon became the principal place for discharging coasters at Gloucester.

*MV G R Vellie at Llanthony Quay in July 1966 with the old and new sheds behind.*

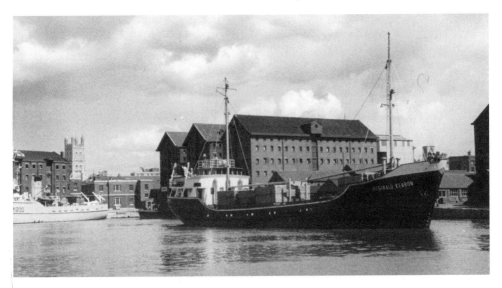

MV Reginald Kearon *turning in the Main Basin at Gloucester in April 1967, having loaded a cargo of boxed car parts for Ireland.*

Many of the visiting coasters were Dutch and were owned by the master, who often had members of his family in the crew. Imports included fertilizers from Rotterdam and Antwerp, oyster-shell for poultry farms from Denmark, chocolate crumb from Cork, granite sets from Portugal and beech logs from France. The beech logs, destined for Permali of Gloucester, were temporarily transferred to one of the timber ponds to prevent them drying out and cracking, but some were so large that they first had to be cut in half to get them out of the ship's hold. The main export cargo was boxed car parts from British Leyland which were regularly carried to Ireland by the MV *Reginald Kearon.* The boxes varied in size according to the components inside, and it required considerable ingenuity on the part of the dockers to fit as many as possible into the ship's hold each time.

At the same time as the canal was attracting more traffic, it also took on a new role - providing a conduit for Severn water needed to supply industrial developments in the Bristol area. In 1962, Bristol Corporation Waterworks opened a modest extraction plant near Purton which pumped water through a pipeline to a treatment plant at Littleton, and in the following year British Waterways installed a new centrifugal pump at Gloucester to supply the canal with more water from the Severn. Ten years later, a larger extraction plant was built at Purton, together with a new water treatment plant, so that Severn water could be sent on to supply a greater area of Bristol. One drawback of these schemes was that with more pumping at Gloucester, more silt settled out in the basin there, and sometimes even Chadborn's lighters went aground with a draught of only 5 feet 6 inches. Normally it was sufficient to dredge the basin thoroughly once a year, but sometimes it was necessary to go back again to clear a local tump deposited on the line of the pump outfall.

*Tug* Severn Iris *cutting through the ice approaching Hempsted Bridge.*

During the winter of 1962-63, there was a long cold spell that led to ice forming on the canal, and the tug crews had to work long hours to keep the traffic moving. The tugs were fitted with steel plates on the bow to protect the hull, and they ran extra trips day and night to try to keep a channel open. This tended to push the central ice up on top of the ice at the side which in some places became several inches thick. The tanker barges usually travelled in convoy with a tug in front to break any new ice, and coasters often needed to be towed by a tug to help them force their way through the narrow cleared channel. Even so, the ice formed so quickly at times that all traffic came to a halt, and it was common for crews to get off their craft and walk on the ice. Eventually, even the dock at Sharpness was frozen over, and men walked across the ice from one side to the other.

During the 1960s, it became apparent that the long established system of transferring timber from large ships to lighters at Sharpness and then man-handling everything again at Gloucester was no longer economic, particularly as some timber arrived in packaged form which did not readily fit into lighters. Price Walker & Co. tried to meet this situation by establishing a storage yard and mill at Sharpness, but other timber merchants started bringing small coasters direct to Gloucester. Some coasters discharged at existing yards, while others made use of a completely new quay purpose-built beside the canal at Monk Meadow. This was built by British Waterways in 1965 by driving in a row of 34 feet long steel piles about 20 feet back from the water's edge and then clearing away the earth in front using a dragline and the No 4 dredger. As timber is a light cargo, many of the coasters carried a significant deck cargo which obscured the pilot's view, and so marker posts were put up on all the

bridges to show where the openings were. The grain trade was also changing in the 1960s, and coasters began to call at the Monk Meadow silo, sometimes loading grain for export and at other times delivering from continental ports.

Meanwhile, there was a gradual reduction in barge and lighter traffic on the canal due to a number of different influences. The role of the dry-cargo barges was greatly affected by the decline in imports to Avonmouth due to the vast growth of container traffic into east coast ports. This in combination with the increasing use of road transport forced British Waterways to run down their fleet during the 1960s. However, some privately owned barges continued to carry wheat from Avonmouth to the mills at Gloucester, Tewkesbury and Worcester for a number of years. The remaining timber lighters were phased out due to the changes in the timber trade noted above and because Moreland's stopped the import of logs in 1969 when it became more economic for the logs to be cut up in the country of origin. Following

*Deals being unloaded from MV* Alexander *at Griggs's yard near Hempsted Bridge in June 1966, the first such cargo to come direct from Scandinavia for many years.*

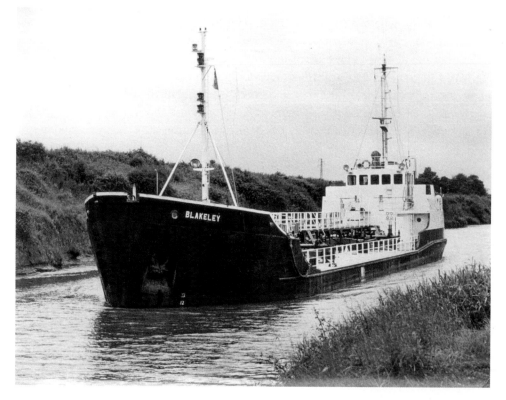

*Coastal tanker MV* Blakeley *in Hardwicke cutting on her way to the Quedgeley oil depot c. 1970.*

renewed concern about erosion of the river bank outside the wall of the Old Arm at Sharpness, many of the redundant lighters were dumped along the bank to give some protection. The role of the tanker barges also declined after Bowker & King introduced a fleet of coastal tankers in 1969 to supply the depot at Quedgeley, and the small depots at Monk Meadow Dock were closed. These new tankers needed to carry the maximum cargo for economic operation, and when the canal water level was low, they were liable to touch the bottom when going though a bridge hole. Following subsequent investigations, it was found that levelling the tidal basin at Sharpness for a big ship caused a measurable reduction in water level as far up the canal as Hardwicke Bridge, and so navigation control and communication procedures were implemented to minimise the consequences.

The decline in barge traffic was to some extent offset by a growth in the number of pleasure craft using the canal. Moorings were made available at Gloucester as well as in the length of the Stroudwater Canal to the east of the Junction, and in 1971 a marina was established in the arm leading to the Old Entrance at Sharpness. The marina office was based on the pontoon *Encore* (that had been converted from the hull of the former No.3 dredger) and the marina workshop was set up on the pontoon

that had been used to support the old Fretherne Bridge when heavy vehicles needed to cross. The decline in barge traffic also affected the work of Davis's boatyard at the Junction, which gradually changed over to dealing with pleasure craft. Such was the growth in this activity that, following the closure of the adjoining canal maintenance yard, the boatyard took over the whole site.

While the coaster traffic on the canal had been increasing in the 1960s, the number of big ships discharging the traditional cargoes of grain and timber at Sharpness remained low, the warehouses there were underused and Severn Mills closed down. Recognising that changes were needed, British Waterways set about attracting new private businesses to Sharpness. These included Trent Wharfage who started importing new cargoes such as animal feed, anthracite, steel, concrete and kraft liner board, Coopers who exported scrap and Greenore Ferry Services who carried containers to and from Ireland. In the 1970s, the traffic handled at Sharpness continued to grow, with the addition of regular services to and from Lagos (Trade Lines) and Bilbao (Span Line), and a Dutch firm built a new grain silo. During the same period, British Waterways laid new concrete quays, installed new cranes and demolished some of the old warehouses and sheds that were no longer needed.

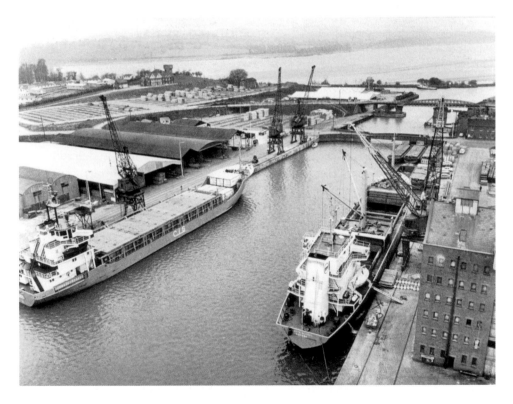

*The north end of Sharpness Dock in April 1976 with MV* Thunar *delivering a part-cargo of fertilizer from Israel and MV* Lotte Scheel *loading a general cargo for Nigeria on behalf of Trade Lines.*

MV Stortemelk *at Sandfield Wharf in March 1987 discharging 832 tons of bulk fishmeal from Germany.*

By the 1970s, however, the economics of using dry-cargo coasters small enough to pass up the canal to Gloucester were becoming marginal. The average number of arrivals fell to less than one per week, mainly bringing grain, timber and granite sets. In addition, a few coasters delivered to Sandfield Wharf where the former grain store was used for receiving cargoes such as animal feedstuffs, fertilizers, fish-meal and potash, but there were virtually no export cargoes. Those coasters that did come were more manoeuvrable than in earlier times and some had remote steering that allowed the pilot to walk about to get a better view. On one trip, a visitor was surprised to be invited to take the wheel and pleased at how successful he was in keeping to the middle of the channel, little realising that the pilot was using the remote steering all the time! As an economy measure, British Waterways sought to close Hardwicke Bridge as it only carried a private road which was very little used. After lengthy negotiations, those affected eventually accepted a compensation package, and the bridge was closed in 1985.

In the early 1980s there was a revival in coaster movements to Gloucester, helped by regular imports of urea from Cork and the occasional export of bulky water filtration plant from Serck Baker's works near Two Mile Bend. In 1985, however, the urea traffic transferred to Dumball Wharf near Bridgwater. In the same year, the Quedgeley petroleum depot ceased operations, cutting out most of the coastal tanker movements,

although occasional deliveries to refurbished storage tanks at Monk Meadow Dock continued for a few years. As other traffic also died away, British Waterways closed down their freight operation at Gloucester in 1988 and made the remaining dockers redundant. A few years later, British Waterways also closed the Repair Yard at Gloucester and moved their maintenance base to the former stables beside Sandfield Bridge. Meanwhile, Sharpness continued to operate as a commercial port handling an increasing variety of cargoes, and two barges carried wheat from Sharpness to Healing's Mill at Tewkesbury.

As the commercial traffic on the canal declined, British Waterways began to consider plans to redevelop the main docks area at Gloucester and to find new uses for the former grain warehouses. The City Council set an example by refurbishing the North Warehouse in 1986 to house their main offices, and the National Waterways Museum opened in Llanthony Warehouse in 1988. These initiatives encouraged a private developer to undertake the refurbishment of other warehouses. At the same time, the historic setting benefited from the use of the dry docks by T. Nielsen & Co. for overhauling classic sailing vessels and replicas used for filming. Meanwhile, the canal became increasingly popular for leisure activities and continued to serve as an important link in transferring Severn water to Bristol.

*SV* Soren Larsen *entering the dry dock at Gloucester in 1979.*

These new uses for the canal were interrupted temporarily in 1990 by the failure of a culvert to the south of Parkend Bridge. Fortunately, the local bridgeman spotted the whirlpool caused by the water draining out through the bottom of the canal, and the stop gates at Parkend and the Junction were closed before the general level dropped very much. British Waterways engineers then undertook an urgent programme of work which initially concentrated on installing pipes and pumps to re-establish the supply of water to Bristol past the affected length that was virtually empty. When the culvert was inspected, it was found that the central section under the canal was made of baulks of timber held together as a tube by iron rings. The timber had been scoured away on the inside - probably accelerated by the grit suspended in the water draining off the nearby motorway. The culvert was repaired by putting a new tube inside the failed one, and the canal was back in operation again within five weeks.

The repair of the culvert was just completed in time for the National Waterways Festival held at Gloucester in August that year. The Festival attracted hundreds of inland waterway boats and thousands of enthusiasts from all over the country, and it highlighted the new role of the docks as a leisure destination. Unfortunately, there then followed a long period of national economic difficulty which inhibited further developments and no doubt contributed to the closure of the City Flour Mills in 1994 and the end of the grain barge traffic to Healing's Mill in 1998. Better times returned in the new century, when a national housing boom stimulated the conversion of the remaining warehouses at Gloucester to apartments, two new bridges were built over the canal near Gloucester and work started on the huge Gloucester Quays scheme to bring shops, housing, hotels, a college and leisure facilities to the area south of Llanthony Bridge.

The construction of the canal was a magnificent achievement for its time, and although the shareholders received little return on their investment, the completed canal has been of great value to the people of Gloucester and the West Midlands. Now that commercial traffic has died out, the canal is developing a new role as a leisure facility, and the regeneration of the docks at Gloucester will continue to bring benefits for years to come.

# References

TNA - The National Archives; GA - Gloucestershire Archives; TWA - The Waterways Archive.

Glos Coll - Gloucestershire Collection in Gloucestershire Archives.

GJ - Gloucester Journal; GC - Gloucestershire Chronicle; Cit - The Citizen

Minute books, contracts, etc of the G&B Canal Co: TNA RAIL 829.

Minute books etc of the Sharpness Dock Co and vessel arrivals at Sharpness: TNA RAIL 864.

Company annual reports: TNA RAIL 1112/11, Glos Coll JV 14.2, GJ passim.

*Gloucester Docks - An Illustrated History* by Hugh Conway-Jones.

## Chapter 1

Initial subscribers: Glos Coll JZ 14.3. Canal routes: GA Q/RUM 2/1, 2/2, 4. Initial meeting: GJ 12 Nov 1792. Acts: 33 Geo III c97, 37 Geo III c54. Mylne diary: Robert Mylne by A.E. Richardson. Canal finance: The Finance of Canal Building in Eighteenth Century England by J.R. Ward. Steam engines: Birmingham Ref Lib, B&W Collection Box 6 Bundle G, Box 3/14/64, 67. Haskew's machine: patent 1796 No 2115, working GJ 1 Aug 1796. Mylne's criticism: GA D2159/1.

## Chapter 2

Acts: 45 Geo III c104, 58 Geo III c17, 3 Geo IV c53, 6 Geo IV c113. Tramroad: The Gloucester & Cheltenham Tramroad by David Bick. Opening the lock: GJ 12 Oct 1812. Route to Sharpness: Observations by J. Upton (Glos Coll JF 14.152). Progress: Telford correspondence at the Ironbridge Gorge Museum and the Institution of Civil Engineers. Dealings with Stroudwater Canal Co: GA: D1180. First stone at Sharpness: GJ 20 Jul 1818. Navvies: Navvyman by Dick Sullivan. Uley canal: GA Q/RUM 135. Opening the temporary Junction: GJ 6 Mar 1820. Cambridge Wharf: GJ 27 Mar 1820. Branch to Frampton Pill: GA Q/RUM 2/3. Sovereign: GJ 19 Nov 1821, GJ 24 Dec 1821. Plan of Sharpness basin: GA D2460/29/4/½. Col. Berkeley's steward: A History of Berkeley Vale by Royce Denning. Plan of bridges: GA D2460/29/3/2/1. Plan of Junction: GA D2460/3/¾/2. Completing the canal: GA TS 225; D2460/3/1/1. Opening day: GJ 28 Apr 1827.

## Chapter 3

Isabella: GC 21 Jun 1834. Entering Sharpness: GJ 28 Aug 1830, GJ 20 Jun 1840. Embankment repair: GA D2460/3/3/1/7. Embankment collapse: GJ 28 Feb 1829. Early traffic: GJ 10 Oct 1829; Diary of a Cotswold Parson ed David Verey; GJ 26 Mar 1831. Fly boats: The Thames & Severn Canal by Humphrey Household. Acts: 2&3 Will IV c111, 4&5 Will IV c54. Water supply difficulties: GA D1180; D2115/2. Bye Laws: Glos Coll J 14.18. Bridge plans: GA D2460/4/7/5/4, 5. Sugar: The Economic Emergence of the Black Country by T J Raybould. Ice: GJ 20, 27 Jan 1838; Geoff Warren in Waterways World Aug 1991; GA D2460/3/¾/9. Emigrant ships: GJ 1 Feb, 15 Feb, 16 May, 4 Jul 1840. Smuggling: GJ 28 May 1842, GC 18 May 1844; Glos Coll J 3.46. Packet boats: Directories 1842-52; Saul & Fretherne Census 1841, 1851. Maintenance equipment: TWA155/1/6. Bridge houses: Hugh Conway-Jones in GSIA Journal 1994. Traffic: GJ 14, 21 Oct 1843, GJ 17 Jan 1846, GJ 20 Feb 1847, GJ 17 Jan 1846, GC 8 Jul, 5 Aug 1843. Clara and Swiftsure: GJ 28 Jun 1845, GJ 26 Jul 1845, GJ 13 Dec 1845, GJ 31 Jan 1846, GJ 4 Jul 1846, GJ 12 Dec 1846, GJ 15 Dec 1849.

## Chapter 4

Opening of Victoria Dock: GJ & GC 21 Apr 1849. Railways: GA PC 1086. Mariner's Chapel: The Mariners Chapel 1849-1909 by Rev W H Whalley. Passenger steamers: GA D4292/6, D6482; GJ 16 Apr 1853, GJ 16 Jul 1853, GJ 30 Jul 1853; Directories. Devore: GJ 13 Aug 1853. Timber trade: GJ 9 Aug 1851, GJ 29 May 1852. New dry dock: GJ 6 Aug 1853. Exports: GJ 20 Mar 1850, GJ 20 Aug 1853, GJ 25 May 1850. Pre-fabricated huts: GJ 20 Aug 1853, GJ 20 Jan 1855, GJ 25 Aug 1855. Post-war traffic: GJ 21 Jun 1856, GJ 12 Apr 1856, GJ 19 Apr 1856. Bye Laws: Glos Coll J 14.104. Telegraph: TNA BT 31/330/1172; GA D637 I/30. Sud Brook: GJ 20 Nov 1858; GA GBR N2/½. Tugs: GJ 29 May 1858; Shipbuilding in the Port of Bristol by Grahame Farr; Glos Coll J 14.2. Edmund Ironsides and Cuirassier: GJ 4 Oct 1862; GA D3080, D4292/6, D4764/4/16; GJ Shipping Arrivals 1862-63. Pilots: GC 1 Dec 1860; 24 & 25 Vict c236; GA D5827/1/1/1; GC 7 Nov 1863, GJ 12 Jun 1886. Purton Mill: Directories, GA D4764/4/16 Book 3. Ship building: Lloyds Register 1875; GJ 20 Feb 1869; Mercantile Navy Lists, Directories. 1860s traffic: Glos Coll 12199; GC 16 Dec 1865, GJ 1 Dec 1860, GC 29 May 1869, GJ Shipping Arrivals & Departures. Cambridge Arm: GA D3080, D4292/6; 1871 Census Slimbridge. Betsy: GJ 5 Nov 1864; GA D3706. Passenger steamers: GC 12 Aug 1865; GA P149 IN 4/1 Feb 1870; GJ 25 Jul 1863, GJ 1 Jul 65. Saul maintenance yard: TWA155/1/6; TWA155/4/2/13; TWA155/1/8; Saul Census 1861,1871. New bridge design: GA D2460/3/3/2/8. Maintenance work: GA D2460/4/4/1; GJ 15 May 1869. Annual inspection: GJ 18 Jul 1868. Pleasure Grounds: GC 18 Jul 1868. Brick making: GC 11 Feb 1837, GC 23 Apr 1842. Shepherd's Patch Wharf, Junction Dry Dock and Junction House: GA D2460/4/4/1. Longboat accidents: GC 17 Jun 1865, GJ 23 Jun 1860.

## Chapter 5

Case for new dock: GJ 10 Jul 1869, GC 24 Jul 1869. Acts 33&34 Vict c61, 37&38 Vict c181, 42&43 Vict c157. Building and opening new dock: GC 29 Apr 1871, Stroud Journal 6 Jan 1872, GC 28 Nov 1874, GC 5 Dec 1874. Smallpox: GC 15, 22, 29 Jul 1871. Speedwell: Shipbuilding in the Port of Bristol by Grahame Farr. More water from the Frome: GA D2460/4/7/6/24. Salt trade: GJ 12 Feb 1887. S&CCCo: Hugh Conway-Jones in Waterways Journal Vol 3. Steam winches: Glos Coll J 14.17; GC 14 Dec 1878, GJ 7 Sep 1901, GJ 4 Jan 1902. Sharpness buildings: Glos Coll A02/13; 1881 Census; GA PA 42/13; 1879 OS map; TWA120/12/1/8; GC 6 Apr 1878; Glos RO P42 IN 4/4; Directory 1876; GC 15 Jun 1878. Severn Railway Bridge: The Rise and Fall of the Severn Bridge Railway 1872-1970 by Ron Huxley; GJ 18 Oct 1879. Coal tip: Glos Coll A03/13; GC 6 Apr 1878; G.P.J. Preece in Ind Arch Review Autumn 1977. Bathing: GJ 19 Aug 1871, GC 23 Jun 1877, GJ 9 Aug 1873, GJ 3 Aug 1878, GJ 10 Aug 1878, GJ 21 Aug 1880. Ice: GC 29 Jan 1881; GA D2460/4/4/2; GC 22 Jan 1881. Timber pond: GA D2460/4/4/2; 1883 OS map.

## Chapter 6

Share prices: GC 25 Jun 1870, 6 Jul 1878. Resolution: GJ 19 Sep 1891. Lighterage: GJ 28 Jun 1879. Inchmaree: GJ 25 Aug 1883. W.K. Wait: GC 25 Nov 1882, GC 21 Nov 1885. Large ships: GJ 20, 27 Jun 1885, GJ 23 Oct 1886. Coal exports: GJ 23 Feb 1884; Glos Coll (H)F6.34(4); Glos Coll J 14.17. Schemes: Glos Coll J14.3, J14.15, J14.17. Steamers: GJ 24 Oct 1885; Glos Coll 46862. River flood: GC 22 May 1886, GA D2460/4/6/5/3. Ballast: GA D2460/4/7/7/6, 7, D2460/4/4/3, D2460/4/4/1; GC 5 Jul 1913. Monk Meadow Dock: GJ 30 Apr 1892. Mud disposal: GA D2460/4/4/1. Price Walker saw mill: GJ 26 Jan 1895. Downing's malthouse: GJ 5 Aug 1899; datestone 1901. Harbour Trustees: A History of the Gloucester Harbour Trustees by W.A. Stone. SS Northern: GJ 23 Dec 1893. Sharpness buildings: GA D2460/4/8/5, 6; Glos Coll A02/14; 1901 OS map. Passenger steamers: GJ 2 Sep 1899, GJ 23 Sep 1899. Lane Round: GJ 3 Feb 1900. Grain elevator: GJ 29 Jun 1901, GJ 17 Aug 1901, GJ 7 Sep 1901.

## Chapter 7

Stevedoring dispute: GJ 22 Apr 1899, GJ 13 Jun 1903. Dock Manager's house: GA D2460/4/8/5/5. Labour dispute: GJ 16 May, 13 Jun, 8 Aug, 7 Nov 1903, GC 20 Feb 1904. Gravel barge sunk: GJ 22 Oct 1904. Traffic: GJ 12 Nov 1904; Glos Coll JV 13.1. Large ships: GJ 24 Sep 1904, GJ 8 Jul 1905. Sharpness ferry: GA PA 42/13. Tokens: Cyril Savage. Canal traffic: GA D2195 D V Webb. S&CCCo: Working Life on Severn & Canal by Hugh Conway-Jones. Elysium Flour Mills: TNA BT31 7884/56491; Jack Heaven. Low revenue: Glos Coll 9865 para 3681-84. Purton bank: GA D2460/4/7/1/10, 52, D2460/4/4/6. Tribune mast: GA D2460/4/4/7 17 Jul 1912; D5827/2/½ p203. Cradle for steam crane: GA D2460/4/4/7 4 Mar 1912, 26 Mar 1913. Assyria and Clan Macpherson: GJ 12 Sep 1914. First World War: David Savage; Glos Coll JR 13.8; Glos Coll 46862; GA CMS 85; Fred Rowbotham. Army Ordnance

Department: GA D2299/2203; NWM Photos; TNA T 1/12144. Gossington magazine: Brian Edwards in GSIA Jnl 1995. Cadburys: Cadbury's archives. Gravel: Brian Edwards. Concrete barges: GJ 30 Nov 1918. Passmen, coal & stone: Bert Fredericks. Post-war traffic: GC 3 Mar 1923; Harry Roberts. Standard Match Factory: GJ 4 Jun 1921; Standard Match of Gloucester by Peter Campion. Foster Bros oil store: GJ 4 Jun 1921; Bert Fredericks. Petroleum depots: GC 15 Sep 1923; GA D2460/4/7/3; Tankers Knottingley by Alan Faulkner. Dredger: Bill Deacon; GA D2460/4/11/34. General Strike: Gazette 8, 15 May 1926, GJ 29 May 1926. Pleasure craft: GA D2460/4/7/4/61, 62, 65; Mercantile Navy List 1929 & 1939; Harold Boulton. Bungalows: Several people. Steam cranes: Cyril Savage; GA D2460/4/4/11. Water for ships: Cyril Savage. Sharpness dry dock: Port of Gloucester 1926, Richard Langford. Act: 25&26 Geo V c26.

## Chapter 8

Memories of Eric Aldridge, Michael Beynon, Bill Deacon, Jack Evans, Jack Heaven, Edna Iles, Ken Price, Cyril Savage, David Savage, Doug Savage, Frank Savage, Ray Savage and Phyllis Smart. Traffic: TNA RAIL 864/56 & 57; GA D2460/4/5. Collier from Lydney, calcium carbide, Pleasure Grounds: GA CMS 85. Severn Ports Warehousing Co: Port of Gloucester 1922, 1936; TNA BT 31/37753/279192. Man suffocated: GJ 30 Jan 1926. Warehouse fire: GJ 10 Nov 1934. Silo: GA D2460/4/8/4/35; Glos Coll NV 15.3. Severn Mills: Port of Gloucester 1936. Viking: Gazette 12, 19, 26 Jun 1937. Seamen ashore: Survey by Capt. F.A. Richardson 1936.

## Chapter 9

Memories of Eric Aldridge, Mike Ayland, Harold Boulton, Derek Browning, Reg Davis, Charles Ellis, Jack Evans, Donald Fowler, Bert Fredericks, Geoffrey Frith, John Harris, Leonard Long, Robert Moreland, R.T. Pilkington, Ken Price, Ivor Prosser, Fred Rowbotham, Palmiro Ruiz, Brian Russell, Frank Savage and Joyce Woodman. Pontoon at Fretherne Bridge: GC 30 Sep 1922. Accident at Hempsted Bridge: Cit 9 Aug 1930. Price Walker & Co: Price Walker & Co 1736-1986 by Hugh Conway-Jones. S&CCCo: Working Life on Severn and Canal by Hugh Conway-Jones. Canal traffic: GA D2460/4/5. Shallow depth of canal: TWA Microfiche 15396. Engineer's Annual Reports: TWA Microfiche 15397. Passenger steamers: GA D4292/6; Directories. Rowing regattas: GJ 1 Aug 1931, GJ 29 Jul 1933, GJ 3 Aug 1935.

## Chapter 10

Memories of Eric Aldridge, Tom Askew, Michael Bishop, Harold Boulton, Fred Carpenter, Reg Davis, Bill Deacon, Terry Dellbridge, Donald Fowler, Bert Fredericks, Dennis Fredericks, Ken Gibbs, Roderick Langstone, Richard Merrett, Bert Phelpstead, Cyril Savage, Alec Simmonds, Joyce Woodman, Dick Woodward. Engineers Annual Reports: TWA Microfiche 15397. Tanker accident: GJ 11 Feb 1939. Dredging and mud disposal: TWA Microfiche 15396; GA D2460/3/3/1/11. Stolen jewellery: Cit 18 Feb 1966.

**Chapter 11**
Memories of Eric Aldridge, John Bendall, Derek Browning, Geoffrey Clayton, Jack
Evans, Donald Fowler, Ken Gibbs, Doug Griffey, Jack Heaven, Ian Heddle, Roger
House, Richard Langford, Richard Merrett, Maurice Penfold, Bert Phelpstead, Ken
Price, Ivor Prosser, Harry Roberts, Palmiro Ruiz, Cyril Savage, Frank Savage, Ray
Savage, Alec Simmonds, John Turl and Brian Waters. Engineer's Annual Reports
1937-48 in NWM collection. Vindicatrix by Roy Derham. Sandfield Wharf: GA
D2460/4/7/4/76; Waterways News Apr 1977. Monk Meadow silo: Glos Coll Walwins
Box 166. RAF at the Junction: TNA AIR 29/1067. Traffic: GA D2460/4/5; TWA
Microfiche 1467; Glos Coll 40018; Cit 20 Jun 1968. Storm: Cit 24-25 Oct 1945.
Wrecks: A History of the Gloucester Harbour Trustees by W.A. Stone. Depth of canal:
GA D2460/4/7/1/29-39; TWA167/7/1/14. Bridge accidents: Cit 25, 27 Feb 1956; Cit
19 Mar 1956. Quedgeley oil depot: GJ 10 Sep 1960. Llanthony Quay: Cit 18 Sep
1961. Purton water intake: The Story of Bristol Waterworks Company 1939-1991 by
A. Hodgson; Cit 15 Mar 1963. Developments at Sharpness: Gazette 18 May 1974;
Glos Coll NF 15.52(46); Glos Coll 40018; Gazette 15 Aug 1970, 18 May 1974.
Monk Meadow Quay: Glos Coll JQ 14.56. End of barge fleet: Mercantile Navy Lists;
TWA167/26/5/3/16/23; Glos Life Jan 1970. Coastal tankers: Glos Coll JQ 14.49;
TWA Microfiche 14714, Cit 31 Jan 1985; Cit 3 Dec 1986. Hardwicke Bridge: TWA
Microfiche 7923. Closure of Freight Office: Cit 20 May 1988. Developments at
Gloucester: Cit 3 Jul 1986, 5 Apr 1988.

# Index

Numbers underlined indicate illustrations or maps